DREAMS *and* SHADOWS

W9-AQA-118

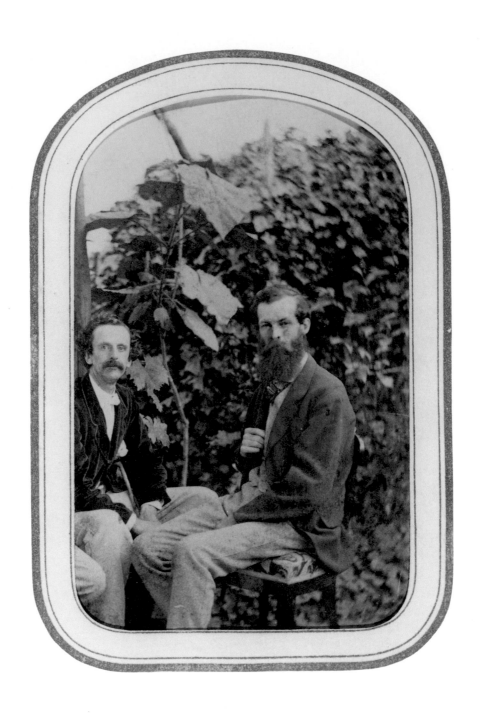

Photograph of Thomas H. Hotchkiss (right) and
Elihu Vedder seated in a garden, ca. 1866–1868.
(Manuscript Collection, New-York Historical Society, pamphlet 1582x)

DREAMS *and* SHADOWS

Thomas H. Hotchkiss in Nineteenth~Century Italy

BARBARA NOVAK

Catalogue by Tracie Felker

THE NEW-YORK HISTORICAL SOCIETY
in association with
UNIVERSE BOOKS

Published in conjunction with the exhibition presented at the
National Academy of Design, September 1993–January 1994

Published in the United States of America in 1993
by Universe
300 Park Avenue South
New York, NY 10010

© 1992 The New-York Historical Society
Essay "Dreams and Shadows: Thomas H. Hotchkiss in
Nineteenth-Century Italy," pages 6–30, © 1992 Barbara Novak

All rights reserved.
No part of this publication may be reproduced, stored in a retrieval system, or
transmitted in any form or by any means, electronic, mechanical, photocopying,
recording or otherwise, without the prior permission of the publisher.

93 94 95 96 97 / 10 9 8 7 6 5 4 3 2 1

Library of Congress Cataloging-in-Publication Data
Novak, Barbara.
 Dreams and shadows: Thomas H. Hotchkiss in nineteenth-century Italy /
Barbara Novak; catalogue entries by Tracie Felker.
 p. cm.
 "The New-York Historical Society in association with Universe Publishing."
 ISBN 0-87663-778-0
 1. Hotchkiss, Thomas H., 1833–1869—Catalogs. 2. Italy in art—
Catalogs. 3. Hudson school of landscape painting. I. Felker, Tracie. II. New-
York Historical Society. III. Title.
N6537.H648A4 1992
759.13—dc20 92-28274
 CIP

Printed in Hong Kong

Design by Douglas & Voss Group, New York

Map of Italy, page 31, courtesy Italian Wine Center,
Italian Trade Commission, New York

On the cover: Thomas H. Hotchkiss, *Roman Aqueduct with Shadows*, watercolor and
gouache with traces of graphite on off-white wove paper, $4^{15}\!/_{16} \times 7^{3}\!/_{4}$ in.,
The New-York Historical Society, x.443(c)

Contents

Foreword and Acknowledgments

The Museum of the New-York Historical Society is world-famous for its collections of nineteenth-century Hudson River School paintings. Amongst this large and significant holding is a treasure of intimate oils and watercolor sketches by Thomas Hiram Hotchkiss. A second generation Hudson River School painter, Hotchkiss's name is unfamiliar today. However, he exemplifies the expatriate American artists who studied and painted in Italy in the mid-nineteenth century. The New-York Historical Society is fortunate to possess almost all of Hotchkiss's extant work.

This large collection came directly to the New-York Historical Society from the family of Asher B. Durand, which inherited Hotchkiss's paintings and papers. The Society also has in its collections the largest single body of works by Asher B. Durand. Donations from the family and friends of artists typify the patterns of patronage and the growth of the collections of the Society.

Hotchkiss was a student and friend of Durand, and, as a young man, he traveled and sketched with him. He befriended Durand's daughter Lucy Durand Woodman and corresponded with her throughout his brief life. When Hotchkiss died in Italy in August 1869, John Durand (the artist's son) had many of Hotchkiss's paintings and personal effects moved to New York, where they were dispersed at public auction. John Durand and George Woodman, Lucy's husband, purchased much of Hotchkiss's surviving work. The majority of the Society's eighty-six Hotchkiss oils, watercolors, and drawings, as well as significant manuscript materials, were donated by Lucy Durand Woodman's daughter Nora in 1932.

The Historical Society is indebted to Barbara Novak, Guest Curator and now trustee of the New-York Historical Society, for her outstanding and pioneering interest in Thomas Hotchkiss. She has amplified her earlier work on Hotchkiss into this catalogue and exhibition. Her considerable expertise and enthusiasm for the subject have inspired all those who worked with her. Tracie Felker, Associate Guest Curator, co-curated the exhibition with Barbara Novak and wrote all the catalogue entries, which provide many new insights into Hotchkiss's work and career. It has been my good fortune to direct this project. Ella Foshay, former Curator of Paintings at the Society, initiated the Hotchkiss project; under her direction, Monique Richards Pettit carried out some of the early research. Annette Blaugrund has worked with energy and enthusiasm to coordinate

the catalogue and special thanks go to the guest curators and Albina De Meio, Administrator of Exhibitions and Registration, for their work on the implementation of the exhibiton.

An integral part of this project was the restoration of the entire collection of oils on canvas and paper, drawings, and watercolors. The conservation was carried out in a team effort, which I supervised in my role as Chief Conservator. The core work was performed by the Society's Paintings and Associate Paintings Conservators, Richard Gallerani and Richard Kowall, Paper and Assistant Paper Conservators, Reba Fishman and Mary Cropley, with invaluable help from Consulting Paintings Conservator Charles Von Nostitz. Glenn Castellano sensitively photographed the entire collection for the catalogue, and Diana Arecco was responsible for coordinating the photography for catalogue production.

Very gracious thanks are due to each of the lenders to our exhibition. Joseph Jeffers Dodge, Henry Melville Fuller, Jane and Simon Parkes, Whitney Sudler Smith, Graham Williford, and an anonymous collector generously permitted us to borrow from their private collections. Galleries, museums, and university lenders include Alexander Gallery, The Brooklyn Museum, The Butler Institute of American Art, The William A. Farnsworth Library and Art Museum, The Haggin Museum, The University of Iowa Museum of Art, The Metropolitan Museum of Art, Munson-Williams-Proctor Institute Museum of Art, Museum of Fine Arts, Boston, National Museum of American Art, The Fine Arts Museums of San Francisco, and Smith College Museum of Art.

This project could not have been carried through without the generous support of the National Endowment for the Arts, which provided funding for conservation and for the implementation of the exhibition, and the Henry Luce Foundation, which supported the research and cataloguing of the work of this important but too little-known American artist.

Holly Hotchner
Director of the Museum

Preface

Although the name of Thomas H. Hotchkiss is little known today, his work was greatly admired in his own time by such renowned older artists as Asher B. Durand. Encouraged by friends, Hotchkiss was drawn to the Italian landscape and settled in Rome in 1860—at a time when other American artists were beginning to train in Paris, where the emphasis was on academic drawing and figure painting. Italy, had, in fact, lost some of its allure as a place to study painting by the late 1840s when American artists gravitated to the art academy in Düsseldorf, Germany. By mid-century, small groups of American art students had already begun to study in Paris, which by the 1870s became the international art mecca.

In Rome, Hotchkiss became part of an international coterie of expatriates that included the American artists Elihu Vedder, Charles Caryl Coleman, and John Rollin Tilton. Although he received no Parisian training, Hotchkiss did create light-infused paintings that shared some of the qualities of French landscape painting. As this catalogue demonstrates, Hotchkiss's commitment to direct visual experience was related to period trends in both France and Italy. His interest in painting outdoors links him to the earlier French Barbizon painters, whose poetic landscapes became popular in the United States in the mid-1850s, as well as to the contemporary Macchiaioli, a group of Italian artists who produced small, brightly colored, broadly painted, realistic studies of their local surroundings. Unlike his peers in France who chiefly concentrated on the human figure, Hotchkiss, following in the tradition of Thomas Cole, father of the "Hudson River School," focused on the ruins in the Italian landscape—but added a modern touch.

Thomas Hiram Hotchkiss and Barbara Novak are kindred spirits, united by a scholar's dedication to the revival of an artist's reputation. Students have perennially heard Professor Novak praise Hotchkiss's jewel-like paintings of Italy. As a former pupil, I knew when I became a research associate at the Historical Society in 1976, it would be my destiny to work on Hotchkiss for the museum's catalogue of landscape and genre paintings. Hotchkiss additionally entered my consciousness since he had been a tenant—briefly in 1859—at the famous Tenth Street Studio Building, the subject of my doctoral dissertation. I am delighted to be associated with Hotchkiss once again as the Historical Society's curatorial coordinator of this catalogue and exhibition.

Hotchkiss is fortunate in capturing the enduring interest of Barbara Novak. It has been a great pleasure for me to work with her on this retrospective exhibition and catalogue, which will secure Hotchkiss's place in the history of American art. Tracie Felker, co-curator and author of the informative catalogue entries, deserves special thanks for her willing and prompt handling of the numerous curatorial and publication chores associated with this project. I would also like to acknowledge James Stave, editor, and Adele Ursone, editorial director at Universe Publishing, for their guidance and support, as well as Kay Douglas and Tom Voss for their sensitive design of this very special book.

Annette Blaugrund
Andrew W. Mellon Senior Curator of
Paintings, Drawings, and Sculpture

Dreams and Shadows:

Thomas H. Hotchkiss in Nineteenth-Century Italy

BARBARA NOVAK

He [had an] indifference to

considerations of fame and fortune.[1]

—JAMES JACKSON JARVES

To have seen Italy without having seen

Sicily is not to have seen Italy at all for

Sicily is the clue to everything.[2]

—GOETHE

. . . one must love space to describe it as

minutely as though there were world

molecules.[3]

—GASTON BACHELARD

Shortly after Thomas Hotchkiss died in Sicily in 1869, the critic James Jackson Jarves wrote: "Death has recently robbed the country of perhaps its most promising landscapist, Hotchkiss, who had settled in Rome. He had rare native gifts. Unhappily his physical strength was not equal to his zeal and conscience . . . He lived so absorbed in his work that but few individuals ever had an opportunity to know his rare ability, and died just as it was maturing to a point that would have placed him at the very head of American landscapists."[4]

Jarves's evaluation of Thomas Hiram Hotchkiss was not exaggerated. But he was aware of the difficulties of dealing with this neglected artist when he noted "few individuals ever had an opportunity to know his rare ability." Most of the known paintings are at The New-York Historical Society. Without this small group, and the scant documentary evidence that survives, Hotchkiss would have eluded history altogether. Yet, ironically, Hotchkiss revered History. His Italian sojourn can be read as a poignant individual response to a larger American dilemma involving Time and Culture.

Indeed, the myths of culture inevitably draw Hotchkiss into a familiar configuration: that of the immensely gifted artist who dies young, penniless, and far from home, of the disease the nineteenth century turned into a signature of sensitivity and doomed genius—tuberculosis. Hotchkiss's short, tragic life ironically validates this myth. The date and place of his birth remained unfixed until now; most sources located it between 1834 and 1837 somewhere in the Catskill/Hudson area. Only recently has it been discovered that he was born ca. 1833 in Coxsackie, New York.[5] We don't know exactly where he is buried or, indeed, if his grave still exists, since it may have been swept away by an earthquake.[6]

We know more about the end than the beginning. He died in the arms of his friend and fellow artist, John Rollin Tilton, in a small house, the so-called Casa degli Inglese built on the ruined amphitheater at Taormina in Sicily, where he painted some of his finest works.[7] He had reached that fatal zone for many young geniuses, around the age of thirty-five.[8] After his death, his works were auctioned off to fellow artists and collectors in Rome and New York to pay his debts.[9] Two cases of his papers and notebooks, along with works to be auctioned, were sent to the New York public administrator in 1870 by the American consul in Rome, David Maitland Armstrong. These documents, too, have been claimed by the myth of neglected genius. Estimated at less than $200 in value, they are

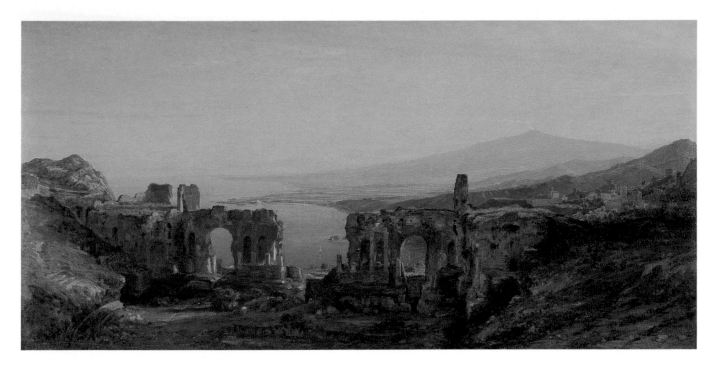

1 Thomas H. Hotchkiss, *Theatre at Taormina*, 1868. Oil on canvas, 15¾ × 30¾ in. Private collection

believed to have been destroyed in accordance with municipal custom.[10] Possibly, they may still surface from the city archives to flesh out the historical enigmas of this elusive figure.

Within the larger myth of Italy's antiquity, its dream of culture, Hotchkiss lived out the myth of the almost destitute artist, lost to history, a candidate for resurrection in a later century. This hope for the future, for the secular transcendence of their work, sustains many neglected artists. Perhaps it sustained Hotchkiss, for the stately progression through a full career was denied him by his foreshortened future. The retrospective dream of the past folds itself neatly into the reciprocal yearning for a future denied, yielding the kind of temporal anxiety that is the mortal flaw in the idealized dream of culture. The modalities of yearning and desire, and the elongated shadows of dread and regret, are visible in his work, forced into coexistence by an imagination that, for all its delicacy, insists on its transformative power.

<div align="center">✻ ✻ ✻</div>

Without a remark by his closest friend, Elihu Vedder, Hotchkiss and his art would probably have remained in limbo. "Some day," Vedder wrote, "his name will not be left out as it now is in the History of American Art." [11] With this exhibition, Vedder's prophecy is realized, and a century of neglect partly discharged. Vedder reinforced the romantic iconography by assigning to Hotchkiss the obligatory arduous childhood and family opposition: "[He] had evidently suffered in his youth, for he had worked in a brickyard under a hard relative who was strongly opposed to his artistic tendencies. . . ."[12] Whatever his duties at the brickyard, they did not compromise that gentle, insistent touch that was there from the beginning. When he emerged into the art world somewhere around his early twenties, he was already a gifted painter. That melting touch would distinguish his hand from those of his fellows. Only Gifford, who helped

to nurse him in his last months, painted with a comparable transparency and subtlety.

The few years that Hotchkiss lived and worked in America were spent in the circle of Asher B. Durand, who at this time was in his fifties. That circle included Suydam, Colman, Hubbard, Post, Champney, and Huntington. Hotchkiss was immediately in touch with artists of considerable sophistication and intelligence. Each summer they traveled to such colonies as Palenville, New York,[13] and North Conway, New Hampshire,[14] planting their white umbrellas in the landscape that was also their subject, decorously titillating—from the evidence—the young women who clustered around them.[15] Hotchkiss's presence was noticed and reported.[16] His appearance on the artistic scene—according to Kubler's definition of a positive "entrance"—was auspicious, indeed golden.[17] His work had excellent notices, especially in *The Crayon*, edited by Asher B. Durand's son, John, and by William J. Stillman, a painter-turned-photographer who also frequented North Conway.[18] A lifelong relationship was established with the "good angel of my life," Durand's daughter Lucy, later Mrs. George Woodman, who gathered together most of the work in the present exhibition,[19] bequeathing it, through her daughter Nora, to The New-York Historical Society.[20]

A scant four years after we become aware of him as an artist, Hotchkiss was elected, in 1859, an Associate of the National Academy of Design at his first nomination,[21] an unusual honor when we consider Heade's failure to be accepted after several years of intermittent residence at 15 Tenth Street in New York (he was finally blackballed in 1868).[22] However, Asher B. Durand, Hotchkiss's protector and mentor, was the president of the Academy at the time of Hotchkiss's election just prior to his departure for Europe. Hotchkiss must also have had the backing of powerful older members of the art community (Huntington, Durand's successor as president of the Academy had also been at North Conway).

In addition, Hotchkiss seems to have had that irreplaceable asset, the respect and approval of his peers. During his brief residence at 15 Tenth Street, around the time of his election to the Academy,[23] Hotchkiss was possibly in close contact not only with Heade, who was there some time during that year, but also with Shattuck and Suydam, already old friends from North Conway, and Church, Gifford, Gignoux, Casilear, Haseltine, William Hart, and Mignot. So, at this early point in his career, the young man was surrounded by some of the most sensitive landscape artists of his moment, artists who could appreciate his genius. That the Durand family believed in him from the outset is further indicated by a letter in Asher B.'s papers, possibly written to John Durand by his sister, Lucy, in 1857: "Colman S. & Hotchkiss have gone on a mountain tramp. I think Hotchkiss will do something yet, he is intellectual and has a good feeling for art. He makes good cloud studies, and don't spend all his time making pretty little pictures at which the others lose time yet."[24] From all this it is reasonable to conclude that the young artist was a marked man.

*　*　*

When did the shadow of tuberculosis, the scourge and romantic fantasy of his age, fall across his path? It was already a family weakness that manifested itself early. Rarely has a disease earned itself such an acceptable social glamour, more obvious in literature (Camille) and opera (La Bohème) than in painting. The nineteenth century made a fetish of death personified, and it lent some of that persona to its victims: the hollow cheeks, the deathly pallor and the hectic flush, the intermittent cycle of remission and relapse, and above all, the red stain on the handkerchief and the final hemorrhage and cachexia as the two personas join. The spiritualization of the disease is a phenomenon that has begged for further study. Susan Sontag suggests that the disease in the nineteenth century "was understood as a manner of appearing"[25] and ". . . all the evidence indicates that the cult of tuberculosis was not simply an invention of romantic poets and opera librettists but a wide-spread attitude, and that the person dying (young) of TB really was perceived as a romantic personality."[26] As one friend wrote of Hotchkiss, "Poor fellow he was far gone in consumption."[27] And the word "consumption" exactly indicates the slow consuming fire that eats away lungs and breath. Sontag connects the individualizing attitude to tuberculosis to its function as a trope for new attitudes (from the late eighteenth into the nineteenth century) toward the self.[28]

Was Hotchkiss's romantic "manner of appearing" apparent not only to those who met and knew him but also to himself? What level of self-consciousness existed here? To be tubercular was almost by definition to be romantic, tragically aware of the brevity of life. How did Hotchkiss's illness affect his work? As we shall see, at times Hotchkiss's excursions into the self border on the protomodern; his romanticism is slightly infected by a European *angst* uncommon in American landscape paintings of his period. And what brought him to Italy? Like the sufferer in Sontag's essay, Hotchkiss could be seen as "a dropout, a wanderer in endless search of the healthy place."[29]

Plagues, as we know from our current experience, develop their own mythology. One of the marks of tuberculosis was a chronic restlessness, as if the sufferer were trying to leave behind his or her shadow. Sufferers sought the earthly arcadia where they would be made whole. Though a contemporary (1863) account of consumption entitled "Weak Lungs, and How to Make them Strong" suggests that "removal to a warm latitude, so generally prescribed some years ago, is now rarely advised,"[30] Hotchkiss's removal to Italy four years earlier was undertaken, at least in part, in conformity to the traditional advice. Yet in searching for his motives, we cannot ignore the seductive power of Italy itself.

The dream of culture had been part of his artistic heritage since the example of Thomas Cole, the father of the Hudson River School, who died in 1848 while Hotchkiss was probably still working in the brickyard. Hotchkiss visited Cole's studio at Catskill on his one trip back to America a year before his death.[31] Though the Durand family offered him their support and friendship up to and even after his death, he returned to Italy, again following Cole's footsteps to Taormina. Cole's Italian dream dominated his life and work.

That dream, for all that has been written about it, remains mysterious, as romantic reverie remains mysterious. Henry James, in his extraordinary tribute to the Italian idyll, *William Wetmore Story and His Friends*, speaks of "so many happy dreams of it, so many preparations, delusions, consolations, a sense of the sterner realities as sweetened and drugged as if, at the perpetual banquet, it had been some Borgia cup concocted for the strenuous mind."[32] The anodyne quality of the dream suppressed restlessness, mortal nostalgias, anxieties, pain. When Hotchkiss arrived in Italy in 1860 he had roughly nine years to live. By turning his back on his curtailed future, he could cast his mind back over two thousand years to a horizon where the dream of Culture was illuminated by the glow of antiquity.

In this dream, Time is reified, and personified. In the nineteenth century, particularly in literature, abstractions cast an anthropomorphic shadow. A body of Time, warmed by the exhalation of this dream, could be preserved as a kind of repository for the artist's own afflicted body, partaking by proxy in the immortality afforded by Time's vast stretches. The individual, through the archaeology of memory and representation applied to the ruins, now free of all their original savagery and politics, could find enough mobility to survive within this vast retrospective paralysis of Time. Thus the maintenance of the Italian idyll—as in any idealization of past time—required selective denial and emphasis to keep its contradictions at bay. Time, Memory, the Landscape, and the Self negotiate the conditions that sustain the dream, drawing on formidable resources of energy to maintain its surface. Thus the narcotic draught of James's "Borgia cup," in proper paradoxical style both numbed the senses and sharpened them, in itself a characteristic of Hotchkiss's disease—and of his artistic practice.

But for American artists, the Arcadian idyll was given extra impetus by a sharp contrast not shared by their European colleagues. Hotchkiss had delivered himself from American newness into the autumnal patina of Italian Time. In so doing, he was fulfilling a painful American need to annex a known past, a civilization and culture by definition barred to the New World.[33] The storied past with recorded deeds, to which Cole had alluded in his famous Lyceum talk,[34] was only available in Europe, in an Italy that also offered its idealized past to European artists. Surely that was why the art crowd at Caffè Greco included so many Germans, Scandinavians, and English as well as Americans.[35] All of them—as their art makes clear—immersed themselves in the idealized fiction of the Roman Arcadia. But for the Americans the contrast of cultures was, as it were, (to appropriate Levi-Strauss's felicitous title) between "the raw and the cooked." For Hotchkiss, to go from America, a country of present and future, to a place where the past receded in an imperial perspective, was to identify his life with that retrospective infinity.

Every communal dream is entertained at different levels of insight by its participants. For many of the expatriates, there was no lack of self-consciousness. Or rather, consciousness of the self in absentia that every dream involves. George Stillman Hillard commented in 1853: "As Rome cannot be comprehended without previous preparation, so it cannot be

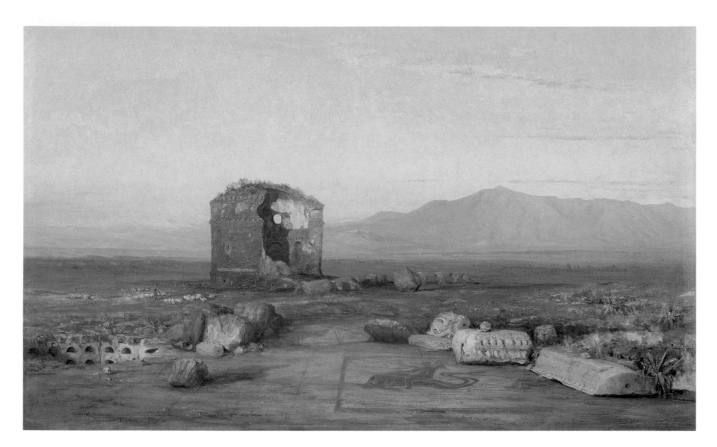

2 Thomas H. Hotchkiss, *Torre dei Schiavi*, 1864. Oil on canvas, 17 × 27 in. Private collection

felt without a certain congeniality of temperament. Something of the imaginative principle—the power of going out of one's self and forgetting the actual in the ideal, and the present in the past—the capacity to sympathize with the dreamer, if not to dream—a willingness to be acted upon, and not to act—these must be wrought into the being of him who would catch all the inspiration of the place. . ."[36]

What is described here is a prescriptive attitude, almost an aesthetic lifestyle that ignored the contingencies of the Italian present. Some, like Margaret Fuller, responded vigorously to the politics and inequities of the day, but most of the artists were absorbed in a final reverie on a city and culture that had sustained artists for aeons. This luxurious meditation was the romantic successor to the enlightened Grand Tour, a tour now internalized into an individual connoisseurship of time past. Time had become subjective; each entered his own paradise in the context of the communal dream.

The dynamics of this manipulation of past, present, and future are illuminated by Merleau-Ponty when he writes: "Change presupposes a certain position which I take up and from which I see things in procession before me: there are no events without someone to whom they happen and whose finite perspective is the basis of their individuality. Time presupposes a view of time. . . . It is not the past that pushes the present, nor the present that pushes the future into being; the future is not prepared behind the observer, it is a brooding presence moving to meet him, like a storm on the horizon."[37] Hotchkiss's "brooding presence" was the certainty of his near mortality. An abridged future could only be met by a turnaround in the opposite direction of linear time. Situating past, present, and future along Merleau-Ponty's *lines of intentionality*,[38] we might posit

that for Hotchkiss this reversal of direction along time's trajectory was not simply the product of the general romantic tropism toward the past, but a realistic consideration of the options of the present. He could mitigate the coughing fits and bleeding by losing himself in the dream of America's alternative paradise.

<p style="text-align:center">* * *</p>

> Your letter came like a good angel in a very dark and almost hopeless period of my life and gave me much pleasure . . . I will tell you truly the reason of my not writing. I have been in such straightened circumstances that I could not pay postage and I felt that it was taking your generosity too far to oblige you to pay for my letters as well as your own . . . I am now very much in want of money and if I had not sold some of my sketches to friends here I should have starved long ago . . . what I shall do if I do not get something from home soon is what I hardly dare imagine. It is not here as it would be at home where I could do some other work until some better time.[39]

So wrote Hotchkiss in December 1862 to Lucy Durand Woodman. Without money and harassed by illness, how did he manage to survive? Who were the friends and patrons who helped sustain him?

There are indications that he had a network of important artists and patrons on both sides of the ocean. But they were not sufficiently forthcoming with funds to allay his anxieties. In the same letter, he asks: "I wonder why Avery does not write me. Last August I received a paper with some writing on the margin saying he would send me 100 dollars in a few days. Since that time I have heard nothing from him although he has sent hopes occasionally."

Samuel P. Avery, connoisseur, collector, dealer, and ultimately founder of the Avery Architectural Library at Columbia, maintained for a while a correspondence with Hotchkiss. He made some effort to help out, posting an occasional draft for $100, and trying to sell some of the art.[40] Before Hotchkiss left for Italy, several other collectors had been drawn to his American landscapes, notably Dr. E. J. Dunning, a member of the United States Sanitary Commission[41] who acquired Hotchkiss's *Harvest Scene*, shown at the National Academy of Design in 1859 and favorably reviewed in *The Crayon*, and W. T. Walters, though no Hotchkiss is presently included in the Walters Collection.[42]

The European correspondence shows how Hotchkiss's fortunes varied. In a letter of November 1862 to Avery, written about a month prior to his lament to Lucy, he said: "In the art world of Rome the prospects look very gloomy for the coming winter; with the present rate of exchange very few will leave home and of these none are likely to buy pictures . . ." Six months later (May 27, 1863), however, he was able to write: "I have had much better success this winter in selling pictures than I expected. I shall be able to get through until next winter very comfortably . . ."[43]

Among American collectors in Italy, Hotchkiss managed to acquire the backing of such figures as William Herriman,[44] an associate of J. P.

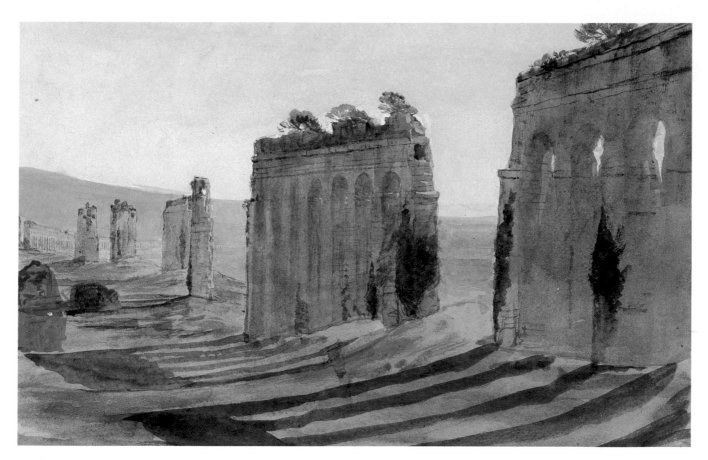

3 Thomas H. Hotchkiss, *Roman Aqueduct with Shadows*. Watercolor and gouache with traces of graphite on off-white wove paper, $4^{15}/_{16} \times 7^{3}/_{4}$ in. The New-York Historical Society, x.443(c)

Morgan, and W. S. Gurnee, who also patronized Vedder. English collectors were drawn to Hotchkiss's work, and several undiscovered works may still be sequestered in English collections.[45] While all this indicates that Hotchkiss had some admirers who offered him support while abroad, his debts at his death show that it fell short.[46]

Though Sicily claimed him intermittently, from 1860 on Hotchkiss based himself primarily in Rome, living for a while at the Palazzo Barberini, where he could count among his neighbors such distinguished fellow tenants as the William Wetmore Storys and the expatriate landscapist John Rollin Tilton, in whose arms Hotchkiss died in Taormina. Other frequent companions, members of his inner circle, living permanently or for extended periods in Italy, included Charles Caryl Coleman, who later did some of the decorative work at the World's Columbian Exposition in Chicago in 1893, and William Graham, an artist much admired by Whistler. George Yewell and the sculptor William Rinehart were also connected with the group. Yewell acquired a number of Hotchkiss's works at auction after his death. And Gifford, on his arrival in Italy in 1868, renewed his acquaintance with the artist he had known in America and called on him several times during the final phases of his illness.[47] If the artists of his circle were not in a position to offer funds, they appear to have offered respect, encouragement, and admiration.

There were some surprising connections and friendships. George Fuller, a more painterly artist of the next generation, may have accompanied Hotchkiss on a trip to Paris, possibly in 1860 when he was en route to Italy.[48] This suggests that Hotchkiss was much more in tune with an

artistic avant garde than one might have expected. In England, he visited the home of John Linnell at Redhill, Surrey, having met one of the younger Linnells (probably William) and Henry Wallis in Italy.[49] As he had with the American artists, Hotchkiss seems to have earned the respect and friendship of his English colleagues.

From England, he wrote to Lucy Durand Woodman (September 26, 1865) that he had spent three weeks in North Wales

> among the mountains with some friends I knew in Italy. The bracing mountain air did me a world of good after the heat of Italy and the closeness of London in July. Since my return I have been painting during every hour of daylight on two pictures which I hope to finish before I go back to Italy. One is nearly done and is liked by several painters, among others by Holman Hunt who expressed himself well pleased with what I showed him. Henry Wallis another Pre-Raphaelite painter has been kind to me both here and in Italy when I first met him—I have found more friends here than I have known before since I left home.[50]

Hotchkiss seems to have had a gift for such friendships, which were far from parochial. The few clues we have indicate an eager cosmopolitan sensibility. Soon after his arrival in Florence in 1860 he went sketching with Elihu Vedder, who would become his closest friend. Probably through Vedder he met the revolutionary Nino Costa, who was a member of the Macchiaioli group. The three artists may have traveled and sketched together in Volterra.[51] Six years later, when Vedder returned to Italy after the Civil War, he set up a studio at 33 Via Margutta, near Costa. Costa may have joined Vedder and Hotchkiss again as they searched for suitable subjects in Umbria—Perugia, Narni, Gubbio—and the central Italian hill towns.[52]

Hotchkiss's contact with Fuller in Paris, with the Pre-Raphaelites in England, with Costa in Italy separates him from the American expatriates who were painting tourist views for Grand Tour travelers. As he developed his own art and attitudes, he was clearly alert to the advanced art and thinking of his moment. An "artist's artist," he commanded the respect not only of the leading older artists, but of younger artists moving their art toward a future he did not live to see. In its own way, his style—not as broad as Vedder's nor as flat as Costa's—pressed against that future by frequently invoking ominous spaces with an expressive power more familiar in early modernism.

<p style="text-align:center">✳ ✳ ✳</p>

In his outrageous and quixotic *Digressions of V. Written For His Own Fun and That of His Friends*, Vedder has left the fullest description of Hotchkiss: "I met Hotchkiss first in Florence. He was a very tall, spare, delicate-looking man, who had evidently suffered in his youth. . . . I did not like him at first because I did not understand him, but he became afterwards my dearest and best-loved friend."[53] Vedder's first impression was of some-

one "somewhat uncouth." At first he felt that Hotchkiss's "recent experience in the brick-yard—an experience useless in every way—made him somewhat rude, and his insidious malady, pettish; but he had a sweet smile and the most beautiful clear eyes I ever saw."[54] When Vedder returned to Italy after the Civil War, Hotchkiss had become the "charming companion" with whom he spent so much time during the last three years of Hotchkiss's life.

A photograph of Hotchkiss and Vedder in The New-York Historical Society gives us the only known glimpse of Hotchkiss (see Frontispiece).[55] "Tall" indeed, according to Vedder, but he is even more gangling and asthenic—the classic tubercular physique. The gentle expression of the eyes confirms other contemporary descriptions. The lower half of the face is masked by a beard that gives an impression of patriarchal seriousness, affording some protection for an artist vulnerable both in personality and health. "Hotchkiss!" Vedder had proclaimed somewhat mysteriously, "the name—how expressive of the man!"[56] If by this he meant an onomatopoetic suspiration of breath signifying sensitivity, this was consistent with other impressions. A report to *The Crayon* in 1856 refers to him as the "thoughtful Hotchkiss,"[57] and Hennessy, who had met him at the National Academy of Design was "impressed by his great modesty and gentleness."[58]

What was Hotchkiss's daily life like? His friends give us some hints. Yewell writes in his Rome diary (December 3, 1867) that he is very busy

with sight-seeing, going to the galleries, and out upon the campagna, sometimes with Vedder . . . and also Thomas H. Hotchkiss . . . I called upon Hotchkiss at his studio in the *Quattro Fontana*, which commands a fine view of Rome. He showed me some fine Sicilian studies & views of Etna from Taormina which were very beautiful and artistic in treatment and excellent in color. . . . [March 22, 1868] . . . looked in upon Charley Coleman, now rapidly recovering . . . Hotchkiss was there and we chatted together for half an hour. [April 30, 1868] Charley came in with Rinehart, and we decided to go to Tivoli tomorrow in the diligence to study a few days. Mr. and Mrs. Mozier, Mr. Gordon's family, . . . Charley and Rinehart with ourselves, form the party. I went up to see Vedder at Hotchkiss's studio to make arrangements. Looked at the new pictures Hotchkiss has lately bought, fine old early Florentine subjects. [Venice, January 15, 1869] Called on Graham this morning and found him in nice quarters near Mrs. Barbier's. Hotchkiss has gone off to the Tyrol. He had bad weather all the time he was here and went off disgusted with Venice. Graham expects to go to work some in San Murano.[59]

In 1868, before the stay in Venice cited by Yewell, Hotchkiss had made his one brief visit back to the States. When Gifford saw him shortly after his return to Italy, he reported that Hotchkiss had had "two turns of bleeding" since his return.[60] Toward the end, enforced limitations of energy and of time must have caused him to measure both out carefully. But he did not skimp on the time devoted to his paintings. Vedder notes that "he was

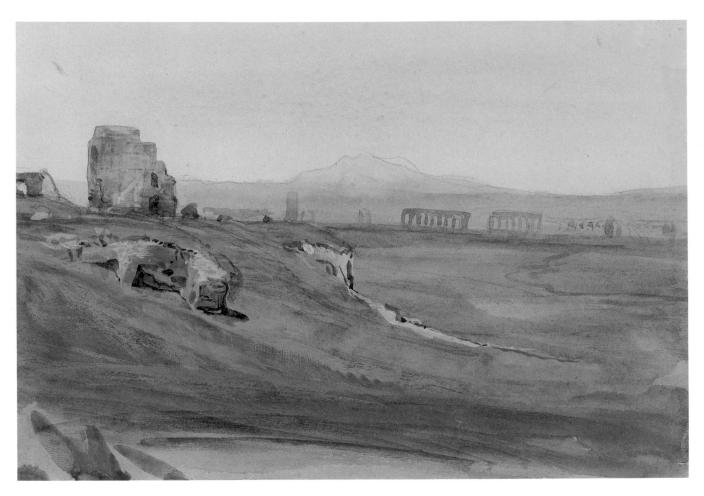

4 Thomas H. Hotchkiss, *Roman Aqueduct.*
Watercolor and gouache with some
graphite on off-white wove paper, 5¼ ×
7⅞ in. The New-York Historical Society,
x.443(D)

careful from the beginning to the end of a picture, taking every precaution that it should be enduring work."[61] "Our tastes were the same," Vedder recalls, "we lived together, painted copies in the Gallery. . . . In Perugia we bric-à-bracked together and bought all our modest means would allow."[62]

Vedder's casual mention of "bric-à-bracking" is deceptive, for Hotchkiss, despite his limited financial resources, was a sophisticated collector. According to Henry Wallis, he owned some Signorellis.[63] At the New York auction of his effects, two of his prized possessions, Piero di Cosimo's *Hunting Scene* and *Return from the Hunt*, were acquired for the Metropolitan Museum by Robert Gordon, a donor and early trustee. The surreal and allegorical overtones of these pictures, characterized in the New York catalogue as "Satyrs, Sacrifice, &c."[64] and only later attributed to Piero di Cosimo, suggest that Hotchkiss's connoisseurship was unlike that of most of his countrymen, as does his close friendship with the Vedder who created *The Lair of the Sea Serpent.*

Vedder wrote to Hotchkiss from New York, while on a visit to the States in 1868:

Both you and Charley are lucky in being in Rome I can tell you . . . I have lately bought a book on old alphabets—it has a complete set of letters of the kind contained in that book of yours that was so full— also for ten dollars a set of Durer's Life of Christ called the Little Passion—reproduced in fac-simile by photolithography. There are to be

had some splendid books . . . one the history of printing, but you and I have some title pages that rather take them down. . . . Don't you be giving away any thing and if you go around to book stores have an eye out for me as well as for yourself.[65]

The New York auction of Hotchkiss's effects at which Gordon acquired the Piero di Cosimos included volumes of illuminated books, an illuminated missile, books by Plutarch and Homer, Ariosto, Wordsworth, Landor (a personal friend of Vedder's), Balzac's works, three volumes of *Modern Painters* and four volumes of other works by Ruskin, Eastlake's *History of Oil Painting*, and Holbein's *Dance of Death*, ancient engravings, illustrations by Millais, and a watercolor by Stansfield of a scene from Hamlet.[66]

Hotchkiss also possessed two blue porcelain vases, a copy after Velasquez of a Spanish prince, and a rare illustrated book (two copies) by Bernardo Gamucci, *Le Antichità della Città di Roma* (1569), some of which are in the present exhibition. For Lucy Durand Woodman, he purchased a bronze statuette and four decorative vases in Rome.

Hotchkiss had a complex and rarefied sensibility, capable of recognizing the genius of a Piero di Cosimo or a Signorelli long before they were in fashion; he prized books as well as art; to him, indeed, books *were* art, as were decorative objects. All of these, we may imagine, fed his sense of Culture, a culture to which he may not have been born or trained. Yet in the brick-yard, somehow, all this existed in potential. The Italian dream brought it to fulfillment.

<p align="center">✻ ✻ ✻</p>

Hotchkiss's Italian works exist in what Gaston Bachelard called "the detemporalisation of the states of great reverie." He posits the suspension of reverie as a state "below being and above nothingness," which subsumes "the contradiction between being and non-being."[67] He goes on to say that states of reverie make "contact with possibilities which destiny has not been able to make use of."[68]

The value of Bachelard's thinking is that it removes reverie from the precincts of nostalgic indulgence of a lost past, and presents it as the matrix from which lyric poetry is generated, that is, poetry which, by annihilating time and distance, elevates the speaker (in this case, the artist) and renovates the present.

Rarely do desire (and painting is its sensual enactment) and a sense of power over culture (albeit a remote culture) fuse so convincingly as in Hotchkiss's art. As I have emphasized, in Hotchkiss's case, this myth of lost culture was augmented by the myth of early death and by the febrile clarity that frequently attended his illness. In its final stages, tuberculosis occasionally generates an unfounded optimism that opens up the possibilities to which Bachelard refers. As Sontag notes, there was often something saintly about the calm with which victims of tuberculosis met their fates.[69]

Reverie relieves the contradictory awareness of limited time (mortality) and illimitable vistas (immortality), even as that contradiction is a

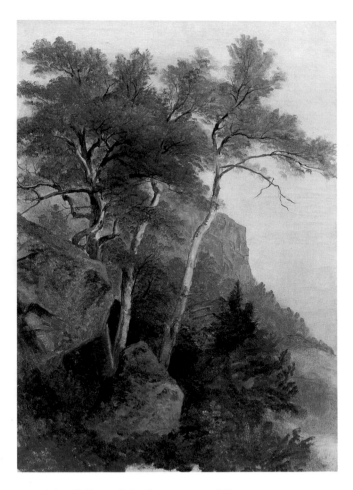

5 Asher B. Durand, *Landscape*, ca. 1855. Oil on canvas, 23⅞ × 16⅞ in. The New-York Historical Society; Gift of Nora Durand Woodman, 1932.26

6 Thomas H. Hotchkiss, *Tree Study, Catskill Clove*, 1858. Oil on canvas, 13⅞₆ × 8½ in. The New-York Historical Society; Gift of Nora Durand Woodman, 1932.37

powerful impetus to reverie. The nineteenth century—the century of mortal youth and romantic epiphanies —abounds with moral cautions about dead ambitions and lost time, from Shelley's "Ozymandias" to Keats's "Ode on a Grecian Urn." But by stretching back over vast distances to fantasies of previous cultures, the mirror reflects back not the lost culture but a utopian desire for life perfected. The powerful forces of reverie—and its powers are formidable—as Bachelard describes it, and as Hotchkiss painted it, "deepen the past of a person by detaching it, through solitude, from contingencies foreign to his being."[70] The Italian dream became for Hotchkiss a means of detachment from the dire contingencies of his mortal predicament. Italy became the factual site of an "imaginary memory."[71]

In constructing that memory, Hotchkiss insisted that the ruins on the Campagna, or Torre dei Schiavi, or the Theater at Taormina, assert their weight and density. As vessels filled with time as if it were a remote but

palpable substance, their pragmatic verisimilitude anchors his fantasy of culture. So the specifics of the Italian monuments are faultlessly rendered. Their tangibility is lucidly stated, no matter how immersed and blurred by warm air or portentous lakes of shadow—shadow in which there is more than a touch of Baudelaire's "smiling regret." The narcotic sense of suspended time—intrinsic to this cultural dream—is a function of reverie translated into atmospheric pulses and transparencies. Romantic reverie, however, in which the dreamer is and is not present, was—no matter how it offered illusions of individuality—a shared convention. It was a communal solution in which escapism, illusions, temporal anxieties, idealism, aestheticism, clichés, notions of culture, ideas about the nature of selfhood, are dissolved in a dream that sustains itself at times through the very forces that threaten it. The origins of that dream lie, of course, in the romantic realization of the self through its annihilation, an absolutism so punishing that, pursued to the extreme, it can be maintained only through a complex variety of strategies and rejections. If successful, another world is substituted, like an hallucination.

How did Hotchkiss reach the degree of sophistication necessary to fulfill his aims? The early works, according to Vedder, were marked by an awareness of Ruskin's writings. Ruskin's books and comments in *The Crayon* (to which Hotchkiss subscribed)[72] around this time had a powerful influence. That influence is visible in the careful accumulation of detail in *Catskill Mountains, Shandaken* (see p. 33). Even more important perhaps was his contact with Asher B. Durand's summer studies, which broke the safe mould of the Claudian composition, substituting a kind of ad hoc pragmatism, thereby making a major contribution to American landscape painting (see figs. 5 & 6). Elsewhere, I have called this "the pragmatic mode."[73] This mode forces a one-on-one confrontation with nature without the interposition of inherited conventions of Claudian structure, which signify cultural sophistication, much like the Reynoldsian endorsements of superior modes from the previous age. *Tree Study, Catskill Clove* and the winter landscapes are unprotected by this discreet snobbism. Hotchkiss was free—as in *Catskill Winter Landscape* (see p. 36)—to develop a style independent of structural stereotypes. The extraordinary durability of the debased Claudian mode can be seen in the obliging landscapes of lesser American artists catering to the tourist trade. Italy, as seen through Claude's eyes, had almost replaced Italy itself. A powerful perceptual paralysis reinforced itself before the same sights and vistas. Hotchkiss rectified this, situating himself in a fresh encounter, via Durand's example, with the Italian landscape and monuments.

Claude, however, entered Hotchkiss's thinking in a subtle way—through his admiration for an admirer, indeed, a rival of Claude's: J. M. W. Turner. In a letter to Durand from London, shortly after his arrival (February 1860), Hotchkiss noted that he had made "two or three sepia and several sketches from the Turners in the National Collection." He was deeply disappointed in the contemporary English landscapes at the British Institution, though he admired a few works by William Holman Hunt and Dante Gabriel Rossetti, "and several landscapes by young men of whom I have never heard . . . But I must think that except Turner our

painters have done more in landscape than the English." Even the Old Masters were, for him, "with the exception of Claud[e] wholly routine and conventional and Claud[e] has only given one or two faces of nature and is perfectly childish in everything else."[74]

Since Turner had aimed to surpass Claude, he would have been pleased at Hotchkiss's response to his works. "Turner . . . ," he wrote, "is to my feeling the greatest of all painters. I can like his pictures without making the effort to do so which is not the case with the old masters in landscape." He admired not only the Turners in the National Gallery, but those in Ruskin's collection, which he had a chance to study carefully, exhibiting a discriminating critical sense. Ruskin "has two or three fine pictures in oil and about fifty water color drawings all important and fine Examples from every period of his work . . . Taken as a whole I think these drawings surpass his oil pictures. They are more quiet and united in idea and less ambitious."[75]

Like many of his American contemporaries, Hotchkiss already knew Turner largely from his engravings. Now the original paintings he saw in London were powerful paradigms. He shared his admiration for Turner with his predecessor, Washington Allston, who claimed that Turner "had no superior of any age,"[76] and with Cropsey, John Henry Hill, Gifford, W. T. Richards, James Hamilton, Frederic Church, and Thomas Moran, to name only some of the best known. Thomas Cole's mixed feelings about Turner did not deter him from using Turner's *Building of Carthage* as one of several models for *Consummation* in *Course of Empire*.

Hotchkiss's later watercolors are, like Turner's, sure, fresh, and limpid—and even freer of convention than their English models. The qualities he isolated in Turner—"delicacy, breadth and unity"[77]—describe his own work. Detouring around the exhausted sign of Claudian structure, Hotchkiss's pragmatic urge mobilized the iconic Italian landscape out of its paralysis. To that landscape, he *invented* his own structural responses. The invention was due in part to the landscape painter's first decision: the act of deciding what to paint. There is a kind of *déjà vû* in landscape painting, where the painter revisits his own landscape, which "returns" to him in his choice of subject. Hotchkiss desired the horizon, and the long horizontals of the flat Roman campagna, which offered an endlessly unframed space. His paintings are often slimly panoramic, recalling the classic luminist structure defined by his American colleagues Heade, Lane, and Kensett while he was away in Italy. Into these narrow spaces, Hotchkiss compressed the sonorous connotations of Time and History that American writers and artists, starved for an authentic past, had attached to European civilization.

Where Luminism was cool and distilled, the atmosphere of Hotchkiss's work softens the luminist-like structure and warms the pragmatic detail. That atmosphere is the medium of the American dream of European culture. As the pulsations of Hotchkiss's touch create this tissue of light, they trap and subsume the contradictions inherent in the grand reverie of a generation. Air in Hotchkiss's paintings is part paint, part light, an emblem of infinity, a distillation of emotion, opening and filling the space with a subtle process. That process, discernible in these

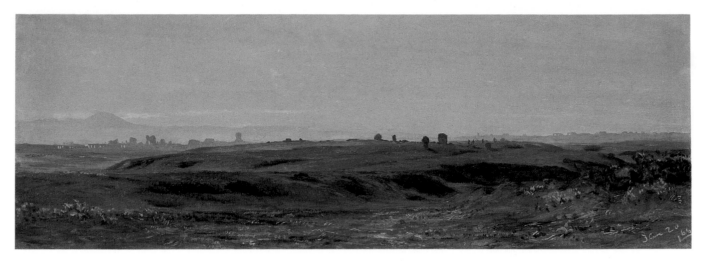

7 Thomas H. Hotchkiss, *Landscape Sketch (Roman Campagna)*, 1866. Oil on wove paper, 5^{15}/$_{16}$ × 15^{11}/$_{16}$ in. The New-York Historical Society; Gift of the Estate of Nora Durand Woodman through Hannah Woodman, 1942.479

minute strokes, unseals the space, making it—as process does—available to the circulation of air and thought. These touches, the signature of process and thus of time, annotate the grander idea of an abstract and frozen Time, thereby ambiguously sustaining it.

Just as the subtle traces of process mobilize Hotchkiss's landscapes, the space of those landscapes is frequently skewed and charged in a way at variance with the limpid reveries so carefully constructed. The elongated shadows, pools of darkness, and somber excavations that frequent his work point its sensibility in another direction. To emphasize the pathetic fallacy here—to say that these shadows are emblems of the shadow across his future—would be to indulge a sentimentality his art always refuses. But the expressive urgency of these shadows and space bespeak certain affinities rather than direct influences. Heade's *Approaching Storm, Beach near Newport*, a somewhat phenomenal occurrence, was painted in the same decade from a similar mid-century aesthetic. A few years later, in the 1870s, Homer's *High Tide* and Eakins's *Pushing for Rail* show similar charged anxieties in terms of space. Space is no longer a poetic envelope that exhales, as it were, the landscape within it, but an expressive force subject to warps, distortions, and discontinuities. Not just space, but a cultural attitude had changed.

In such paintings as *Roman Colosseum*, *Landscape Sketch (Roman Campagna)* (fig. 7), and *Scene in Italy (Roman Campagna)* (see p. 73), Hotchkiss, like Heade, presages certain aspects of modernist painting: Munch's haunting images, surrealist mystery. This is hardly surprising. Surrealism and Expressionism, after all, inherit the romantic dream, but a dream that now registers other disruptive forces. While speculation on what Hotchkiss might have done had he lived is unrewarding, it may be that the expressive urgency in such paintings would have enabled him to comprehend and survive a changed aesthetic and cultural environment. This speaks to the issue of how an artist identifies himself in relation to his work, and how that self is constructed. We usually correlate touch, process, and charged space with an assertive presence. That presence, no matter how discreetly stated, donates an anthropomorphic cast to the painting's space and time and, through complex transactions, to the reveries they engender. Hotchkiss's self is never totally erased in these paintings. On the con-

trary, it is poignantly present, borne by those pulsations of touch that accumulate the liquid delicacies of his paint films. The veils of color that convert into atmosphere and luminosity are based on principles of transparency and opacity that distinguish the painterly tradition—one found, in American art, most frequently in the hands of cosmopolitan artists alert to European artistic traditions.

Add to the above a certain mild obsessiveness in choice of subject, for Hotchkiss, once he had identified a subject, returned to it again and again. Versions and series of his key subjects exist: the Theater at Taormina, Torre dei Schiavi, the Roman Aqueduct, the Colosseum. This could be seen simply as standard practice, developing an idea from sketch to finished picture in larger and smaller versions. But the need to define and refine certain images has, in Hotchkiss's case, a different urgency. While he reclaimed the icons of the Italian landscape for his purposes, he turned them, through repetition, into the emblems of his individual reverie. Hotchkiss's identification with these subjects is thus intense, an urge (to paraphrase Cézanne) to *realize* his dream, to make it palpable, inhabiting and reinhabiting the same places and monuments. They bear him back into the infinite stretches of antiquity, where the dying body could be shielded from the depredations of time. There it survives in the elusive signs of process that describe space, volume, and substance. As Bachelard puts it: "the man of reverie is always in space which has volume. Truly inhabiting the whole volume of his space, the man of reverie is . . . *in* his world, in an *inside* which has no *outside* . . . the dreamer is *plunged* in his reverie. The world no longer poses any opposition to him."[78]

Hotchkiss's entry into that space is convincing. His pursuit of the dream bespeaks a determination and desire for perfection that must have been physically punishing. In conducting his chronic illness he was not prudent. He traveled incessantly over the landscape of his dream, and his concentration, as he annotated that dream in painting after painting, did not flag. A powerful will sustained his voyage into that ideal space. The sublimated nostalgias implicit in the dream resist anything that would compromise them. But, as pointed out above, shadows frequently invade the luminous poetry, intimations of mortality inseparable from the romantic adventure. Thus the paintings present the different complexions of regret and hope, signifying equivocal notions of time that consume the present in which Hotchkiss is wasting away. Regret casts its shadow across his dream space by acknowledging its artificiality, even as that space returns to him its potent hope of a future perfected in a remote past.

ACKNOWLEDGMENTS

I would like to acknowledge especially Annette Blaugrund's involvement and support at every step of this project. In her devotion to bringing it to fruition she was unstinting of her time and energy, which are much appreciated. Tracie Felker's contribution has been indispensable. Her research added new material, and her patience and energy in coordinating, checking, and guiding this monograph to completion were exemplary. I would also like to thank Ella Foshay for initiating the Hotchkiss pro-

ject with her unwavering support for my belief that he should be restored to history. Hopefully we are now further advanced toward that goal.

NOTES

1. James Jackson Jarves, "Art: Our Greatest Landscapist," *The Independent* (May 30, 1872): 2.

2. Johann Wolfgang Goethe, *Italian Journey, 1786–1788*, trans. W. H. Auden and Elizabeth Mayer (San Francisco: North Point Press, 1982) 240, entry of April 13, 1787.

3. Gaston Bachelard, *The Poetics of Space* (New York: The Orion Press, 1964) 159.

4. James Jackson Jarves, "Art-Museums, Amateurs and Artists in America," *The Art-Journal*, London (May 1, 1870): 130.

5. The recent discovery of Hotchkiss's passport application, dated October 6, 1859, lists his age as 26, placing his birthdate ca. 1833 in Coxsackie, New York. General Records of the Department of State, Record Group 59, Passport Number 15890, National Archives. I am grateful to Merl M. Moore and Tracie Felker for this information. [David] Maitland Armstrong states in *Day Before Yesterday: Reminiscences of a Varied Life* (New York: Charles Scribner's Sons, 1920) 188 that Hotchkiss was born at Hudson, N.Y. but his source for this is not known. Evidence has traditionally pointed to a birthplace in the Greene County area, though the records still elude us. Some of the family evidently lived in or near Athens. Most recently, Tracie Felker has posited a residence in Mt. Morris, based on a newspaper clipping in the Manuscript Collection, New-York Historical Society, pamphlet 1582x: "Mr. Hotchkiss, a young man from Mt. Morris." A "James Hotchkiss, Brick-Maker," is listed in the Rochester, New York, city directories from 1847 to 1849. Rochester is located near Mt. Morris.

6. Nathalia Wright, in "The Official Record of Thomas Hotchkiss' Death: Evidence for the Date of His Birth," *Art Quarterly* (Fall–Winter 1967): 264–5, says that Hotchkiss was "presumably buried in what is now the *acattòlico* or protestant cemetery, toward the foot of the hill at the northern extremity of the town, just below the Greek amphitheater he depicted in his *Taormina the Island of Sicily . . .*" and posits an unmarked grave. A letter from William Graham to George Yewell, however, dated August 31, 1869, reports on a note from Mrs. Tilton informing him of Hotchkiss's death in John Tilton's arms and stating that "Mr. Tilton was to leave on Sat. 20 for Messina with the body there to have it buried in the Protestant cemetery of that place." (George Yewell Papers, Archives of American Art, Smithsonian Institution, Roll 2428, Frames 212–3.) Armstrong (op. cit., 190) speaks of a *nameless* grave at Messina, never marked by a stone, and suggests, too, that an earthquake has probably obliterated the cemetery. Elihu Vedder, in *The Digressions of V* (Boston and New York: Houghton Mifflin Co., 1910) 418, speaks of a neglected grave "where at Taormina he lies buried." My own search for the grave in Taormina in August 1963 was fruitless. The NYHS pamphlet cited above includes an obituary based on a "private letter," stating that Mr. Tilton "undertook

to convey his remains to Rome, to be interred there at his own request." That Hotchkiss did intend initially to be buried in Rome is suggested by a letter of November 28, 1869 to John Durand from Benjamin Bellows Grant Stone, whom Hotchkiss visited in Cole's old studio at Catskill on his last trip home: "Hotchkiss spoke of the little burial place or lot he had bought near Rome and expressed the hope of being buried there." See John Durand Papers, Rare Book and Manuscript Division, New York Public Library, Astor, Lenox and Tilden Foundations.

7. In contrast to the elusiveness until now of Hotchkiss's place and date of birth, we have John Tilton's eyewitness account of his death as recorded in Mrs. Tilton's letter cited above, but again, the relative simplicity of this fact is contested by a small discrepancy as to the actual date. Graham notes that according to the Tilton letter, Hotchkiss died on August 19. Mrs. Tilton wrote: "Mr. Tilton had gone there some days ago not expecting to find Mr. Hotchkiss there; but there he was; and ill with bleeding at the lungs. He seemed better after my husband's arrival and they dined together; after dinner each went to their rooms to lie down when Mr. Tilton hear [*sic*] Mr. Hotchkiss knock. He went to him, found him bleeding violently and in a few minutes he died in my husbands arms and on the floor." George Yewell Papers, Archives of American Art, Smithsonian Institution, Roll 2428, Frames 212–3. See Appendix below. The official death record filed in Taormina, however, cites the date as August 18, and lists the hour of 5 (PM) and the place as the "house of this Amphitheater." See Wright, op. cit., 264.

8. According to his passport application, we now know that Hotchkiss was about 35 or 36 years old at his death. E. P. Richardson, years ago, in *Painting in America* (New York: Thomas Y. Crowell Co., 1956) 228, gave a possible birthdate of 1834. The death record in the archives at Taormina lists his age as 32, which moves his birthdate up to 1837. An obituary written in a 19th-century hand in the NYHS pamphlet cited above states that he died at 4 o'clock on the afternoon of the 19th of August 1869 and that he was "Born in Greene County New York State. aged 35 years."

9. We have more records about the proceedings *after* Hotchkiss's death than we do of his life. See Barbara Novak O'Doherty, "Thomas H. Hotchkiss, An American in Italy," *Art Quarterly* 29, no. 1, (1966): 14 ff. for the complications of his debts and the necessity for two auctions, in Rome and New York. See also the appendix to that article, where the *Catalogue of Artist's Effects* for the New York auction on December 9, 1871 at Johnston & Van Tassell is listed in full, annotated, possibly by John Durand, as to prices and bidders (25–6). That catalogue is in the John Durand Papers, NYPL, loc. cit. The Manuscript Collection of the New-York Historical Society has another copy, with annotations by a different hand (possibly Lucy Durand Woodman or her husband George, who was also a bidder). See Appendix below. See also the letter from Carrie Vedder in Appendix below (Rome, March 19, 1871, Elihu Vedder Papers, Archives of American Art, Smithsonian Institution, Roll 516, Frames 512–4) for an account of the Rome auction.

10. See Municipal Archives and Records Center, New York City, Folder of Public Administration, Liber 95, p. 137, Location 08-029012. Petition

addressed to the Surrogate of the County of New York, July 25, 1870, by Andrew J. Rogers, Public Administrator, and filed August 16, 1870, stating that "said deceased died possessed of certain personal property in the State of New York, the value of which does not exceed the sum of about Two Hundred dollars" and that "said deceased was at or immediately previous to his death a resident of the City of New York." This latter claim of residency (Hotchkiss's last address in the States presumably being 15 Tenth Street before his departure for Italy; see *Next to Nature, Landscape Paintings from the National Academy of Design*, exh. cat. [New York: Harper & Row, 1980; introduction by Barbara Novak, edited by Barbara Novak and Annette Blaugrund; 13]) seems to have justified the Public Administrator's claim to Hotchkiss's effects. The petition was granted and recorded on August 19, 1870. See Novak O'Doherty, op. cit., 28, for contents of the two cases of effects shipped to the Public Administrator.

11. Vedder, *Digressions*, op. cit., 429.

12. Ibid., 418.

13. See Hotchkiss's letter from Palenville, New York (May 27, 1855), to the editors of *The Crayon*, asking for his issue of *The Crayon* to be transferred from Catskill to his summer address. (John Durand Papers, NYPL, loc. cit.)

14. See "Sketchings: Domestic Art Gossip," *The Crayon* 3 (Aug. 1856): 250: "Our home artists are distributed about the country in various pleasant localities. Messrs. Champney, Coleman [*sic*], Shattuck and Hotchkiss are at Conway, Mr. Durand is at Campton, both villages being near the White Mountains."

15. See a series of letters to the editor in *The Crayon* 3 by "Burnt Umber" (Sept. 1856): 282–3, "Poppy Oil" (Oct. 1856): 317–8, "Poppy Oil" and Alvan Fisher (as "Mummy") (Nov. 1856): 347–9, for accounts of artist activities in West Campton and North Conway, New Hampshire.

16. Something of the range of Hotchkiss's travels as a member of this group was chronicled by *The Crayon*. See "Sketchings: Domestic Art Gossip," *The Crayon* 4 (Aug. 1857): 252: "The artists of our country have never been so generally dispersed throughout the length and breadth of the land—in fact, the world—as at the present time . . . Messrs. Hart, Hotchkiss, and Hill are in the neighborhood of Catskill . . ." "Sketchings: Domestic Art Gossip," *The Crayon* 5 (Aug. 1858): 238: "Artists generally are in summer quarters. Kensett was lately at Ramapo. Suydam is now there; Gifford and Hubbard are exploring the Erie Railroad region; Coleman [*sic*] is at Lake George; Hart is in Connecticut; Durand, Gerry, and Hotchkiss are among the Catskills . . ." and "Sketchings: Domestic Art Gossip," *The Crayon* 6 (Aug. 1859): 256:" . . . Durand, Suydam, and Hotchkiss are at Geneseo . . ."

17. George Kubler, *The Shape of Time* (New York and London: Yale University Press, 1962) 7.

18. See "Sketchings: National Academy of Design," *The Crayon* 4 (July 1857): 222: "Mr. T. H. Hotchkiss is represented by four works, his studies from Nature being the most conspicuous. These are faithful and creditable works, showing marked advance upon previous efforts. No. 428, 'The Meadows of North Conway' is particularly noticeable." See also "Sketchings: Exhibition of the National Academy of Design," *The Crayon* 5 (May

1858): 148, commenting on his continued advancement in No. 407, *Summer-Conway Valley*, at the National Academy of Design. By March 1859, *The Crayon* was reporting on Hotchkiss along with Durand, an extraordinary artistic pairing for such a young artist: "Hotchkiss has upon his easel a view of the Catskill Mountains towards sunset, which is a very successful work. The sky is especially noticeable for its luminousness. Durand is engaged upon a large upright composition, representing scenery suggestive of the Plaaterkill Clove, Catskill Mountains . . ." "Sketchings: Domestic Art Gossip," *The Crayon* 6 (March 1859): 91. By June, he is being considered along with Gifford: "We have no admiration to bestow on Gifford's fine picture of 'Mansfield Mountain,' at the expense of Hotchkiss's 'Harvesting'; the glow of light and the amplitude of space, the realization of atmosphere, and the idea of an extensive prospect in the former, do not forestall delight while contemplating the exquisite expression of light and atmosphere, of the same hour of the day, in the latter; the ideas suggested by the small composition are expressed with equal power and equal poetry of feeling as those of the large one," "Sketchings: National Academy of Design Second Notice," *The Crayon* 6 (June 1859): 191. And by December, in "Sketchings: Domestic Art Gossip," the criticism (or rather praise) had escalated even further: "Hotchkiss has made a few remarkable studies of trees in sepia and oil. For delicacy of touch and faithful drawing they are almost unsurpassable. One, of an elm tree, is a marvellous production," *The Crayon* 6 (Dec. 1859): 379.

19. Most of these works seem to have been sent as gifts to Lucy Durand Woodman, although some may have been purchased by her husband, George, at the New York auction in 1871. Some may also have been purchased at auction by John Durand, then passed down into the family. Hotchkiss not only sent Lucy gifts of his work, but bought things for her. His letters to Lucy, in the Manuscript Collection of the NYHS, were among the first documents of his life to surface.

20. See listings of Hotchkiss's works and their provenance in Richard J. Koke, et. al., *American Landscape and Genre Paintings in the New-York Historical Society* (New York and Boston: New-York Historical Society, in association with G. K. Hall and Co., 1982) 165 ff.

21. See *Next to Nature, Landscape Paintings from the National Academy of Design*, op. cit., 13.

22. Ibid.

23. Ibid.

24. See Asher B. Durand Papers, Rare Book and Manuscript Division, New York Public Library, Astor, Lenox and Tilden Foundations, filed with letters of 1857. Undated fragment.

25. See Susan Sontag, *Illness as Metaphor* (New York: Farrar, Strauss & Giroux, 1977) 28.

26. Ibid., 30.

27. See letter from William John Hennessy, Feb. 17, 1908, National Academy of Design Archives, correspondence file.

28. Sontag, op. cit., 30.

29. Ibid., 33.

30. See Dio Lewis, M.D. "Weak Lungs, and How to Make Them Strong,"

The Atlantic Monthly 11, no. 68 (June 1863): 663. I am especially indebted to Tracie Felker for this reference. See also the notice "Sketchings: Domestic Art Gossip," in *The Crayon* 6 (December 1859): 379, which concludes: "Mr. Hotchkiss sailed lately for Europe, where he has gone for the benefit of his health." In his reminiscence of Hotchkiss (loc. cit.) Hennessy says: "Hotchkiss. I met him only once before he went to Italy for his health's sake—I was only a student in the Life School at the time . . . [he] was then under doctor's orders to go abroad to Italy or Spain, he chose Italy."

31. After Hotchkiss's death, Benjamin Bellows Grant Stone, an artist who was then occupying Cole's old studio at Catskill, wrote to John Durand on November 28, 1869, reporting on Hotchkiss's visit the previous year. See John Durand Papers, NYPL, loc. cit. See also Novak O'Doherty, op. cit., 13–4.

32. See Henry James, *William Wetmore Story and His Friends* (2 vols., Boston: Houghton Mifflin & Co., 1903; 2 vols. in one, New York: Da Capo Press, 1969) 1: 329.

33. The list of American painters who visited Italy for shorter or longer periods of time in the early to mid-19th century includes such well-known figures as Allston, Morse, Cole, Cropsey, Durand, Bierstadt, Whittredge, Church, Kensett, Gifford, Heade, and Huntington. Among the artists who count almost as expatriates because of their extended time in Italy and their identification with Italian subject matter we might include Page, Haseltine, Vedder, John J. Chapman, George Loring Brown, and John Rollin Tilton, who was Hotchkiss's neighbor at the Palazzo Barberini. In addition to such name figures, there were countless others, as well as sculptors and writers, who were lured there by the Italian dream. See my chapter "Arcady Revisited: Americans in Italy" in *Nature and Culture: American Landscape and Painting 1825–1875* (New York: Oxford University Press, 1980) 203 ff.

34. See Thomas Cole, "Essay on American Scenery," 1835, in John W. McCoubrey, ed., *American Art: 1700–1960, Sources and Documents* (Englewood Cliffs, New Jersey: Prentice-Hall, 1965) 108: "He who stands on Mont Albano and looks down on ancient Rome, has his mind peopled with the gigantic associations of the storied past . . ."

35. A contemporary account of the Caffè Greco, in 1866–67, when Hotchkiss might have frequented it, describes it as "that haunt of Bohemia, the meeting place of all nationalities, where every European language was heard from sundown to midnight. Writers, musicians, painters and sculptors, poor and rich, successful or only hopeful, turned in there after their supper or no supper to take the inevitable cup of coffee and smoke the inevitable pipe. . . . Rome was indeed a centre of the world, it was more than that, it was the centre of Art, and the Cafe Greco [*sic*] was the centre of Rome, even more than the Vatican." See A. M. W. Stirling, *The Richmond Papers*, 205–7, quoted in Regina Soria, *Elihu Vedder, American Visionary Artist in Rome (1836-1923)* (Cranbury, N.J.: Fairleigh Dickinson University Press, 1970) 256, n. 5. See also Vedder, *Digressions*, op. cit., 333, "In the long room, way back in the Caffe—'The Omnibus'—the American and English artists used to congregate."

36. George Stillman Hillard, *Six Months in Italy*, (2 vols., Boston: Ticknor and Read, 1853) 1: 204.

37. See Maurice Merleau-Ponty, *Phenomenology of Perception* (New Jersey: The Humanities Press, 1976) 425, who also comments, "Time is the 'affecting of self by self.'"

38. Ibid., 411.

39. Manuscript Collection, New-York Historical Society. Hotchkiss Papers.

40. A letter from Avery, dated Sept. 12, 1861, indicates that Avery had, from time to time, posted some money to Hotchkiss (see John Durand Papers, NYPL, loc. cit.): "Long and weary has been the time since I last wrote to you—and no doubt the time has also been one of anxiety to you, the affairs of our country have of course given you many anxious hours, away from home—among strangers and with precarious means of support. I have often thought that your position was very harrassing . . . I am glad however at last to be able to enclose you a draft for 100$. . . . You must believe that *I* did all I could *immediately* to dispose of your things but could get *no* encouragement . . ." See Appendix below.

41. Avery in the same letter speaks of Dunning's efforts on Hotchkiss's behalf, purchasing the *Mackerel* for 25 dollars ("the *only* offer I had") and comments: "He is one of the government sanitary committee and has called home from Fort Munroe."

42. See letter from Samuel P. Avery to John Durand (John Durand Papers, NYPL, loc. cit.) September 1860: "I sent the enclosed to Mr. Walters that Hotchkiss might tell his own story. Mr. W is not disposed to send any more money, but is willing he should sell the pictures painting [*sic*] for him—and do another in any number of years hence," and letter of Sept. 15, 1861, loc. cit., to Hotchkiss himself: "About Mr. Walters. I do not think that he will care to add to the original commission given you—he was very particular about *that* at the time and you should have complied with it. He always said that he knew nothing of your work and would prefer to have you do him a companion to the *first* one, if that should prove satisfactory."

43. See Susan A. Hutchinson, "Old Letters: The Avery Collection of Artists' Letters in the Brooklyn Museum," *Brooklyn Museum Quarterly* 2, no. 2 (July 1915): 287.

44. See Soria, *Vedder*, op. cit., 63 ff. for intermittent mention of the Herrimans and Gurnee.

45. See letter from W. J. Hennessy, loc. cit., where he states: "I heard from an English artist, while I was living in France some years later, that [Hotchkiss's] health was not good, but that he managed to go on with his painting, and that he sold most of his pictures at that time to English visitors in Italy."

46. An extended correspondence on this matter, specifically in reference to his debt to John Linnell, appears in the David Maitland Armstrong material (filed under Hotchkiss) in the John Durand Papers at the NYPL, loc. cit. See especially Armstrong's letters of August 3, and October 11, 1870 to Durand; Durand's letters of July 6, September 2, and November 12 of that year to Armstrong, and Durand's letter to Linnell of September 2.

47. See Gifford's letter from Rome to his father of September 28, 1868 (Sanford R. Gifford Papers, Archives of American Art, Smithsonian Institu-

tion, Roll D21, Frames 44–46) where he notes: "Called on Hotchkiss, landscape painter from New York, who has been here nine years. He has just returned from America, where he has been to spend a month. He is a painter of fine talent. Poor fellow, he is consumptive, and is not likely to last long. He . . . looks very feeble. . . ." On September 30, Gifford called on Hotchkiss again, "whom I found very weak from bleeding—offered to remain with him, but he declined as he had another friend who came and was with him at night." On October 4, when Gifford called again, he noted that Hotchkiss was better.

48. See George Yewell Diary (Archives of American Art, Smithsonian Institution, Roll 2428, Frames 382–3) where Yewell notes on December 3, 1867: "For the past ten days I have been very busy with sight-seeing, going to the galleries, and out upon the campagna, sometimes with Vedder who has lived in Rome for many years . . . and also Thomas H. Hotchkiss whom I knew in New York as far back as 1856 and who I saw in Paris with George Fuller where they passed through on their way to Italy."

49. A letter to Lucy Durand Woodman from London on July 15, 1865 (Manuscript Collection, New-York Historical Society) notes: "I left Rome about the 20th of June and arrived here or rather in England (for I staid a few days on Red Hill in the house of Mr. Linnell the painter whose son came with me from Italy on the 3rd of July) . . . I am staying with a friend M. Henry Wallis a painter of reputation among the Pre-Raphaelites at whose invitation I came to England. By him I have been introduced to many of the first families here and have been kindly received. . . ." Although an earlier reading suggested that John Linnell Jr. may have been Hotchkiss's friend, recent research indicates that it may have been William Linnell, who was in Rome from October 1861 to June 1862 and from January 1863 to September 1865. See Alfred T. Story, *The Life of John Linnell* (2 vols. London: Richard Bentley and Son, 1892) 2: 110, 122, 161. A letter from John Linnell, Sr. to William in Italy on October 8, 1864 reads: "Beware of Americans, North and South. They are repudiators of debts; so, whatever you do, expect nothing again. I will attend to all you wish, but can't judge here—you can." (2: 150) I am grateful to Tracie Felker for this information.

50. Manuscript Collection, New-York Historical Society. Hotchkiss Papers.

51. See note 6 in entry 3 for a discussion of Hotchkiss's trip to Volterra.

52. See Vedder, *Digressions*, op. cit., 418 ff. See Regina Soria in *Perceptions and Evocations: The Art of Elihu Vedder* (Washington, D.C.: Smithsonian Institution Press for the National Collection of Fine Arts, 1979) 16.

53. Vedder, *Digressions*, op. cit., 418.

54. Ibid., 421.

55. See Manuscript Collection, New-York Historical Society, pamphlet 1582x.

56. Vedder, *Digressions*, op. cit., 418.

57. Alvan Fisher (as "Mummy"), "Letter to the Editor," *The Crayon* 3 (November 1856): 348.

58. Hennessy, loc. cit.

59. See Yewell Papers, loc. cit., Frames 382–3, 390, 394, 402.

60. Gifford Papers, loc. cit.

61. Vedder, *Digressions*, op. cit., 429.

62. Ibid., 422.

63. See Soria, *Vedder*, op. cit., 257, "From a letter to Vedder by an English artist and art expert, Henry Wallis, it appears that Hotchkiss had also been able to secure some Signorelli's." Wallis's letter (Vedder Papers, Archives of American Art, Smithsonian Institution, Roll 516, Frames 482–5) states: "Dan has just forwarded me the information you were so kind as to send us reflecting poor Hotchkiss' sale. I was sorry to hear the Signorellis were going to New York, that being the case I am afraid we have not much chance of securing them for the National Gallery. I think you are sufficiently cosmopolitan not to be offended at that regret. . . . I wish I could find myself at the sale, to have got some of his delightful sketches I have enjoyed so often." Wallis also mentions some coins Hotchkiss intended sending to his son Felix. If the Signorellis were in the New York sale, it is difficult to ascertain this from the catalogue. The Piero di Cosimos were listed without the artist's name, see note 64.

64. See Federico Zeri and Elizabeth E. Gardner, *Italian Paintings: A Catalogue of the Collection of the Metropolitan Museum of Art, Florentine School* (New York: Metropolitan Museum of Art, 1971) 176, 177, 180. *A Hunting Scene* and *The Return From the Hunt*, gifts of Robert Gordon, 1875. Ex. Coll: Thomas H. Hotchkiss Rome (until 1869). See also Armstrong, op. cit., 191, who told Gordon of the paintings, and the New York auction catalogue (Johnston & Van Tassel) Dec. 9, 1871, where the paintings are listed as nos. 29 and 30.

65. Vedder Ms., Archives of American Art, Smithsonian Institution, Charles Hart Autograph Collection, Chicago, Roll D5, Frame 327, December 21, 1868.

66. See Johnston & Van Tassel auction catalogue, op. cit. (see also Appendix).

67. Gaston Bachelard, *The Poetics of Reverie* (Boston: Beacon Press, 1971) 111.

68. Ibid., 112.

69. Sontag, op. cit., 16.

70. Bachelard, *The Poetics of Reverie*, op. cit., 120.

71. Ibid., 121.

72. See John Durand Papers, NYPL, loc. cit., letter from Palenville, May 27, 1855, where Hotchkiss asks to have his subscription to *The Crayon* transferred to Palenville for the summer. Ruskin had a question and answer column in *The Crayon*.

73. See Barbara Novak, *American Painting of the Nineteenth Century: Realism, Idealism and the American Experience* (New York: Praeger, 1969) 80 ff. where I first elaborate the idea of the "happened upon" landscape. See also Novak, *Nature and Culture*, op. cit., 232.

74. Letter of Feb. 9, 1860. Asher B. Durand Papers, NYPL, loc. cit.

75. Ibid.

76. Letter to H. Pickering, November 23, 1827, quoted in Jared B. Flagg, *The Life and Letters of Washington Allston* (1892; New York: Da Capo Press, 1969) 203–4.

77. Letter of Feb. 9, 1860, Asher B. Durand Papers, NYPL, loc. cit.

78. Bachelard, *The Poetics of Reverie*, op. cit., 167.

Catalogue of
Works

Tracie Felker

I

Catskill Works

*H*otchkiss's *earliest known paintings* are landscape views and nature studies of the Catskill Mountains. He is first recorded in the area in May 1855, when he asked John Durand, editor of the art journal *The Crayon*, to send his weekly copy of the publication to his summer address in Palenville, a popular artists' colony near the entrance of Catskill Clove.[1] As a fledgling artist, Hotchkiss seems to have quickly immersed himself in the landscape aesthetic of the Hudson River School, exhibiting his first landscape paintings, three views of Catskill Clove, at the National Academy of Design the following spring of 1856.[2] Although these paintings are unlocated, they probably share with his earliest dated work, *Catskill Mountains, Shandaken, N.Y.*, 1856, a precocious technical facility and careful observation of nature (Fig. 1). *Catskill Mountains, Shandaken*, shows a tall summer meadow ablaze in afternoon sunlight. The foreground is thick with wild grasses and flowers, their luxuriant foliage spilling in every direction. This effulgence is recorded by Hotchkiss with meticulous attention to individual form and nuances of color, light, and texture. A dark pool in the center of the image provides a respite from the oppressively close picture space and excessive natural detail.

Hotchkiss's celebration of detail in *Catskill Mountains, Shandaken*, reflects the influence of John Ruskin (1819–1900), the foremost art critic of the time. Ruskin urged an uncompromising truth to nature, "selecting nothing and rejecting nothing," that became a maxim among many American landscapists of the third quarter of the nineteenth century. Ruskin's aesthetic theory was largely corroborated by Asher B. Durand (1796–1886) in a series of letters published in *The Crayon* in 1855. These letters encouraged fellow American artists to draw and paint directly from nature in order to attain "as minute portraiture as possible." Although Durand felt that exact replication of nature was impossible, and that, ultimately, realism should be subordinate to idealism ("Realism signifies little else than a disciplinary stage of Idealism"), the painstaking exercise of sketching from nature instilled in the artist a thorough knowledge of each object in nature and increased his technical facility.[3] Hotchkiss's nature studies, *Cloud Study, Catskill Mountains* and *Tree Study, Catskill Clove*, demonstrate his willingness to follow Durand's advice (Figs. 2, 3; see also p. 18).[4] Both images focus on single objects in nature in order to investigate the distinctive shapes, colors, and textures that characterize their type. Indeed, *Tree Study, Catskill Clove* may have been painted in Durand's company as the

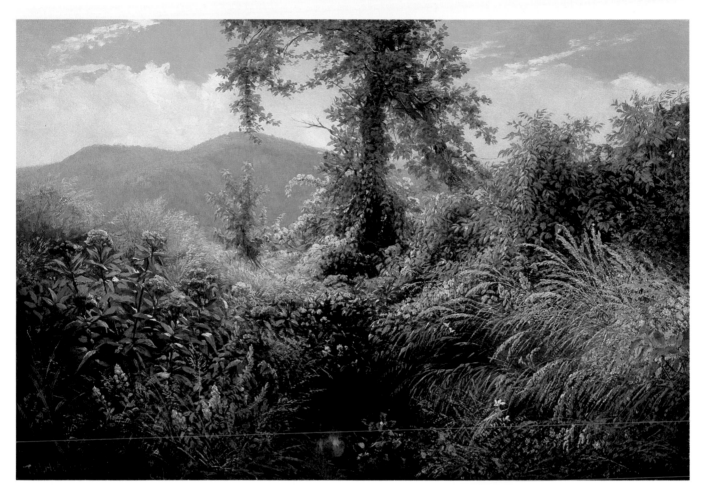

two artists are known to have sketched together in Catskill in August 1858.[5] Although Hotchkiss eventually renounced the kind of unedited realism advocated by Ruskin,[6] he continued to produce close-up nature studies, as can be seen in later drawings and paintings made in Italy.[7]

Two early Hotchkiss landscapes, *Catskill Winter Landscape* and *Winter Landscape, Catskill*, are among his most successful Hudson River School compositions (Figs. 4, 5). Overcoming the harsh light, lack of foliage, and loss of foreground detail that generally attend winter landscapes, Hotchkiss found pictorial interest in the shifting play of blue-gray shadows and the contrasting textures of soft, wet snow and thin, brittle branches. His pigment seems to mimic the texture of the snow itself with alternate strokes of color and thick white impasto. The monochromatic palette is broken by a line of dark green and brown trees, a few of which retain their rust-red leaves. This freshness of color and the freely handled brushwork suggest the artist may have been working outdoors, responding to the shifting light and deepening shadows.

Hotchkiss's landscape, *Catskill Mountains (Haying)*, and its preparatory study, give some idea of his early working methods (Figs. 6, 7). The small sketch, in oil on paper, was probably painted on the spot. Using thick pigment and broad brushstrokes, the artist deftly indicated each part of the landscape by using contrasting bands of color and overlapping forms. Working in the studio on the final canvas, Hotchkiss transformed this quick memorandum into a fully realized picture space. He defined the

1 Thomas H. Hotchkiss, *Catskill Mountains, Shandaken, N.Y.*, 1856. Oil on canvas, 10^{15}/$_{16}$ × 15^{13}/$_{16}$ in. The New-York Historical Society; Gift of Nora Durand Woodman, 1932.44

2　Thomas H. Hotchkiss, *Cloud Study, Catskill Mountains*, ca. 1856–59. Oil on laid paper, 6⅞ × 13⅛ in. The New-York Historical Society; Gift of Nora Durand Woodman, 1932.189

topography more precisely, clarifying the contours of the terrain and changing the profile of the distant mountains. He also added narrative interest: figures gathering hay in the middle ground with a farmhouse, road, and fence nearby. Hotchkiss's preparatory study functioned primarily as a color note, reminding him of the chromatic relationships he observed in nature, while allowing him some imaginative freedom in the exact disposition of the landscape.

Hotchkiss returned to the theme of harvesting in three landscapes, *Haying in the Catskills, New York, Harvest Scene,* and *Landscape Sketch (New England Scene),* all completed by 1859 (Figs. 8–10).[8] These paintings show how quickly Hotchkiss was able to integrate his detailed studies of nature within larger compositions.[9] Unlike the idea-laden, highly composed landscapes of Thomas Cole (1801–1848), Frederic E. Church (1826–1900), or Albert Bierstadt (1830–1902), Hotchkiss's compositions are subdued in tone, depicting scenes of quiet domesticity. This early preference can be seen throughout his oeuvre: later landscapes are filled with a similar sense of silence and tranquillity.

Despite Durand's advice to the young artist in *The Crayon* to forgo sketching in oil until he mastered drawing nature with pencil and paper, Hotchkiss seems to have worked directly in oil early in his career. Several of these studies, such as *Catskill Mountains, New York,* 1857, are painted on paper, a highly portable and convenient support for plein-air sketching (Fig. 11). Hotchkiss's practice may have been influenced by Durand's own oil studies of the 1850s depicting woodland interiors or individual studies of trees and rocks. In 1859, Hotchkiss and Durand sketched together at Geneseo, New York, where both artists apparently worked in oil.[10] On the basis of Hotchkiss's extant studies, it appears that his touch was more painterly than the senior artist's, with greater freedom of stroke and less detail. Hotchkiss's plein-air compositions more closely resemble those of his contemporary, Frederic E. Church, whose remarkable oil sketches from nature are considered among his finest work.

ACKNOWLEDGMENTS

I would like to thank Barbara Novak for giving me the opportunity to work with her on this project and Annette Blaugrund for her support and

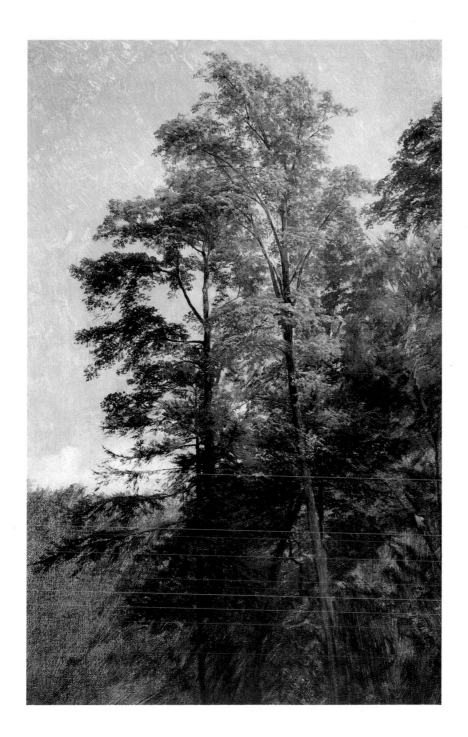

3 Thomas H. Hotchkiss, *Tree Study, Catskill Clove*, 1858. Oil on canvas, 13⁷⁄₁₆ × 8½ in. The New-York Historical Society; Gift of Nora Durand Woodman, 1932.37

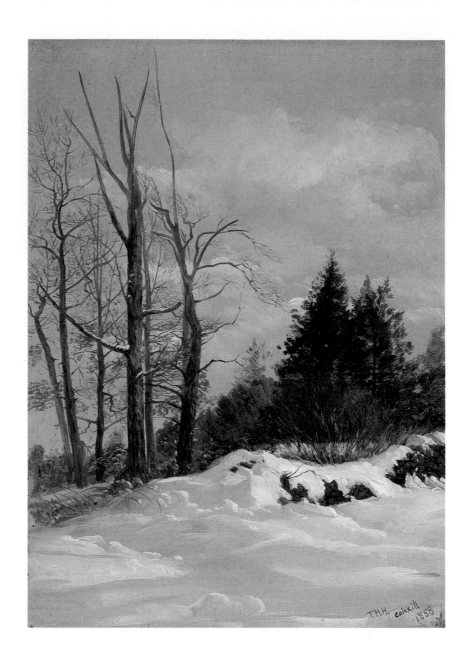

4 Thomas H. Hotchkiss, *Catskill Winter
 Landscape*, 1858. Oil on canvas, 11 × 7¾ in.
 The New-York Historical Society; Gift
 of the Estate of Nora Durand
 Woodman through Hannah Woodman,
 1942.480

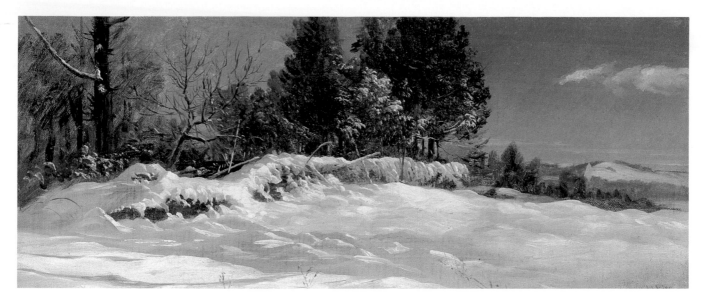

5 Thomas H. Hotchkiss, *Winter Landscape,
Catskill*, 1858. Oil on canvas, 6¾ × 15½ in.
Graham Williford

constant attention to the myriad details of this exhibition and catalogue.
I would also like to thank Timothy Anglin Burgard for his careful read-
ing of these entries in manuscript form.

NOTES

1. Letter from Hotchkiss to John Durand, May 27, 1855. John Durand
 Papers, Rare Book and Manuscript Division, New York Public
 Library, Astor, Lenox and Tilden Foundations.
2. A reviewer of the National Academy of Design exhibition in 1856
 described Hotchkiss's contributions as having "very decided good
 points," although "the imagination and observation they evince are
 much better than the executive skill of the artist." "National Acade-
 my of Design. Fourth Article," *New York Tribune* (May 3, 1856): 9.
3. Asher B. Durand, "Letters on Landscape Painting, No. VIII," *The
 Crayon* 1 (June 6, 1855): 354.
4. Hotchkiss's tree studies received praise from a critic writing for *The
 Crayon*, who remarked that "Hotchkiss has made a few remarkable
 studies of trees in sepia and oil. For delicacy of touch and faithful
 drawing they are almost unsurpassable. One, of an elm tree, is a mar-
 vellous production." "Sketchings: Domestic Art Gossip," *The Crayon*
 6 (Dec. 1859): 379.
5. "Sketchings: Domestic Art Gossip," *The Crayon* 5 (Aug. 1858): 238.
6. Elihu Vedder claimed that Hotchkiss later "vented his indignation in
 unmistakable terms," at having spent so many years "in those Miss-
 Nancyish efforts so dear to the readers and practical followers of
 Ruskin." Vedder continued, "I know to the literary mind Ruskin's
 language is beautifully convincing and sufficient, and to the moral
 mind his real goodness turns aside the question into a moral ques-
 tion. Again I must say it is strange to see how in the practice of his
 art-writing, he violates and disregards all those precepts of strict
 adherence to truth which he exacts from the painter." Elihu Vedder,

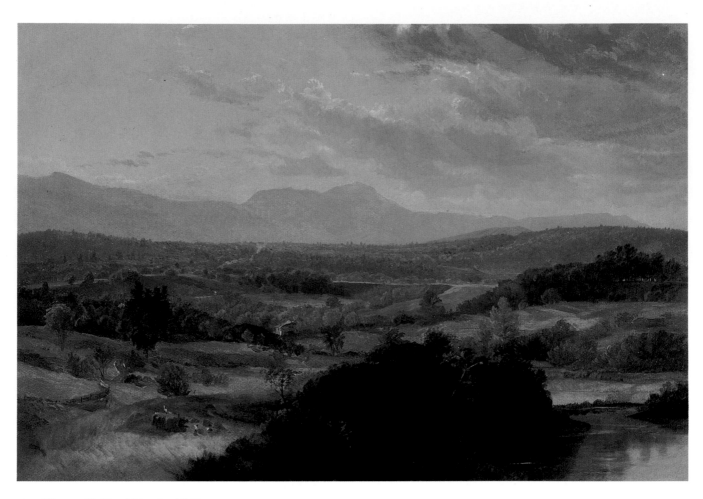

6 Thomas H. Hotchkiss, *Catskill Mountains (Haying)*, ca. 1856–59. Oil on canvas, 11 × 15⅞ in. The New-York Historical Society; Gift of Nora Durand Woodman, 1932.188

7 Thomas H. Hotchkiss, *Study for Catskill Mountains (Haying)*, ca. 1856–59. Oil on wove paper, 4¾ x 7 in. The New-York Historical Society; Gift of Nora Durand Woodman, 1932.187

The Digressions of V (Boston and New York: Houghton Mifflin Co., 1910), 418–421.

7. Hotchkiss's fellow artists and friends in Italy prized his detailed nature studies. Two of his watercolors, *Study of a Briar* and *Oak Leaves*, were kept by John R. Tilton in a scrapbook from Rome. William H. Rinehart also had several works by Hotchkiss, including *Apple Tree in Blossom—Study*, included in an inventory of Rinehart's estate in 1874. The inventory also lists an oil painting by Hotchkiss, *Campagna*, with a note in the margin, "left to E. Vedder." In his will, Rinehart left "the small picture painted by Mr. Hotchkiss" to Charles C. Coleman. John N. Tilton Papers, Archives of American Art, Smithsonian Institution, Roll 2082, Frames 1050–1, and William H. Rinehart Papers, Roll 3116, Frames 70, 251, 277, and 288–9.

8. *Harvest Scene* was exhibited at the National Academy of Design in 1859. Richard J. Koke et. al., in *American Landscape and Genre Paintings in the New-York Historical Society* (3 vols. New York and Boston: New-York Historical Society in association with G. K. Hall and Co., 1982), vol. 2, 173 proposes a date of 1866 for *Landscape Sketch (New England Scene)*. This date is much too late for the style and subject of this work. It was undoubtedly executed before Hotchkiss's departure for Europe in December 1859.

9. Hotchkiss seems to have made important changes to the composition of *Landscape Sketch (New England Scene)*. At some point, he scraped out a tall tree that formerly stood on the right. Traces of its original outline can still be seen.

10. See Asher B. Durand's letter to his son John from Geneseo, August 7, 1859: "I want you to direct Mr. Knoedler to put up & send me 8 tubes of flake white . . . Mr. Hotchkiss wants part of it (of the white). He has some poppy oil from Knoedler's and the white ground in [it] is

8 Thomas H. Hotchkiss, *Haying in the Catskills, New York*, ca. 1858. Oil on canvas, 5¾ x 11⅛ in. Graham Williford

9 Thomas H. Hotchkiss, *Harvest Scene*, 1858.
Oil on canvas, 5½ x 11¾ in. Jane and
Simon Parkes

much better than mine as appears from some that he has ground him-
self here as an experiment. With all my troubles I believe I have
learned more of the management of colour in the painting of trees
than by all my previous practice altho I have never produced so little
in the same space of time, not having made but 4 studies in five
weeks." John Durand Papers, Rare Book and Manuscript Division,
New York Public Library, Astor, Lenox and Tilden Foundations.

10 Thomas H. Hotchkiss, *Landscape Sketch
(New England Scene)*, ca. 1856–59. Oil on
canvas, 10⅞ x 15⅞ in. The New-York His-
torical Society; Gift of the Estate of
Nora Durand Woodman through Han-
nah Woodman, 1942.481

11 Thomas H. Hotchkiss, *Catskill Mountains,
New York*, 1857. Oil and graphite on
paper, 6¾ x 14⅝ in. The New-York His-
torical Society; Gift of Nora Durand
Woodman, 1932.222

II

New Hampshire
Works

The magnificent scenery of the White Mountains in New Hampshire has attracted naturalists and explorers since its earliest discovery. The area was inaccessible to the casual visitor until railroad connections were established in the 1840s. Landscape painters were among the first tourists to arrive, journeying from Boston and New York in the early 1850s to spend the summer painting and sketching.[1] One of the most popular destinations for artists was the small village of North Conway, New Hampshire. Located on the eastern flank of the White Mountains, in a broad intervale with open fields and a spectacular view of Mount Washington fifteen miles away, North Conway became America's first important artists' colony, flourishing from 1850 to the 1880s.[2] The combination of gentle hills, fertile plains, and distant mountain vistas at North Conway was considered ideal by landscape painters, who sought to depict nature in a variety of forms, light, and weather.[3]

Hotchkiss was one of many artists who traveled to North Conway in 1856 to spend the summer sketching. Among his colleagues were fellow artists Alvan Fisher (1792–1863), Benjamin Champney (1817–1907), Aaron Shattuck (1832–1928), Samuel Colman (1832–1920), James Suydam (1819–1865), and William James Stillman (1828–1901).[4] In an adjacent valley, Asher B. Durand was residing at West Campton.[5] A convivial atmosphere developed between the artists; they sketched together, ate together, and lodged together.[6] A typical day among the painters in West Campton was described by a resident artist: "At half-past six, we breakfast, and afterwards if the weather is bad, (as it often is, though never without our being perfectly satisfied that it is infinitely worse over there in Conway) we read the *Herald*, the *Tribune*, and the *Boston Daily Traveller*, which come by the mail of the previous day, or we chat, or read, or write, or go out into the barn and make studies of the cattle . . . When the day is fair, we sally out with our traps, in twos and threes, or perhaps, a committee of the whole for the morning study."[7] As one of the youngest artists in the group, Hotchkiss undoubtedly benefitted from the informal fraternity, advice, and critical appraisal of the more senior members.

The attention of artists sketching in North Conway was constantly turned toward the magisterial presence of Mount Washington. The highest mountain in the northeastern states, its snow-covered peak commanded the surrounding terrain fifty miles away. Its prospect, particularly the sweeping view through Conway Valley, was considered one of the finest on the East Coast.[8] Hotchkiss's painting, *Mount Washington, New*

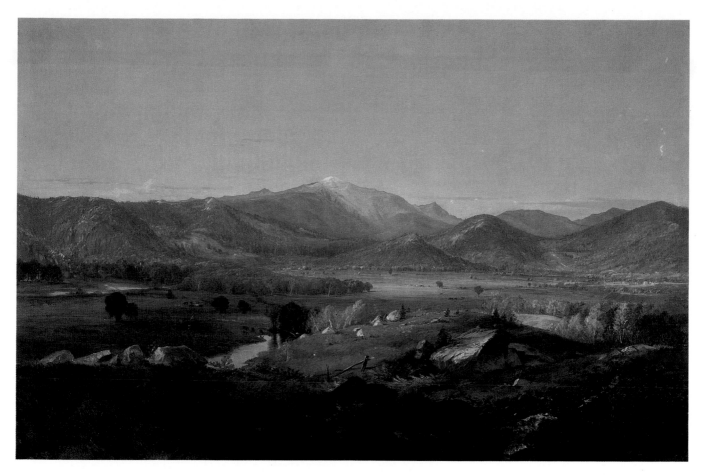

1 Thomas H. Hotchkiss, *Mount Washington, New Hampshire*, 1857. Oil on canvas, 20 × 29⅞ in. The New-York Historical Society; The Robert L. Stuart Collection, on permanent loan from the New York Public Library, Stuart 5

Hampshire (Fig. 1), is his largest and most ambitious early composition.[9] It was probably painted in the artist's studio in New York City in the winter of 1856–57, using sketches made the previous summer.[10] Hotchkiss's landscape is more broadly painted and less insistent upon detail than similar views by his contemporaries. John F. Kensett's painting, *The White Mountains—From North Conway*, 1851 (Wellesley College Museum of Art), is perhaps the most celebrated view of the White Mountains.[11] It is a grandiose vision, uniting foreground detail and distant mountain peaks in a comprehensive survey of the entire valley. By comparison, Hotchkiss's canvas is modest in scope. There is much less detail and anecdotal interest. The composition is less structured so that the eye travels freely through the picture space, back and forth across the low hills and open farmland. The mountains themselves are undifferentiated, lacking the precision of topography so evident in Kensett's work. Hotchkiss may have been inspired by Durand's canvas from the previous summer, *Mount Washington from Conway Valley* (private collection), which shares this perspective.[12] The prospect is taken from a point north of the village, perhaps from Dinsmore's, the farm where Hotchkiss was lodging with Shattuck and Colman outside North Conway.[13] The views from that locale were acknowledged as excellent for their distances.

In contrast to the panoramic breadth of *Mount Washington*, Hotchkiss's painting, *Mountain Stream, White Mountains, New Hampshire* (Fig. 2), shows his continued commitment to the close study of nature.[14] This diminutive work appears to have been painted on the spot, with great attention paid to the particularities of form, color, and light.[15] Using short quick brush-

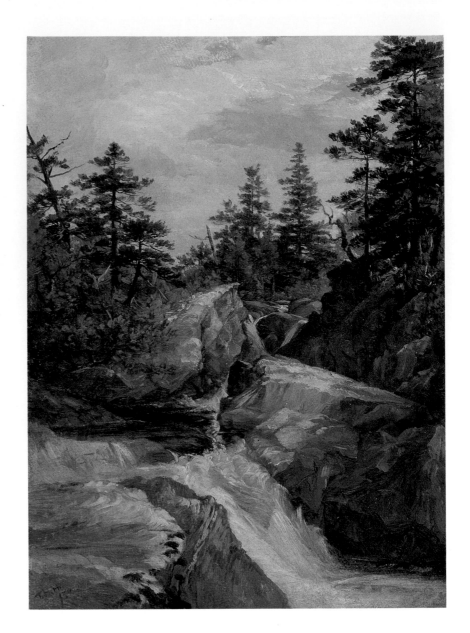

2 Thomas H. Hotchkiss, *Mountain Stream,*
 White Mountains, N.H., 1856. Oil on canvas
 mounted on panel, 9⅞ × 7⅛ in. The
 New-York Historical Society; Gift of
 Nora Durand Woodman, 1932.191

strokes, the artist focused on the contrasting textures of rock, water, and foliage. The lack of finish and the uncomposed, happened-upon character of his composition is similar to Durand's plein-air studies of the mid-1850s. The subject of this painting may be "Artist's Brook," described by North Conway artists as one of their favorite sketching spots.[16]

In December 1859, Hotchkiss sailed for London. Shortly after his arrival, he wrote Durand that he had seen the watercolors and paintings by J. M. W. Turner (1775–1851) in the National Gallery and in Ruskin's private collection. Hotchkiss was particularly impressed by the watercolors, which he described as superior to Turner's oils, more unified in idea and less ambitious in execution.[17] Hotchkiss also mentioned that he was working on two paintings and that he had finished several sepia drawings. These sheets were probably similar to Hotchkiss's earlier ink and wash drawing, *Study of Trees,* ca. 1859 (Fig. 3).[18] Hotchkiss's choice of sepia was unusual (American landscape artists generally preferred graphite pencil), and may reflect his admiration for the rich chiaroscuro found in Turner's wash drawings and engravings.[19] Hotchkiss's technique is fairly accomplished. Working with wet and dry brushes, the artist built up layers of

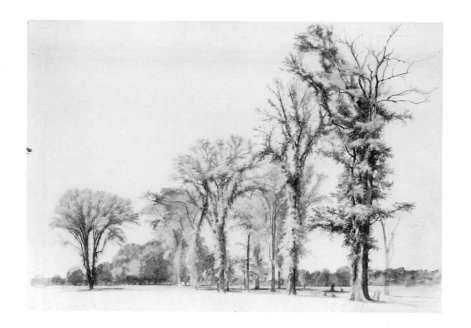

3 Thomas H. Hotchkiss, *Study of Trees*, ca. 1859. Brown ink wash with touches of white gouache and traces of graphite and charcoal on cream wove paper, 14⅞ × 21¼ in. The New-York Historical Society; Gift of Nora Durand Woodman, 1932.221

tone, occasionally blotting pigment from the surface and reworking these sections with greater definition. Although the tree in the immediate foreground attests to Hotchkiss's enduring interest in meticulous detail, the mass of fine, feathery strokes and broad handling of form elsewhere in the drawing suggests the influence of Turner's painterly touch.

NOTES

1. John Paul Driscoll and John K. Howat, *John Frederick Kensett: An American Master*, exh. cat. (New York and London: W. W. Norton & Co. in association with the Worcester Art Museum, 1985), 63.
2. Barbara J. MacAdam, 'A Proper Distance from the Hills': Nineteenth-Century Landscape Painting in North Conway," in *"A Sweet Foretaste of Heaven": Artists in the White Mountains 1830–1930* (Hanover and London: University Press of New England, 1988), 21.
3. Benjamin Champney described his first impressions of the landscape at North Conway: "We were delighted with the surrounding scenery, the wide stretch of the intervales, broken with well-tilled farms . . . with the noble elms dotted about in pretty groups. Then beyond the Saco, the massive forms of the ledges rose up, their granite walls covered with forests . . . The whole formed a scene of surpassing beauty, rarely to be found anywhere. We had seen grander, higher mountains in Switzerland, but not often so much beauty and artistic picturesqueness brought together in one valley." Benjamin Champney, *Sixty Years' Memories of Art and Artists* (Woburn, Mass.: Wallace & Andrews, 1900), 102–3.
4. From 1862 to 1865, William J. Stillman was the American consul in Rome. Given that his acquaintance with Hotchkiss probably dates from 1856, it is unfortunate that Stillman never mentions Hotchkiss in his lengthy *Autobiography of a Journalist* (London: Grant Richards, 1901). The two were certainly acquainted by 1858, when both artists were tenants in the Tenth Street Studio Building in New York. See Annette Blaugrund, "Tenth Street Studio Building; A Roster, 1851–1895," *American Art Journal* 14, no. 2 (Spring 1982): 64–71.

5. "Sketchings: Domestic Art Gossip," *The Crayon* 3 (Aug. 1856): 250: "Our home artists are distributed about the country in various pleasant localities. Messrs. Champney, Coleman, Shattuck and Hotchkiss are at Conway, Mr. Durand is at Campton, both villages being near the White Mountains." Alvan Fisher (as "Mummy"), "Letter to the Editor," *The Crayon* 3 (Nov. 1856): 348, mentions the presence of Hotchkiss in North Conway in October.

6. Samuel Colman described a joint sketching trip from North Conway in a letter to his sister in August 1856: "I have just been spending a week on a mountain top about ten miles from here. We first carried our traps to the top and went down to the nearest farm house at night returning bright and early every morning. We had each day fair and many a feast of wonderful skies and clouds did we enjoy. We made the best studies of the summer there and did two weeks work in one." Colman Papers, Archives of American Art, Smithsonian Institution, Roll 832, Frames 1021–2. Colman does not name his sketching companion, but it could well have been Hotchkiss, who was lodging with Colman at the same boardinghouse outside North Conway.

7. Poppy Oil, "Letter to the Editor," *The Crayon* 3 (Oct. 1856): 318.

8. A correspondent to *The Crayon* in 1856 extolled the beauty of the landscape around North Conway, adding: "But above all, and absorbing all, is that transcendent vista bounded by Mount Washington. To this mountain all eyes turn, as they do in Naples to the smoking Vesuvius. It is always seen. Every hour brings its splendid change. Now blue, now grey, now in sunshine, and now in shadow,—hidden by clouds, forcing its peak through them, or clothed by their creeping shadows, it always rewards the beholder with a new and rapturous emotion." Burnt Umber, "Letter to the Editor," *The Crayon* 3 (Sept. 1856): 283.

9. *Mount Washington, New Hampshire* may have been the painting Hotchkiss exhibited at the National Academy of Design in 1857 as *Meadows of North Conway, New Hampshire*. Bartlett Cowdrey, ed. *National Academy of Design Exhibition Record, 1826–1860* (2 vols. New York: New-York Historical Society, 1943), 1: 238.

10. One of these summer sketches may be the small oil study by Hotchkiss at the Museum of Fine Arts, Boston, *Landscape*.

11. This view of Mount Washington became famous after Kensett exhibited his painting, *The White Mountains—From North Conway*, to great acclaim at the National Academy of Design in 1851. The composition was engraved by James Smillie that year for the American Art-Union and distributed by the thousands to its members. It was reissued later as a lithograph by Currier and Ives.

12. Durand's painting, *Mount Washington From Conway Valley*, 1855, is reproduced in Robert L. McGrath and Barbara J. MacAdam, *"A Sweet Foretaste of Heaven"*, op. cit., 52. Benjamin Champney's canvas, *Conway Meadows, New Hampshire*, 1872 (Vose Galleries), shares the same prospect.

13. Alvan Fisher (as "Mummy"), "Letter to the Editor," *The Crayon* 3 (Nov. 1856): 348–9. In a review of the National Academy of Design annual exhibition in 1857, the *New York Times* complained of the "evident cliqueism" of Colman, Hotchkiss, and Shattuck, "all clever and advancing artists." "Exhibition of the National Academy: Third Notice," *New York Times*, (June 20, 1857): 4.

14. This meticulous study of nature was undoubtedly painted under the influence of Ruskin. Enthusiasm for Ruskin was high: the autumn Hotchkiss spent at North Conway, a correspondent to *The Crayon* reported that Rev. Ware of Augusta, Maine, had just arrived at West Campton with the latest volume of Ruskin's *Modern Painters*. Poppy Oil, "Letter to the Editor," *The Crayon* 3 (Oct. 1856): 317.

15. Champney testified to the challenge of obtaining naturalistic effects: "'Tis true that sometimes it is difficult to find just the tint that will reproduce a certain effect in Nature as all conscientious painters know. As an instance, a number of artists sat down before a group of boulders one day to make close studies of the purple and gray tones broken by brown, green and yellow lichens. This was at North Conway... After struggling a long time with our intricate subject we sat down to eat our meal, but our thoughts could not be kept away from the problem before us, and David Johnson of New York exclaimed after a long silence: 'It's purple, by thunder!'" Champney, op. cit., 138–9.

16. Burnt Umber, "Letter to the Editor," *The Crayon* 3 (Sept. 1856): 283, described the picturesque streams around North Conway: "Into the Saco [River] run innumerable tributary streams, which, near their sources, upon the mountains, form the most lovely rapids and cascades. One of them, the "Artist's Brook," is a clean, clear, darkly shaded mountain rivulet, picturesque at every inch of its way, and classic with the remembrance of beautiful pictures. It fairly waltzes on its way, so unceasing and constant are its turns. Far up on the mountain, it forms a cascade, a most lovely spot, deep-hidden in the recesses of the primitive forest." Over 40 years later, Champney described the same scene: "The beautiful little rocky stream, afterwards called 'Artist's Brook,' fascinated us with its sparkle, its amber color, and its gray rocks broken with patches of green moss. Many of our first studies were made there." Champney, op. cit., 103.

17. Thomas H. Hotchkiss to Asher B. Durand, February 9, 1860. Asher B. Durand Papers, Rare Book and Manuscript Division, New York Public Library, Astor, Lenox and Tilden Foundations.

18. Many of Hotchkiss's drawings and paintings appear to have been signed by another hand after his death. Hotchkiss's own signature is quite distinctive: the cross-stroke in the first "H" in "Hotchkiss" hooks from the lower left to upper right. This drawing, *Study of Trees*, bears an authentic signature by the artist.

19. Thomas H. Hotchkiss to Asher B. Durand, February 9, 1860. Asher B. Durand Papers, loc. cit. Of Ruskin's collection of Turner watercolors, Hotchkiss noted: "Some of these drawings we are familiar with from Engravings of and other from Ruskins Eloquent descriptions which are next to seeing the things themselves." In a letter of 1862 to Samuel P. Avery, Hotchkiss mentioned trading one of his sketches after Turner for two proofs from Turner's *Liber Studiorum*. See Susan A. Hutchinson, "Old Letters: The Avery Collection of Artists' Letters in The Brooklyn Museum," *Brooklyn Museum Quarterly* 2, no. 2 (July 1915): 286–8. Hotchkiss's letters were deaccessioned from the Brooklyn Museum in 1940, along with the rest of the Avery collection. Their present location is unknown.

III

Early Italian Works

*H*otchkiss *left London* in the early spring of 1860, stopping in Paris on his way to Italy.[1] By summer he had arrived in Florence, where he met Elihu Vedder (1836–1923), an American landscape and figure painter who had been living in Italy for the past three years. The two artists quickly became friends, copying Old Master paintings together and sketching in the countryside near Fiesole, outside Florence.[2] Vedder characterized Hotchkiss's art during this period as "the pure product of the teachings of Ruskin," adding that he, too, was deeply influenced by the British theoretician, "filling my studio with careful studies I have never used."[3]

Hotchkiss's watercolor, *View of Florence* (Fig. 1) probably dates to his first visit to Florence. The panoramic view was taken from the terrace in front of the church of San Miniato al Monte, a convent across the Arno. This spot commands one of the finest views of Florence and the surrounding countryside. Using pen and ink, the artist carefully drew the outlines of the city, recording the distinctive profiles of the Duomo, Campanile, and Baptistery on the right, the tower of the Palazzo Vecchio at center and the graceful arches of the Ponte Vecchio, the oldest bridge in the city, at the far left.[4] So precise is Hotchkiss's delineation that it appears as if he traced the image from an engraving or photograph. This armature of outline is softened by the addition of watercolor: pink, rose, and lavender suffuse the scene with a warmth that appears repeatedly in his Italian landscapes.

In addition to the sketching trips Hotchkiss and Vedder made in and around Florence, they may have traveled to Umbria during the summer of 1860.[5] Several watercolors on blue paper, depicting the picturesque hill towns typical of this region (Figs. 2–5), may date to this early sketching trip. Hotchkiss was fascinated with the silhouettes of these medieval buildings against the sky, their massive walls rising dramatically above the plains below. His choice of blue paper as a support indicates his awareness of European drawing practice, where colored paper was more available and artists used these papers as a middle tone, developing the image by adding highlight and shadow. By applying his watercolor and gouache rather opaquely in several of these watercolors, Hotchkiss forfeited the advantages of this technique. *Italian Hill Town* is one of the most successful of this group, the earth tones of the buildings becoming more transparent as the city walls recede into the distance (Fig. 5).

Hotchkiss visited San Gimignano, a small walled town northwest of Siena, in June. Its hilltop setting, richly decorated churches, and well-pre-

1 Thomas H. Hotchkiss, *View of Florence* (detail), ca. 1860. Watercolor, white gouache, and pen and black ink with traces of charcoal on ivory wove paper, 8⅝ × 16 in. The New-York Historical Society, 14908

served medieval architecture make it one of the most picturesque villages in Italy. Hotchkiss's watercolor, *San Gimignano, Tuscany* (Fig. 6), depicts the Torre del Commune, a thirteenth-century brick tower in the middle of town. San Gimignano was famous for its fortress-like towers; it once had more than fifty within its walls, of which thirteen are extant. These towers were erected as symbols of power and prestige and as strongholds for noble families. Hotchkiss's subject and vertical format is similar to a canvas Vedder painted two years earlier (Fig. 7). Perhaps Vedder shared his sketches of the area with Hotchkiss prior to this trip. In his own composition, Hotchkiss moved closer to the Torre, accentuating its height and bulk by eliminating foreground detail and narrative interest.

Leaving San Gimignano, Hotchkiss traveled to the Etruscan hilltown of Volterra, only a few miles away.[6] The origins and character of the Etruscan civilization, which flourished in Tuscany from 700 B.C. to the second century B.C., remain cloaked in mystery. According to the Romans, the Etruscans were masters of engineering and town planning, although very little of their architecture remains. Hotchkiss's watercolor, *Gateway, Volterra, Tuscany* (Fig. 8) is a view of the Porta all' Archo, an ancient gate to the city and part of the original defensive wall.[7] The piers forming the two sides of the gate are constructed of large blocks of stone laid horizontally without cement. The three carved heads adorning the keystone and imposts are also Etruscan and are thought to represent local deities. Their sculptured surfaces are badly weathered and only barely indicated by the artist. The arch itself is a later reconstruction from the first century B.C.[8]

NOTES

1. On February 9, 1860, Hotchkiss wrote Asher B. Durand that he hoped to leave London within the next several weeks, traveling to Paris and then to Italy. Asher B. Durand Papers, Rare Book and Manuscript Division, New York Public Library, Astor, Lenox and Tilden Foun-

2 Thomas H. Hotchkiss, *Italian Hill Town*,
ca. 1860. Watercolor and gouache and
pen and red-brown ink on blue wove
paper, 8 × 12 in. The New-York Histori-
cal Society; Gift of Nora Durand
Woodman, 1932.217

3 Thomas H. Hotchkiss, *Entry to Italian Hill
Town*, ca. 1860. Watercolor and gouache
with pen and brown ink on blue wove
paper, 7⅛ × 7¾ in. The New-York His-
torical Society, x.443(FF)

4 Thomas H. Hotchkiss, *Italian Villa on Hill*, ca. 1860. Watercolor and gouache with pen and brown ink on blue wove paper, 5 × 7 in. The New-York Historical Society, x.443(GG)

5 Thomas H. Hotchkiss, *Italian Hill Town*, ca. 1860. Watercolor and gouache, pen and brown ink and traces of charcoal on blue wove paper, 5¾ × 7⅝ in. The New-York Historical Society; Gift of Nora Durand Woodman, 1932.218

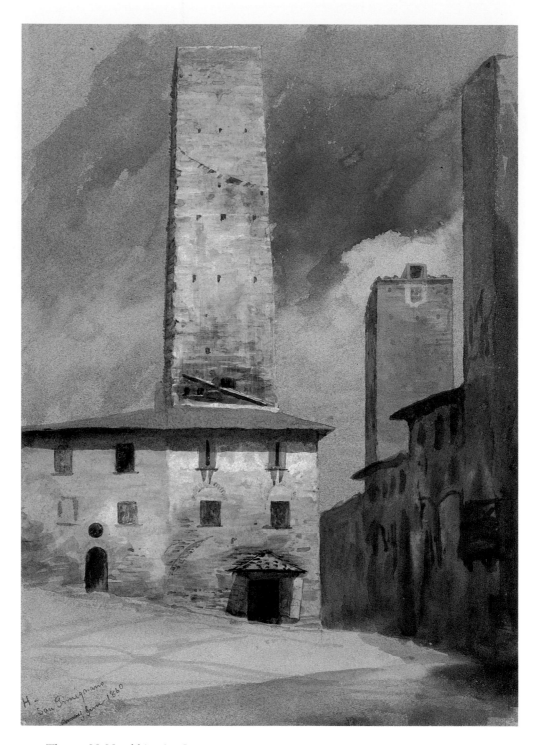

6 Thomas H. Hotchkiss, *San Gimignano,*
Tuscany, 1860. Watercolor and gouache
and graphite on blue wove paper, 11⅟₁₆ ×
8⅛ in. The New-York Historical Society;
Gift of Nora Durand Woodman,
1932.192

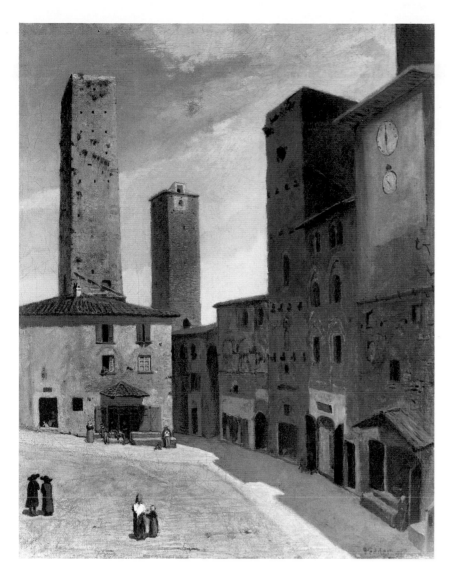

7 Elihu Vedder, *San Gimignano, Tuscany*, 1858. Oil on canvas, 17 × 13¾ in. Joseph Jeffers Dodge, Jacksonville, Florida

dations. According to George H. Yewell (1830–1923), Hotchkiss traveled from London to Italy with the American artist George Fuller (1822–1884). George Yewell Papers, Archives of American Art, Smithsonian Institution, Roll 2428, Frames 382–3. A search through the George Fuller Papers at the Archives of American Art found no reference to his travels with Hotchkiss.

2. In his autobiography, *The Digressions of V* (Boston and New York: Houghton Mifflin Co., 1910), 422, Elihu Vedder recalled that he and Hotchkiss used to paint copies together "in an old church where the pictures, intended for churches, had just the right light, and not as now in the old Town Hall. I shall never forget those peaceful days spent in the white light of that calm and spacious church." As early as September 1861, Samuel P. Avery warned Hotchkiss not to send any more copies to New York with the hopes of selling them. Samuel P. Avery to Thomas Hotchkiss, September 12, 1861. John Durand Papers, Rare Book and Manuscript Division, New York Public Library, Astor, Lenox and Tilden Foundations.

3. Vedder, op. cit., 160–1, 418.

4. This view of Florence was a popular site for tourists. Hotchkiss's composition is very similar to Thomas Cole's *View of Florence from San Miniato*, 1837 (Cleveland Museum of Art). Both views were preceded by an engraving after Turner published in 1831. See Ellwood C. Parry III, *The Art of Thomas Cole: Ambition and Imagination* (Newark, Del.: University of Delaware Press, 1988), 192.

5. Regina Soria, *Dictionary of Nineteenth-Century American Artists in Italy, 1790–1914* (London & Toronto: Associated University Presses, 1982), 313.

6. Hotchkiss may have traveled to Volterra with Elihu Vedder and Nino (Giovanni) Costa (1827–1903), although the documentation on this is contradictory. In August, 1860, Elihu Vedder traveled to Volterra to sketch. In a letter to his father on August 6, 1860, Vedder says only that "I with two companions both artists came down to this place to sketch from nature." Vedder Papers, Archives of American Art, Smithsonian Institution, Roll 515, Frame 1079. Years later, in *The Digressions of V*, 421, Vedder claimed that Hotchkiss accompanied him to Volterra, but other than relating their trip to his early residence in Florence, Vedder does not say precisely when, nor does he mention Costa in this context. Joshua C. Taylor, in "Perceptions and Digressions," *Perceptions and Evocations: The Art of Elihu Vedder* (Washington, D.C.: Smithsonian Institution Press for the National Collection of Fine Arts, 1979), 52–53, states that Hotchkiss reached Florence "probably in the summer of 1860 . . . it cannot be long after . . . that he joined Vedder and Nino Costa on a sketching trip to Volterra." Regina Soria, op. cit., 313, says only that Vedder went to Umbria with Hotchkiss and that Vedder went to Volterra with Henry W. Waugh and George Washington Green. She apparently bases this information on a letter from an anonymous correspondent (possibly William J. Stillman) reprinted from the "Chicago Record" in *The Crayon* 7 (Nov. 1860): 325, who mentions Hotchkiss was in Switzerland during August, 1860, and that Green, Waugh, and himself went with Vedder to Volterra. Since Hotchkiss's watercolor *Gateway, Volterra, Tuscany* is dated June, 1860, it would seem that Vedder and Hotchkiss made separate trips to that city.

7. Vedder also painted this ancient gate in *Old Man Entering the Gate of Volterra*, ca. 1860. In his composition, only the lower half of the edifice is visible. The painting is reproduced in Vedder's *Digressions*, 299. Its present location is unknown.

8. Banister Fletcher, *A History of Architecture*, ed. John Musgrove (London: Butterworths, 1987), 221.

8 Thomas H. Hotchkiss, *Gateway, Volterra,*
 Tuscany, 1860. Watercolor and gouache
 on light blue laid paper, 12¼ × 8¾ in. The
 New-York Historical Society; Gift of
 Nora Durand Woodman, 1932.195

IV

Life Drawing

Academic drawing was considered essential to an artist's professional education in the nineteenth century. This training was designed to teach the basic elements of art by guiding the artist through progressively difficult exercises in draftsmanship, from copying engravings and plaster casts to drawing the live nude model. In the United States, there were few opportunities for this type of study.[1] Thus for many nineteenth-century American artists, attending life classes in the art academies in Europe was their first opportunity to study the human figure. Thomas Cole (1801–1848), Sanford R. Gifford (1823–1880), and John F. Kensett (1816–1872) are all known to have studied academic drawing while living in Italy.[2]

Hotchkiss's interest in life drawing is confirmed in a letter he wrote Lucy Durand Woodman from Rome in January 1863, in which he mentioned he was taking life classes every evening at the Academy.[3] It is not known which academy Hotchkiss attended, although it may have been the English Academy, which offered free classes to Italian and foreign artists. Hotchkiss's close friend, Elihu Vedder, was a devoted student of academic drawing and may have encouraged the young artist to pursue this mode of study.[4] Vedder himself studied drawing in a private atelier in Florence from 1859 to 1860, and also took free night classes at the Accademia Galli, where artists could paint from the nude.[5] Upon his return to Italy in 1867, Vedder continued his study of drawing at Gigi's Academy in Rome, one of the most popular studios in the city.[6] In many academies, evenings of life drawing alternated with evenings of costume study. These classes provided the artist with an opportunity to master a variety of figure types and drapery for future compositions.[7] If desired, artists could also hire their own models on a daily basis from among those available at the "model's exchange" on the Spanish Steps.[8]

Although figures rarely appear in Hotchkiss's landscapes, he occasionally included a shepherd, monk, or peasant in his paintings to add narrative or pictorial interest. These figures are usually quite small, with little or no discernible detail, as in *Cypresses and Convent of San Miniato, Florence* (see p. 62). Although Hotchkiss may have studied figure painting in his youth, this full-length costume study is Hotchkiss's only known figure drawing.[9] Its scale and subject suggests it was drawn from a professional model in a life class during the artist's residency in Italy. Given its emphasis on accuracy and detail, Hotchkiss's drawing was probably executed early in his career, about 1860 to 1863.

1 Thomas H. Hotchkiss, *Study of a Monk*,
ca. 1860–63. Oil and graphite on off-
white wove paper, 11¼ × 7⅞ in. The New-
York Historical Society; Gift of Nora
Durand Woodman, 1932.197

Study of a Monk (Fig. 1) is exceptionally accomplished. Painted in oil on prepared paper, Hotchkiss first blocked in the subject with graphite underdrawing, portions of which are still visible. As he worked up the figure in oil, his primary concern was the handling of light, which fell obliquely across the composition, creating areas of highlight and deep shadow. The modeling of the heavy folds of drapery is not labored, but determined by fluid brushstrokes building subtle gradations of tone. The inscription in lower right corner of the sheet, dating the work 1860 to 1861, is not in the artist's hand.

NOTES

1. For more information on academic training in America in the 19th century, see Lois Marie Fink and Joshua C. Taylor, *Academy: The Academic Tradition in American Art*, exh. cat. (Washington, D.C.: National Collection of Fine Arts, 1975).

2. Ellwood C. Parry, III, "Thomas Cole and the Problem of Figure Painting," *American Art Journal* 4, no. 1 (Spring 1972): 79–81, suggests Cole studied the nude model at the Accademia in Florence ca. 1831–32. For Gifford's studies in life drawing at the English Academy in Rome ca. 1857, see Ila Weiss, *Poetic Landscape: The Art and Experience of Sanford R. Gifford* (Newark, Del.: University of Delaware Press, 1987), 76. Kensett attended drawing classes in Rome ca. 1845–47. See John Paul Driscoll and John K. Howat, *John Frederick Kensett: An American Master*, exh. cat. (New York and London: Worcester Art Museum in association with W. W. Norton & Co., 1985), 58. Benjamin Champney, who was with Kensett in Rome, described their visits to the evening costume classes, "where the models posed for two hours. We had hard work to finish our drawings in outline and watercolor in that time. This was good practice, and gave us quickness of perception and trained our eyes and hands." Benjamin Champney, *Sixty Years' Memories of Art and Artists* (Woburn, Mass.: Wallace & Andrews, 1900), 74.

3. Thomas H. Hotchkiss to Lucy Durand Woodman, January 3, 1863. Manuscript Collection, The New-York Historical Society.

4. There is no indication Hotchkiss attended life classes at the National Academy of Design in New York. I would like to thank Therese Rosinsky, Archives, National Academy of Design, for checking the registers for these classes.

5. Regina Soria, *Elihu Vedder, American Visionary Artist in Rome (1836–1923)* (Cranbury, N.J.: Fairleigh Dickinson University Press, 1970), 25, 27, 29. In Florence, Vedder studied with the academic painter Raffaello Bonaiuti.

6. Founded by Luigi "Gigi" Talarico, a former model, the academy offered inexpensive classes with a stage and live models for amateur and professional artists. Regina Soria, *Dictionary of Nineteenth-Century American Artists in Italy, 1790–1914* (London & Toronto: Associated University Presses, 1982), 35.

7. Kensett's costume studies from the mid-1840s are typical of this type and show a wide range of figures in provincial Italian costume, including several in monastic garb.

8. William Wetmore Story, *Roba di Roma* (2 vols. London: W. Clowes and Sons, 1863), 1: 35.

9. An unidentified newspaper clipping dated April 1853, mentions that Mr. Hotchkiss "has at Brent's Studio, a picture representing a group of peasant children at a cottage door. This sweetly colored work of Art, is well worth a larger notice than I can give it here, but to see this fine effort of a young hand, —well worthy of a more practised master, will well repay those whose happy leisure allows them to lounge around Painter's rooms while the sun shines." Another undated clipping discusses Mr. Brent's studio and then mentions that Mr. Hotchkin [*sic*], "a young man from Mt. Morris, is displaying much merit in the truthfulnes of his figure pieces. The 'Game of Marbles,' representing a group of ragged urchins playing at the door of an old building, has many good points —Study and perseverance will bring him fame." Manuscript Collection, The New-York Historical Society, Pamphlet 1582x. Henry J. Brent is listed in the Rochester, New York, city directories as an artist from 1853 to 1854. I would like to thank Timothy Anglin Burgard for bringing this pamphlet to my attention.

V

San Miniato, Florence

The Romanesque church of San Miniato al Monte crowns one of the highest hills southeast of Florence. Founded as a Benedictine monastery in the eleventh century, it is one of the oldest and most beloved Florentine buildings. Its exterior, like the Baptistery and Duomo, is sheathed in contrasting marble, creating a highly patterned surface that is distinctly Tuscan. In the sixteenth century, the church was fortified by Michelangelo as a defensive outpost against the deposed Medici. Subsequently, it was occupied several times by warring armies. Despite its previous military role, the church remains a secluded and restful spot; the broad terrace in front provides an unparalleled view of Florence and the Arno valley. In 1860–61, Hotchkiss painted an exquisite watercolor from this overlook (see p. 49).

Hotchkiss's three oil paintings of this site, *Cypresses and Convent of San Miniato, Florence; Cypresses;* and *Sketch from Nature (Cypress Trees at San Miniato),* do not show the church but the beautifully landscaped gardens behind it (Figs. 1–3). This area was laid out in 1839 by Niccolò Matas as a large suburban cemetery surrounded by cypress trees. It was quickly filled with ornate tombs of the best Florentine families. The floors and walls of the church were also covered with sepulchral slabs, so that by 1867, guidebooks complained that "a visit to this elegant basilica during the hot months is far from agreeable, and at times not unattended with danger. . . In its present state San Miniato is little else than one great Golgotha, and a receptacle for the memorials of sentiment and vanity of the modern Florentines."[1] The cemetery continued to be used until the early twentieth century.

Although Hotchkiss's landscapes are similar in composition, there are substantial differences in technique. The first two works are fairly finished views of two monks strolling through the garden at San Miniato.[2] In the background are monuments belonging to the newly expanded cemetery. The cypress trees lining the garden path cast long shadows across the foreground, creating alternating bands of light and dark that lead the eye into the far distance. This pattern is repeated in the silhouettes of the trees against the sky. The third work is much more loosely painted. Individual forms are blocked in the composition without precise definition or three-dimensional modeling. The sky has been repainted with a thick, opaque pigment, which cuts into the edges of the foliage and gives the landscape an oppressive, airless quality. There are fewer trees at the far right, making the line of cypresses less compact and rhythmic.

These differences in technique and composition suggest the third work was a preparatory study for Hotchkiss's 1864 canvases. Another version of this composition appears in a painting by Elihu Vedder, *Cypress Trees on San Mini-*

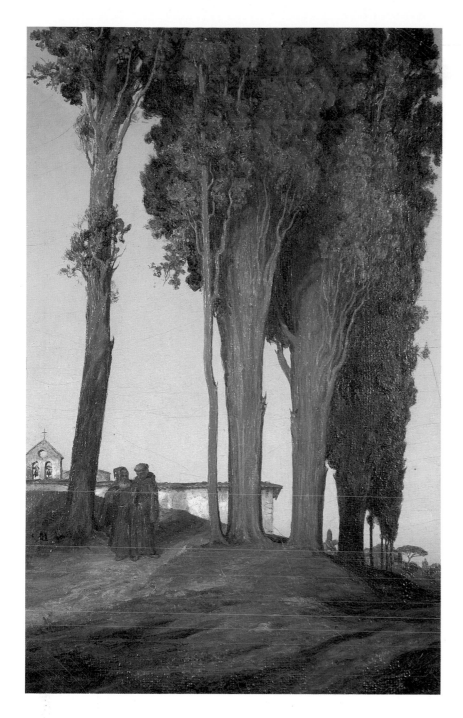

1 Thomas H. Hotchkiss, *Cypresses,* ca. 1864.
Oil on canvas, 13½ × 8½ in. Whitney
Sudler Smith

ato, Florence, ca. 1865 (Fig. 4). Although Vedder may have copied Hotchkiss's
1864 canvas in New York while it was on exhibition at the National Acade-
my of Design, it seems more likely that both artists were working from sketch-
es made on the spot during their summer together in Florence in 1860.[3] Like
Hotchkiss, Vedder repainted the sky in his composition. With their viscous
daubs of paint and immediacy of execution, all four works recall the painter-
ly technique of the Macchiaioli painters, a group of contemporary Italian
artists working in an Impressionist style.[4] Vedder's relationship with the Mac-
chiaioli dated back to 1858; he may have introduced Hotchkiss to their circle
in 1860.[5] Ultimately, Hotchkiss did not assume either the subject matter (pri-
marily scenes of contemporary life) or the bright palette of the Macchiaioli,
although he may have been influenced by their direct visual response and vig-
orous brushwork, as can be seen in several of Hotchkiss's later landscapes.

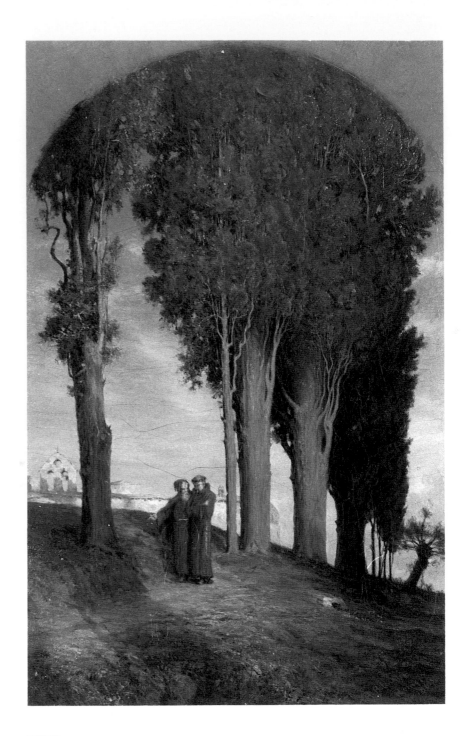

2 Thomas H. Hotchkiss, *Cypresses and Convent of San Miniato, Florence, Italy,* 1864. Oil on canvas, 14¾ × 9⅛ in. Collection of the William A. Farnsworth Library and Art Museum, Rockland, Maine

NOTES

1. *A Handbook for Travellers in Central Italy* (London: John Murray, 1867), 198.
2. The high degree of finish suggests that one of these two works may be the Hotchkiss painting exhibited at the National Academy of Design in 1865 as *Cypresses at the Convent of San Miniato, Florence.* Maria Naylor, ed. *The National Academy of Design Exhibition Record, 1861–1900* (2 vols. New York: Kennedy Galleries, 1973), 1: 456. A reviewer of this Academy exhibition in *The Nation,* July 13, 1865, was unusually complimentary: "Mr. Hotchkiss' picture, No. 570, "Cypresses at the Convent of San Miniato, Florence," is a good portrait of the trees, and the sunset light falling on the trees and hillside in bars alternated with bars of shadow from other trees unseen, is warm and real. The picture is therefore very interesting, for

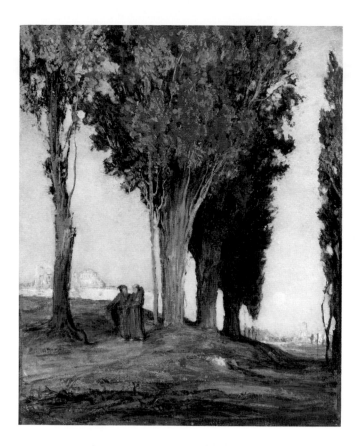

3 Thomas H. Hotchkiss, *Sketch from Nature (Cypress Trees at San Miniato al Monte, Florence)*, ca. 1864. Oil on paper, 13¼ × 10¾ in. The New-York Historical Society; Gift of Nora Durand Woodman, 1932.50

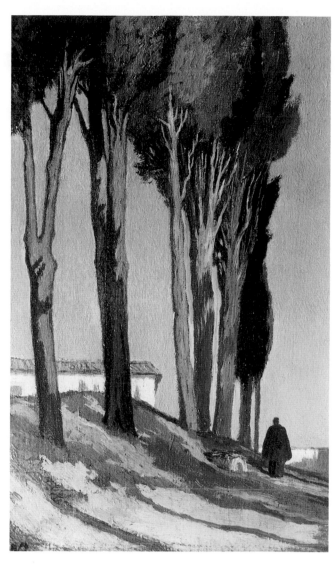

4 Elihu Vedder, *Cypress Trees on San Miniato, Florence*, ca. 1865. Oil on paper, 9¾ × 6½ in. Jane and Simon Parkes

the cypress is a strange tree to us in America, and of strongly individual character, and these are noble specimens of their kind. The monks are not successful, but are not to be wished away, only to be wished better."

3. Vedder's painting is undated, although an old inscription on the verso (not in the artist's hand) reads "1865," when he was working in New York. It is also possible this painting is identical to a later work identified by Regina Soria in *Elihu Vedder: An American Visionary Artist in Rome (1836–1923)* (Cranbury, N.J.: Fairleigh Dickinson University Press, 1970), 293, cat. no. 110 as "Cypresses at San Miniato, c. 1867."

4. For English publications on the Macchiaioli, see Manchester City Art Gallery, *The Macchiaioli: Masters of Realism in Tuscany*, exh. cat. (Rome: De Luca Publisher, 1982), Stair Sainty Matthiesen, *The Macchiaioli: Tuscan Painters of the Sunlight*, exh. cat. (London: Matthiesen, 1984), and Norma Broude, *The Macchiaioli: Italian Painters of the Nineteenth Century* (New Haven and London: Yale University Press, 1987).

5. For a discussion of Vedder's relationship with the Macchiaioli, see Regina Soria, "An American Macchiaiolo: New Insights into Elihu Vedder's Florentine Experience, 1857–1860," in Irma B. Jaffe, ed., *The Italian Presence in American Art, 1760–1860* (New York: Fordham University Press, 1989), 165–75.

Roman Colosseum and Arch of Titus

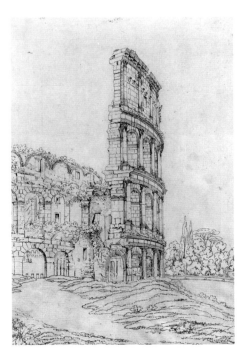

1 Thomas H. Hotchkiss, *Roman Colosseum*, ca. 1860–61. Pen and brown ink and graphite on light brown laid paper, 18⅟₁₆ × 12⅝ in. The New-York Historical Society; Gift of Nora Durand Woodman, 1932.204

The Colosseum is perhaps the most potent symbol of imperial Rome, and it is generally considered the pinnacle of Roman design and engineering. Built by the Flavian emperors Vespasian, Titus, and Domitian from A.D. 70 to 80, the Colosseum stands just outside the Forum on ground that was formerly an artificial lake in Nero's private pleasure garden, the Domus Aurea. It is one of several public buildings constructed during the imperial age to accommodate the growing cultural and social needs of the city. Modeled on semicircular Greek amphitheaters, the Colosseum is a large ellipse, enclosing a raised arena. A sophisticated system of concourses, ramps, and stairways provided access and crowd control to three tiers of interior seating, where over fifty thousand spectators could witness the elaborate naval spectacles, ceremonies, parades, and deadly combats staged in the arena. Despite vandalism, looting, and quarrying of its marble and travertine facing, the Colosseum is one of the best-preserved and most famous monuments of ancient Rome.

Hotchkiss was one of many artists in the nineteenth century who sketched and painted the Roman Colosseum. One of his earliest views is a careful architectural study of a section of the southeastern façade (Fig. 1). The drawing focuses on the vertical thrust of three tiers of arcades (Doric, Ionic, and Corinthian) and the attic story, tracing the details of the stonework in painstaking outline. Drawn initially in graphite, the image was reinforced with pen and brown ink for greatest possible clarity. The lack of shading, meticulous attention to architectural detail, and exact perspective suggest that Hotchkiss used a camera obscura or other mechanical aid in constructing the image. The landscape contours and foliage were not drawn from nature, but were added as decorative elements, using a calligraphic formula found in drawing manuals. Finally, the sheet was squared with a ruler for enlargement or transfer to another support, although no other version of this image is known.

The luxuriant vegetation seen growing on Hotchkiss's sketch of the Colosseum was much admired by artists such as Thomas Cole, whose romantic sensibility was drawn to the overgrown and decaying ruins.[1] Indeed, some exotic floral species, thought to have been introduced with animal fodder from ancient times, still grew within the great monument.[2] The visual impact of this scene was permanently changed in 1870, however, as the arena was excavated and this herbage removed. The renovations were lamented by the English writer Augustus Hare, who described

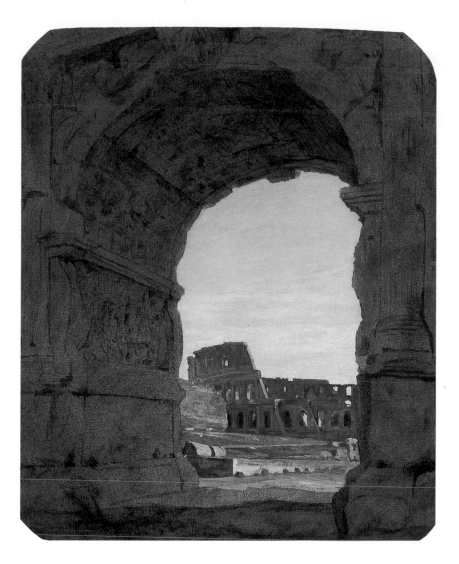

2 Thomas H. Hotchkiss, *Arch of Titus and Roman Colosseum*. Oil on wove paper mounted on panel, 15⅝ × 13⅛ in. The New-York Historical Society; Gift of Nora Durand Woodman, 1932.205

the arena of the Colosseum in 1840 as resembling "an English abbey, an uneven grassy space littered with masses of ruin, amid which large trees grew and flourished." The loss of its distinctive vegetation was "much regretted by lovers of the picturesque."[3]

Another favorite monument for Roman view painters in the eighteenth and nineteenth centuries was the Arch of Titus, the triumphal arch built shortly after A.D. 81 to commemorate the destruction of Jerusalem by Titus eleven years earlier. Located on the Via Sacra between the Colosseum and Roman Forum, the arch is richly ornamented with bas-relief sculpture, engraving, and architectural decoration. Beneath its deeply recessed and coffered barrel vault are carved reliefs depicting the victorious general on one side and a procession of Roman soldiers carrying away the spoils of the war on the other. These details are only barely visible in Hotchkiss's unfinished painting of the monument, *Arch of Titus and Roman Colosseum* (Fig. 2). The arch itself reveals the artist's underdrawing and preparatory ground, while the background view of the Colosseum has been fully worked in color. Hotchkiss's composition is very similar to a view of the arch attributed to three American artists, George P. A. Healy (1813–1894), Jervis McEntee (1828–1891), and Frederic E. Church, which was painted in Rome ca. 1869–71. The proportions and perspective of

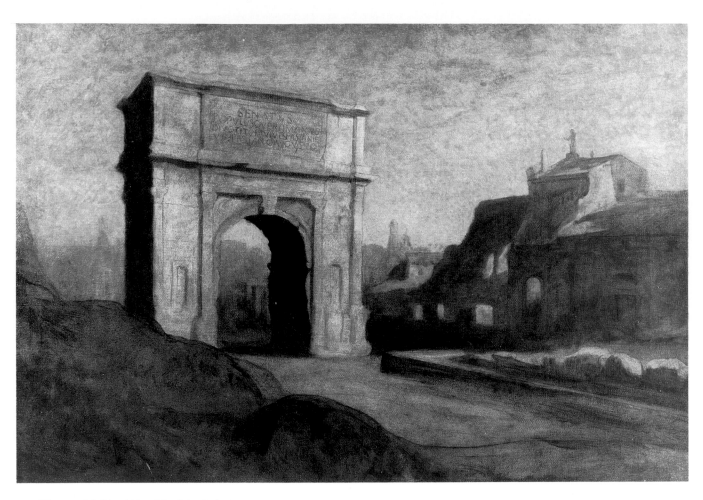

3　Thomas H. Hotchkiss, *Moonlight, Arch of Titus, Rome*, 1867. Oil on canvas, 14⅜ × 21 in. The New-York Historical Society; Gift of Nora Durand Woodman, 1932.43

their composition, *The Arch of Titus* (The Newark Museum), as well as Hotchkiss's, may have been taken from a tourist photograph widely available in the nineteenth century.[4] Both compositions are also identical to a watercolor view by the English artist Thomas Hartley Cromek, *The Colosseum Seen through the Arch of Titus*, exhibited at the Royal Academy in 1850.[5]

Two paintings by Hotchkiss, *Moonlight, Arch of Titus, Rome*, 1867, and *Roman Colosseum*, also appear to be unfinished studies (Figs. 3, 4). Their forms are blocked in with thin washes of brown underpaint, leaving many of the pictorial details unresolved. Rather than recreate the scenes with archaeological accuracy, Hotchkiss used the hulking forms of these structures to create dreamlike images, alternative readings of conventional tourist motifs. In *Roman Colosseum*, large rocks in the foreground displace the amphitheater as the most prominent object in the composition, blocking visual access to the middle and far distances, and challenging the traditional reverence with which this building is held. In *Moonlight, Arch of Titus*, the church of Santa Francesca Romana looms on the right, its fine Romanesque belltower clearly visible. Behind it, the great mass of the Basilica of Maxentius dwarfs its surroundings, light emanating mysteriously from within its vast vaulted structure. Seen together, the church and basilica seem curiously alive, as if a crouching creature lurked beneath the shadows of this moonlit night. By juxtaposing these three monuments within his composition, Hotchkiss seems to acknowledge the uneasy coexistence of pagan and Christian civilizations within the fabric of Rome.

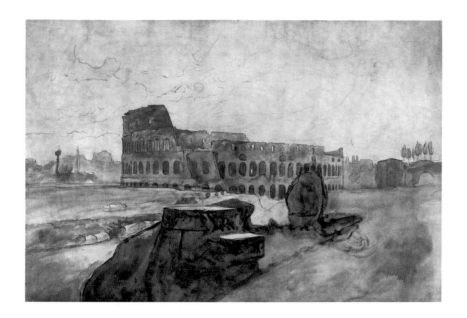

4 Thomas H. Hotchkiss, *Roman Colosseum.*
 Oil on canvas, 14⅜ × 21 in. The New-
 York Historical Society; Gift of Nora
 Durand Woodman, 1932.51

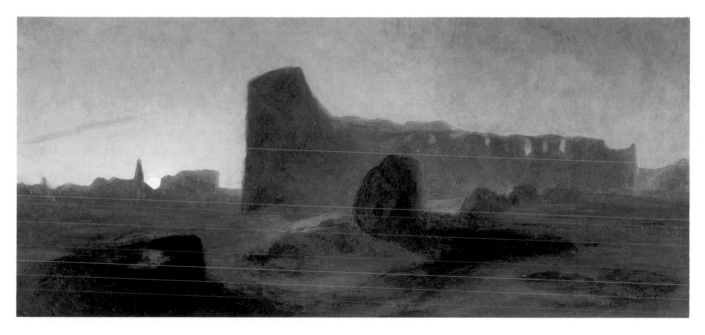

5 Thomas H. Hotchkiss, *Sunset on the Colos-
 seum.* Oil on paper, 5¹⁵⁄₁₆ × 13⁷⁄₁₆ in. The
 New-York Historical Society; Gift of
 Nora Durand Woodman, 1932.206

Visiting the Colosseum by moonlight was a favorite tourist pastime in Rome. William Wetmore Story (1819–1895), an American sculptor living in Rome, described the experience tourists sought: "Shadows deepen in the open arena, block up the arches and galleries, confuse the lines of the benches, and shroud its decay. You rise and walk musingly into the centre of the arena, and, looking round its dim, vast circumference, you suddenly behold the benches of old, thronged with their myriad of human forms—the ghosts of those who once sat there."[6] Despite the popularity of these nocturnal visits, few American artists depicted the moonlit scene.[7] Hotchkiss's *Sunset on the Colosseum* (Fig. 5) is one of the rare attempts to capture this evocative moment, with the profile of the Colosseum emerging from a darkened mass of indistinct forms.[8] His composition is reminiscent of Cole's challenge that "he who would see and feel the grandeur of the Colosseum must spend his hour there, at night, when the

moon is shedding over its magic splendor. . . The mighty spectacle, mysterious and dark, opens beneath the eye more like some awful dream than an earthly reality, —a vision of the valley and shadow of death, rather than the substantial work of man."[9]

Hotchkiss's oil painting on paper *Roman Colosseum*, 1868, shows his increasing mastery over space (Fig. 6). In this small study, the magnificent structure plays only an incidental role at far left, its thick walls glowing with the orange and red tones of failing light. The subject of the painting is the horizontal bowl of foreground space, which Barbara Novak describes as "potently empty, like a narrow stage behind which the drama of landscape and ruins unfolds."[10] Indeed, the cliff on the right and the Colosseum on the left serve as framing devices for an empty stage, where time seems to stand still beside these ancient monuments. Like many other artists' interpretations of the Roman Colosseum, Hotchkiss's paintings of the amphitheater express a range of attitudes couched in nineteenth-century political and aesthetic preoccupations. As William L. Vance has observed, for American artists there was "an ambivalent attitude toward imperial power, its rise, its glories and terrors, and its fall. The Colosseum becomes the Moby-Dick of architecture, a sublimely multivalent symbol, sacred yet malignant, alien and dreadful yet magnificent, ravaged yet enduring."[11]

NOTES

1. Thomas Cole described the Colosseum as "the object that affected me the most" during his 1832 visit to Rome: "It is stupendous, yet beautiful in its destruction. From the broad arena within, it rises around you, arch above arch, broken and desolate, and mantled in many parts with the laurustinus, the acanthus, and numerous other plants and flowers, exquisite both for their colour and fragrance. It looks more like a work of nature than of man; for the regularity of art is lost, in a great measure, in dilapidation, and the luxuriant herbage, clinging to its ruins as to 'mouth its distress,' completes the illusion." Louis L. Noble, *The Course of Empire, Voyage of Life, and Other Pictures of Thomas Cole, N.A.* (New York: Cornish, Lamport & Co., 1853), 159.

2. Cole collected exotic botanical specimens from the Colosseum and saved them for future reference. One collection of pressed flowers is at the Detroit Institute of Arts while another came into the collection of Frederic E. Church at Olana, where two pages of a Herbarium contain "Flowers gathered by Thomas Cole—Artist." See Barbara Novak, "Arcady Revisited," in *The Arcadian Landscape: Nineteenth-Century American Painters in Italy*, exh. cat. (University of Kansas Museum of Art, 1972), xviii.

3. Hare quoted by Georgina Masson, *The Companion Guide to Rome* (London: Collins, 1965), 357.

4. William L. Vance, *America's Rome* (2 vols. New Haven and London: Yale University Press, 1989), 1: 57. This photograph, now in the Archives of American Art, bears "carefully drawn rulings to determine exact perspective and proportions" of the monument.

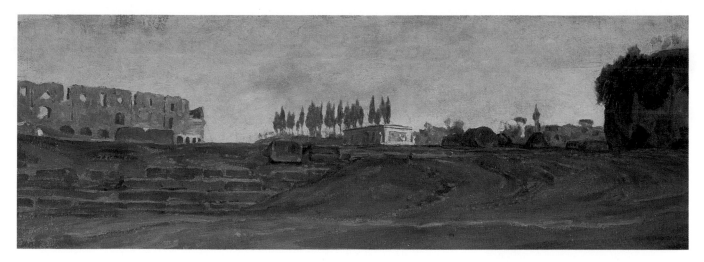

5. Lois Dinnerstein, "The Significance of the Colosseum in the First Century of American Art," *Arts Magazine* 58 (June 1984): 120. Healy may have seen the Cromek painting in London in 1850.

6. William Wetmore Story, *Roba di Roma* (2 vols. London: W. Clowes and Sons, 1853), 1: 244.

7. Dinnerstein, 118.

8. This painting may be the Hotchkiss canvas seen by Tuckerman in the artist's studio, "a small picture of the 'Colosseum by Moonlight,' which may be termed a good attempt to accomplish an impossibility." Henry T. Tuckerman, *Book of the Artists* (Reprint. New York: James F. Carr, 1967), 569.

9. Noble, 159–60.

10. Barbara Novak O'Doherty, "Thomas H. Hotchkiss: An American in Italy," *The Art Quarterly* 29, no. 1 (1966): 11.

11. Vance, 45.

6 Thomas H. Hotchkiss, *Roman Colosseum*, 1868. Oil on paper mounted on panel, 5¹³⁄₁₆ × 16½ in. The New-York Historical Society; Gift of Nora Durand Woodman, 1932.39

VII

Monte Mario, Rome

1 Thomas H. Hotchkiss, *Monte Mario, Rome*, 1868. Oil on paper, 17 × 11⅞ in. The New-York Historical Society; Gift of Nora Durand Woodman, 1932.7

Just outside the city walls of Rome, the high hill of Monte Mario offers spectacular views of the city, the Campagna, the mountains, and the sea. Elihu Vedder's wife, Carrie, described this locale as providing "exquisite glimpses, or full views rather, of lovely gardens, with Rome and St. Peter's in the background looking one way, of the magnificent snow-covered mountains looking the other."[1] In the nineteenth century, Monte Mario was also recommended to tourists for two noteworthy Renaissance villas located there, the Villa Mellini on the summit and the Villa Madama below.[2] Both villas were lavishly decorated (Raphael had designed the Villa Madama for Pope Clement VII) and were open to the public. The Villa Mellini was surrounded by a vast cypress garden, accessible by either a long, winding carriage road or a footpath leading up the steep hillside.

Despite the beauty of this site, paintings of the view from Monte Mario are relatively rare. Hotchkiss completed two paintings from this prospect, *Monte Mario, Rome* and *Italian Landscape (Monte Mario, Rome)* (Figs. 1, 2). Practically identical, with the exception of size, they are among his finest works. Their similarity suggests that the artist received a commission for a copy of his initial composition, although it is not known which work was executed first. Both paintings can be dated to the last year of Hotchkiss's life based on his inscription and date on *Monte Mario, Rome.*

The success of Hotchkiss's composition depends upon its delicate balance of spatial and tonal contrasts. In the foreground, six cypress trees sway in a gentle rhythm along a wide hillside path. This area overlooks an extensive valley, with a broad river winding through the landscape below. Although the foreground is clearly bounded by the crisp profiles of the cypress trees, their peeling bark and twisting branches seem deliberately anthropomorphic, extending from their trunks like fingers and perforating the background sky. A low arching bridge at center spans the river, joining the left and right halves of the landscape and providing a focal point for the composition. Light also bisects the painting: while the background is filled with the luminous glow of Hotchkiss's sky, and is reflected in the river below, the foreground is in almost complete shadow, with slivers of light filtering through the tall trees. Such sophisticated handling of light and color recalls Hotchkiss's admiration of Turner, some of whose influence can be seen in Hotchkiss's later Italian landscapes.

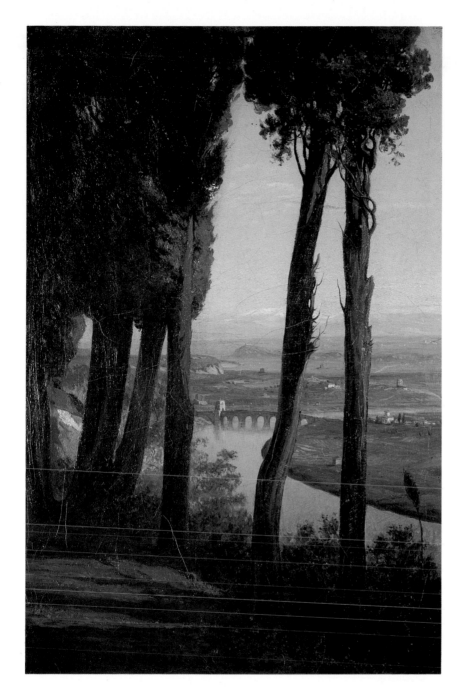

2 Thomas H. Hotchkiss, *Italian Landscape
(Monte Mario, Rome)*, ca. 1868. Oil on can-
vas, 13¾ × 9 in. Whitney Sudler Smith

NOTES

1. Carrie Vedder quoted in Regina Soria, *Elihu Vedder: American Visionary
 Artist in Rome (1836–1923)* (Cranbury, N.J.: Fairleigh Dickinson Uni-
 versity Press, 1970), 75.
2. *Hand-Book or New Guide of Rome and the Environs according to Vasi and Nibby*
 (Rome: L. Piale, 1854), 498, and Karl Baedeker, *Italy, Handbook for Trav-
 ellers: Central Italy and Rome* (Leipsic: Karl Baedeker, 1900), 368–9.

VIII

Roman Campagna

In the nineteenth century, the vast, undulating plain of the Roman Campagna surrounded the city of Rome and stretched for more than twenty-five miles in all directions. Girdled by a low ridge of mountains to the north and east, the Campagna seemed like a gently rolling sea, its surface dimpled by streams, pools, gorges, and hollows. In the spring, the land burst into bloom with wild flowers and grasses, which soon withered beneath the unrelenting summer sun. Other than the occasional goatherd, artist, or passing traveler, the Campagna was remarkably vacant, devoid of human habitation or agriculture. Writing at mid-century, the American travel writer George Hillard noted that unlike most large cities, Rome was not reached by slow degrees through suburban expansion, "nor does the tide of population come imperceptibly to an end, like a spent wave that dies along a level beach. But, as soon as the gates are passed, we come upon a far-reaching tract of monotonous desolation, in which every pulse of life seems to have ceased to beat. Far as the eye can pierce, it rests upon a plain of dreary and somber verdure, which extends in every direction . . ."[1] This endless, barren landscape had a brooding quality disliked by some,[2] but described by one contemporary writer as having its own special charm, "which they who are only hurrying on to Rome, and to whom it is an obstruction and a tediousness, cannot, of course, perceive. It is dreary, weird, ghostly, —the home of the winds; but its silence, sadness, and solitude are both soothing and impressive."[3]

Hotchkiss's paintings of the Campagna, *Scene in Italy* and *Landscape Sketch* (Figs. 1, 2; see also p. 21), capture this sense of silence and solitude. Only the presence of a shepherd and his flock break the stasis of his compositions, open-ended segments of a treeless expanse. Hotchkiss's handling of paint was equally restrained: using long horizontal strokes, his brush skimmed across the surface from edge to edge, mimicking the panoramic sweep of the Campagna itself. Light fills the sky, flooding the image with color and palpable atmosphere. In *Study, Italian Landscape* (Fig. 3), possibly painted in the highlands closer to the Apennine Mountains, Hotchkiss used a minimum of stoke to define the bare, round hills. Within this small composition, he was able to develop a sense of immense distance by pulling the viewer's eye across simple overlapping planes to the snow-capped mountain on the horizon. Such intimate landscapes inspired the nine-teenth-century critic James Jackson Jarves to declare that there are "simple sketches by [Hotchkiss] which contain more general and particular truths

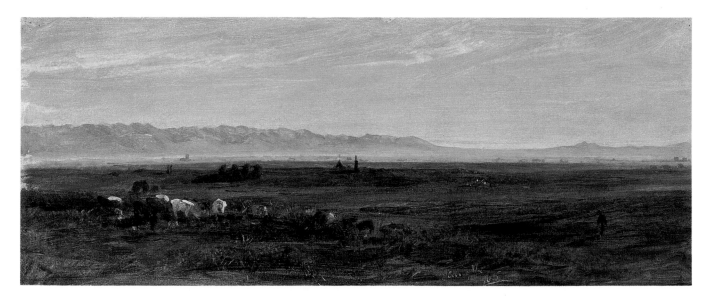

1 Thomas H. Hotchkiss, *Scene in Italy
 (Roman Campagna)*, 1865. Oil on paper
 mounted on canvas, 6⁹/₁₆ × 16⁹/₁₆ in. The
 New-York Historical Society; Gift of
 Nora Durand Woodman, 1932.40

of nature, enriched by the pure feeling and sentiment that bespeak a heart and head alive to her best outward moods and spirit . . . than can be found in acres of the canvases of the more pretentious realists of the Bierstadt sort. He impressed, not so much the fancy or imagination as the senses and the intellect in general."[4] Elihu Vedder was also keenly appreciative of the poetic quality of such works, unencumbered by unnecessary detail and the pictorial clichés accompanying most picture-postcard landscapes purchased by tourists visiting Rome. Years after Hotchkiss's death, Vedder described his friend's work as containing "not a trace of ostentation, but full of the most exquisite, delicate work, and giving just what he saw and felt—some tranquil scene in Nature at her best."[5]

Although the Campagna was unpeopled, it bore the traces of human ambition and aspirations to immortality. Strewn across the landscape were a wide variety of ruins, from single fragments of stone to larger structures that still retained traces of their original function. These included the remains of imperial villas, as well as hundreds of tombs still standing on the sun-drenched plain. Some of the most impressive tombs lined the Via Appia, an ancient road that led from Rome to Naples. Hillard reported that the remains of more than ninety could be counted within a short stretch of the Appian Way.[6] Although once adorned with marble, sculpture, and carvings, most of these edifices had lost their decorative veneers and were reduced to their crude brick foundations.

In a remarkable series of watercolors, Hotchkiss sketched several of these ruins on the Roman Campagna (Figs. 4, 5).[7] Seen in isolation, these monuments have a timeless nobility, standing erect while all else lies prostrate. While Hotchkiss may have admired their strength and endurance through two thousand years, these ruins may have evoked other feelings as well. Hillard referred to the Campagna as "a great historical palimpsest," where the proud structures erected upon its plain were now "no more than monuments of lost power and memorials of faded glory."[8] Some of Hotchkiss's sketches convey this sense of lost significance (Figs. 6, 7). The blocks of stone and brick are now reduced to little more than abstract shapes, detached from their historic context. The attraction of

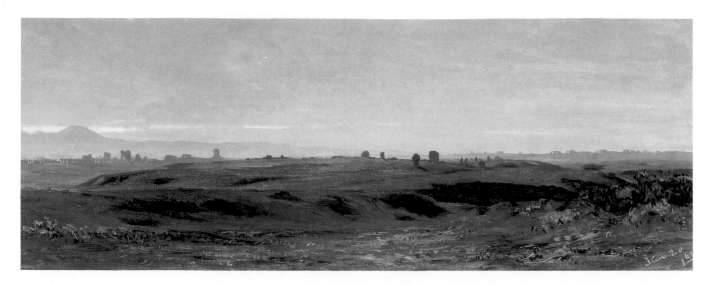

2 Thomas H. Hotchkiss, *Landscape Sketch (Roman Campagna)*, 1866. Oil on wove paper, 5¹⁵⁄₁₆ × 15¹¹⁄₁₆ in. The New-York Historical Society; Gift of the Estate of Nora Durand Woodman through Hannah Woodman, 1942.479

these hulking forms for the artist seems primarily formal. Freed from the onus of representing specific place and time, Hotchkiss explores larger issues of space, light, and composition. The results must have seemed peculiarly stark and unfinished to nineteenth-century viewers.

NOTES

1. George Stillman Hillard, *Six Months in Italy* (Boston: Ticknor and Fields, 1853), 308.
2. Bayard Taylor in *Views Afoot* described the landscape of the Campagna in 1845 as "one of the most wretched than can be imagined. Miles and miles of uncultivated land with scarcely a single habitation extend on either side of the road, and the few shepherds who watch their flocks in the marshy hollows look wild and savage enough for any kind of crime." Taylor quoted in William L. Vance, *America's Rome* (2 vols. New Haven and London: Yale University Press, 1989), 1: 71.

3 Thomas H. Hotchkiss, *Study, Italian Landscape*. Oil on wove paper, 3¼ × 9 in. The New-York Historical Society; Gift of Nora Durand Woodman, 1932.212

4 Thomas H. Hotchkiss, *Ruins on the Roman Campagna*, ca. 1861. Watercolor and gouache over traces of graphite on off-white wove paper, 5⁵⁄₁₆ × 7⅞ in. The New-York Historical Society, x.443(J)

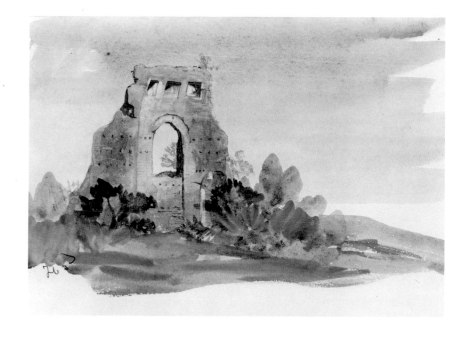

5 Thomas H. Hotchkiss, *Ruins on the Roman Campagna*, ca. 1861. Watercolor, gouache, and graphite on off-white wove paper, 4⅞ × 7¼ in. The New-York Historical Society, x.443(w)

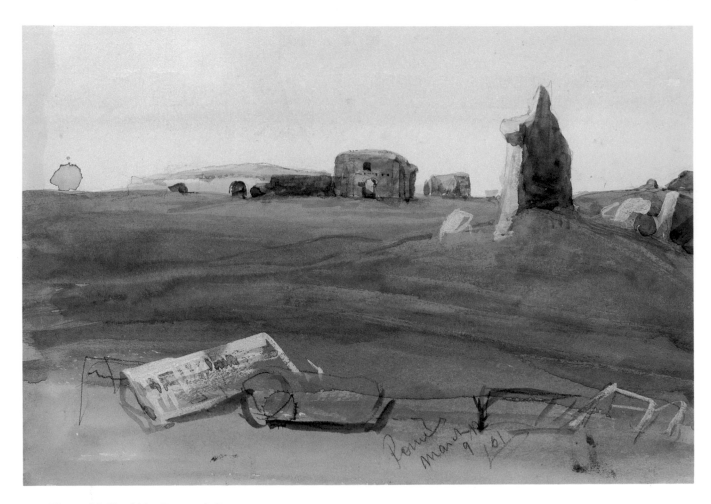

6 Thomas H. Hotchkiss, *Ruins on the Roman Campagna*, 1861. Watercolor and gouache with traces of graphite on off-white wove paper, 5³/₈ × 7⅞ in. The New-York Historical Society, x.443(t)

3. William Wetmore Story, *Roba di Roma* (2 vols. London: W. Clowes & Sons, 1863), 1: 3–4.

4. James Jackson Jarves, "Art-Museums, Amateurs, and Artists in America," *The Art-Journal*, London (May 1, 1870): 130.

5. Elihu Vedder, *The Digressions of V* (Boston and New York: Houghton Mifflin Co., 1910), 418.

6. Hillard, 314.

7. When acquired by The New-York Historical Society in 1932, these sheets were part of a group of thirty-three loose sketches that were inserted in a modern album stamped "Photographs" on the cover. An inscription (not in the artist's hand) on the flyleaf reads: "Sketches made by / Thomas H. Hotchkiss / Rome, Italy." Several sheets bear dates of 1861 or 1862. Most are undated. See Richard J. Koke et. al., *American Landscape and Genre Paintings at The New-York Historical Society* (3 vols. New York and Boston: New-York Historical Society in association with G. K. Hall and Co., 1982) 2: 179.

8. Hillard, 311.

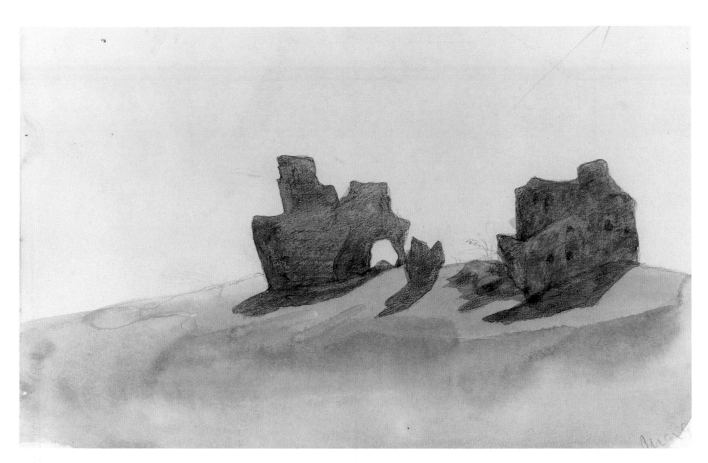

7 Thomas H. Hotchkiss, *Ruins*, ca. 1861. Watercolor and gouache with traces of graphite on off-white wove paper, 5 × 7¾ in. The New-York Historical Society, X.443(DD)

IX

Roman Aqueduct

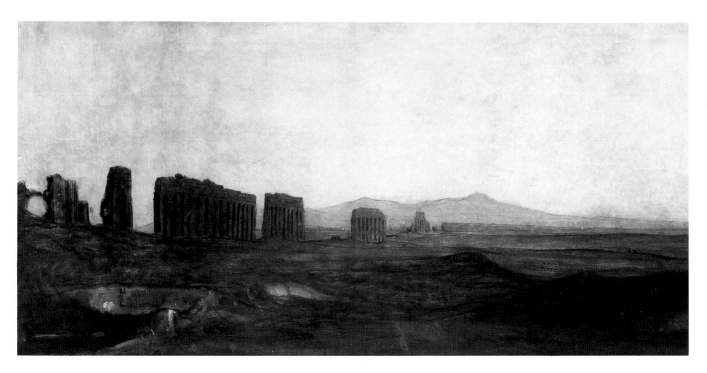

1 Thomas H. Hotchkiss, *Roman Aqueduct*. Oil on canvas, 16 x 31¾ in. The New-York Historical Society; Gift of Nora Durand Woodman, 1932.38

One of the most popular subjects for nineteenth-century landscape painters working in Rome was the Claudian Aqueduct, an ancient channel that carried water from the mountains of Albano over thirty miles to the center of Rome. Construction of the aqueduct was begun by the Roman emperor Caligula and completed in A.D. 52 by his successor, Claudius. Using gravitational flow from small falls in the conduit to keep the water moving, the Claudian Aqueduct was one of eleven principal systems that supplied the metropolis, guaranteeing Roman citizens a steady supply of fresh water. Although in ruin for many centuries, over ten miles of arches still stretched across the Roman Campagna in the nineteenth century, marking the rolling countryside with geometric regularity. A contemporary writer described the appeal of this long line of broken and decaying arches: "Just in proportion as these aqueducts have lost in usefulness they have gained in beauty. The hand of time and the mace of violence—which have broken their formal lines and shattered the smooth ring of their arches—which have made nooks and hollows for grass and wild flowers and running vines to take root in—have substituted variety for uniformity, and added that peculiar charm of the picturesque, which

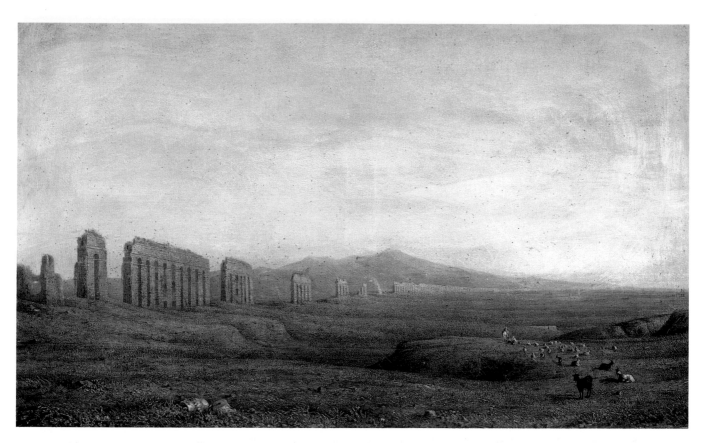

2 John Rollin Tilton, *Roman Campagna*,
1862. Oil on canvas, 22½ x 36¼ in. Cour-
tesy of the Museum of Fine Arts,
Boston. Bequest of Miss Catharine A.
Barstow, 10.18

3 Thomas H. Hotchkiss, *Roman Aqueduct*.
Pen and black ink and graphite on off-
white wove paper, 17¾ x 8 in. The New-
York Historical Society, 14909

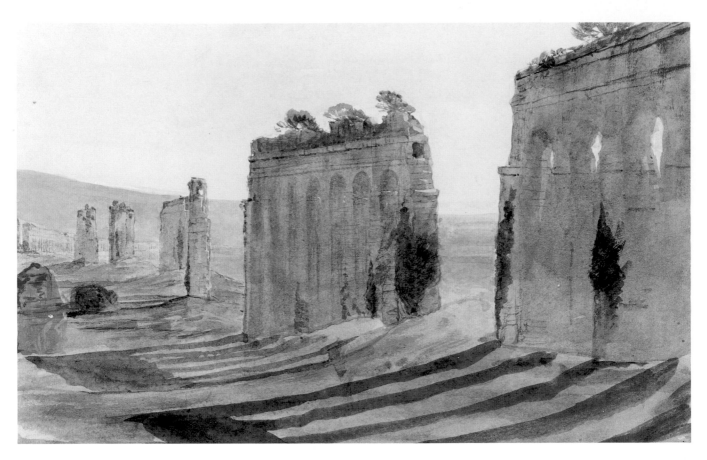

4 Thomas H. Hotchkiss, *Roman Aqueduct with Shadows*. Watercolor and gouache with traces of graphite on off-white wove paper, 4¹⁵⁄₁₆ x 7¾ in. The New-York Historical Society, x.443(c)

makes an old mill or a ruined bridge more attractive to painters than the perfect structure."[1] For painters in search of the picturesque, the Claudian Aqueduct provided a perfect combination of irregular form, undulating line, and historic association.

Hotchkiss was one of several nineteenth-century American artists to paint this landscape, including Thomas Cole, George Loring Brown, Jasper Cropsey, Sanford R. Gifford, John R. Tilton, and George Inness. Although Cole painted several versions of the aqueduct, his earliest canvas, *Aqueduct Near Rome*, 1832 (Washington University Gallery of Art), was perhaps the most widely known.[2] This composition was the first of many American landscapes to use a similar perspective: the chain of arches is seen in diminishing perspective from left to right, their silhouettes framed by the low ridges of the Apennine Mountains in the distance. Hotchkiss's unfinished painting *Roman Aqueduct* (Fig. 1) shares with Cole's composition a sensitivity to the placement of form within the landscape, but is much less detailed, with a more expansive sense of space and sky. Cole's fully worked canvas utilizes contrasts of light, color, and texture to develop spacial recession and define form, while Hotchkiss's composition is tonal, spatially ambiguous, and monochromatic. The luminous sky and rosy palette only hint at the artist's final intentions. Hotchkiss's perspective is nearly identical to that in John Rollin Tilton's *Roman Campagna*, 1862 (Fig. 2). Perhaps the two artists sketched together in the Campagna. Despite the apparent simplicity of his composition, Hotchkiss made an elaborate preparatory drawing for his painting (Fig. 3). Sketched in graphite on thin paper, the architectural details of the aqueduct were drawn with painstak-

5 Thomas H. Hotchkiss, *Roman Aqueduct*. Watercolor and gouache with some graphite on off-white wove paper, 5¼ x 7⅞ in. The New-York Historical Society, X.443(D)

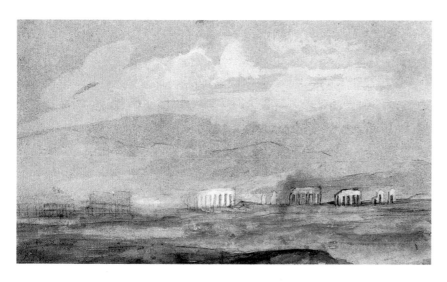

6 Thomas H. Hotchkiss, *Roman Aqueduct*. Watercolor, gouache, and black chalk on blue laid paper, 5⅝ x 7⅝ in. The New-York Historical Society, X.443(R)

ing accuracy. The verso was then rubbed with charcoal, the outlines incised with a blunt point, and the sheet squared for transfer. It is the only surviving example of Hotchkiss's use of a preparatory drawing, a practice he probably employed for other canvases as well.

In addition to his large canvas, Hotchkiss painted at least six other views of the site. Of these, five are watercolors, which exhibit an impressive range of technique. Several sheets seem precociously modern. Their reductive compositions and brilliant color may have been influenced by Turner's watercolors, which Hotchkiss greatly admired. One of the most beautiful, *Roman Aqueduct with Shadows*, is a close-up view of the large stone arches, with the early morning sun casting long blue-green shadows across the foreground (Fig. 4; see also p. 13). The image is full of color and movement as the eye is swept along the broad bands of light and dark toward the cool lavender mountains beyond. Another view, *Roman Aqueduct* (Fig. 5; see also p. 16), places the structure further into the distance, a tiny silhouette against the mountains with large ruins atop a hill in the left middle ground. The foreground is empty, a concave bowl of space and air that invites the viewer to enter the solitary plain.

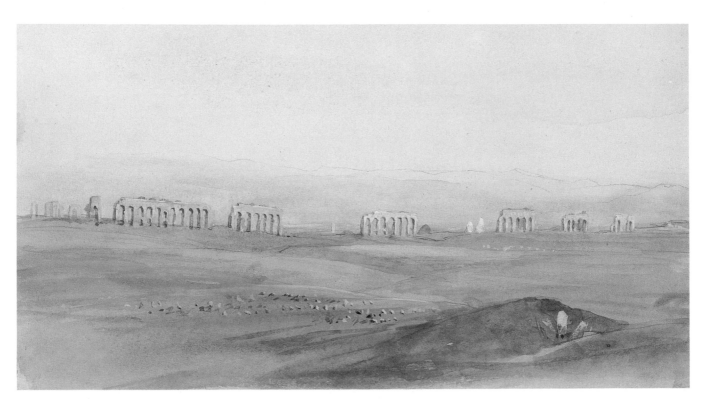

7 Thomas H. Hotchkiss, *Roman Aqueduct.* Watercolor and gouache with traces of graphite on off-white wove paper, 5 x 7⅞ in. The New-York Historical Society, X.443(B)

Three other watercolors are progressively more coloristic, less concerned with the monument as a recognizable image. They are among Hotchkiss's most experimental, freely handled plein-air studies, images that capture the fleeting sensations of light and color (Figs. 6–8). The last sheet, *Roman Aqueduct in Distance*, uses almost transparent washes of color in superimposed layers upon the page. Hotchkiss continued this approach in a small oil study on paper, quickly brushing in the landscape with horizontal strokes without concern for precise topographic definition. The aqueduct is barely visible on the horizon as a row of connected arches against the radiant sky (Fig. 9).

Hotchkiss's visual retreat from the famous monument suggests he felt some ambivalence toward this ruin. As William L. Vance has observed, the "marvelous engineering feat of the Roman civilization that carried the sustaining water of life into the great city" seems to transcend time and space as it enters the artists' compositions on one side and stretches across the landscape to the other. The reality, however, "lies in the ravages at the center of the scene and in the utter desolation that spreads around them."[3] The Claudian Aqueduct, like the other ancient ruins dotting the Roman Campagna, is a reminder of the impermanence of life, a wasted remnant of a former civilization.

NOTES

1. George Stillman Hillard, *Six Months in Italy* (Boston: Ticknor and Fields, 1853), 312.
2. Although Hotchkiss may not have seen Cole's original painting *Aqueduct Near Rome*, 1832 (then in a private collection), the image was reproduced in an engraving by James Smillie and published by Henry T.

8 Thomas H. Hotchkiss, *Roman Aqueduct in Distance*, 1861. Watercolor, gouache, and graphite on off-white wove paper, 5 x 7⅞ in. The New-York Historical Society, X.443(E)

9 Thomas H. Hotchkiss, *Roman Aqueduct*. Oil on wove paper, 6⅜ x 8⅜ in. The New-York Historical Society; Gift of Nora Durand Woodman, 1932.198

Tuckerman as a frontispiece to his *Italian Sketch Book* in 1835. The engraving was also published in *The Token* in 1837. William L. Vance, *America's Rome* (2 vols. New Haven and London: Yale University Press, 1989), 1: 68, and Ila Weiss, *Poetic Landscape: The Art and Experience of Sanford R. Gifford* (Newark, Del.: University of Delaware Press, 1987), 203.

3. Vance, 70.

Baths of Caracalla

Septimius Severus began construction of a vast suite of public baths in Rome during his reign as Roman emperor from A.D. 193 to 211. Upon his death, his son Marcus Aurelius Antoninus (known as Caracalla) ascended the throne and supervised the completion and decoration of the sumptuous baths. Other than this single act of civic generosity, Caracalla is remembered principally for his military conquests, territorial expansion, his ruthless and tyrannical rule—and for having murdered his younger brother and several ministers to safeguard his climb to power. In 217 he was assassinated by his troops.

The Baths of Caracalla covered several square acres southeast of the Forum. It far surpassed in scale and ornamentation the earlier public baths of Titus and Trajan. By using a series of arches and vaults, Roman architects were able to create immense interior spaces suitable for these large public facilities. An essentially Roman invention, the baths provided much more than comfortable and luxurious bathing. They also served as a community center for club activities, sports, art exhibitions, and lectures. The baths were the center of social life in Rome, their doors open to every free Roman citizen. Although the expense required to maintain the baths and large staff was enormous, their operation was subsidized by the government, so that "the entrance fee amounted to a fraction of a penny, and even this was waived by emperors eager to make a good impression."[1] The Baths could accommodate as many as 1600 bathers a day and were in continual use until the sixth century, when the aqueducts that supplied them were destroyed.

Hotchkiss was one of many eighteenth and nineteenth-century artists attracted to the Baths of Caracalla. Its massive ruins have a dark, solemn quality that appealed to a romantic sensibility. In this watercolor, however, Hotchkiss chose a more modest image, the triangular patterning of one of the colorful tile floors.[2] Marking the design first in graphite, the artist then added watercolor, mimicking the shape of the tiles in his own triangular composition. The cipher "Hcok" in the lower right corner appears on several other Hotchkiss drawings and is probably in the artist's hand.

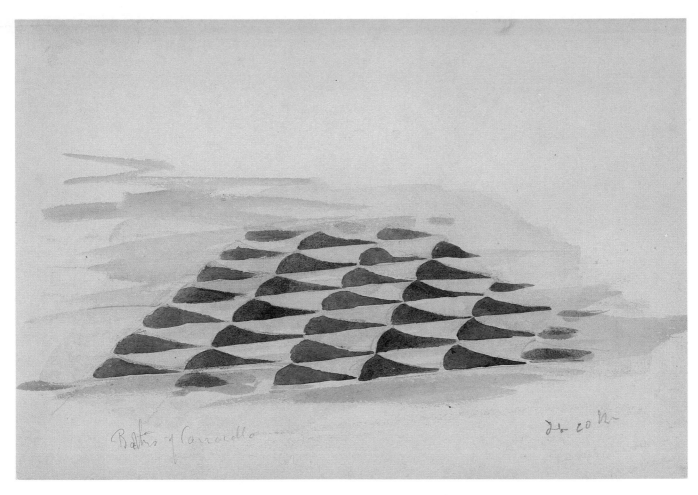

NOTES

1. Michael Grant, *The World of Rome* (New York and Toronto: New American Library), 304–5.

2. This section of tile floor may be the recently excavated mosaic pavement at the Baths of Caracalla described in *A Handbook of Rome and Its Environs* (London: John Murray, 1869), 61, as "of a fish-scale form, very beautiful . . . and formed of pieces of red and green porphyry and white marble."

1 Thomas H. Hotchkiss, *Floor Tiles from the Baths of Caracalla*, ca. 1861. Watercolor and gray wash over traces of graphite on off-white wove paper, 5⅜ × 7¾ in. The New-York Historical Society, x.443(F)

Torre dei Schiavi

About two and a half miles outside the ancient gates of Rome are the remains of an extensive villa built by the Gordian emperors, who reigned from A.D. 238 to 244. The villa contained a variety of structures, including a large reservoir, hot and cold baths, a mausoleum, and a marble colonnaded edifice with three basilicas. Contemporary Roman writers described the country residence as elaborate in scale and sumptuous in rare and imported materials.[1] After the fall of the imperial family, the complex fell into disrepair, its ruins stretching for more than a mile. In the Middle Ages, the mausoleum was used as a church, while another portion of the villa served as a military watchtower. The entire area eventually became known as the Torre dei Schiavi, although in the nineteenth century, this designation generally referred to the mausoleum only, the most impressive of the Gordian ruins and the one in the best condition. The interior of the circular, domed mausoleum was lit by four round win-

1 Thomas H. Hotchkiss, *Torre dei Schiavi,* 1864. Oil on canvas, 17 × 27 in. Private collection

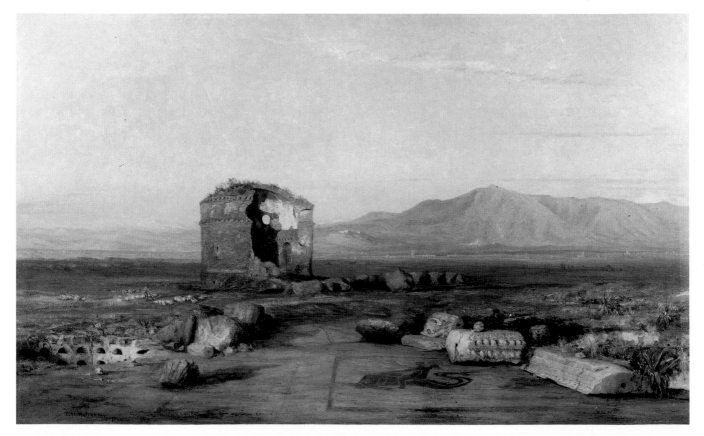

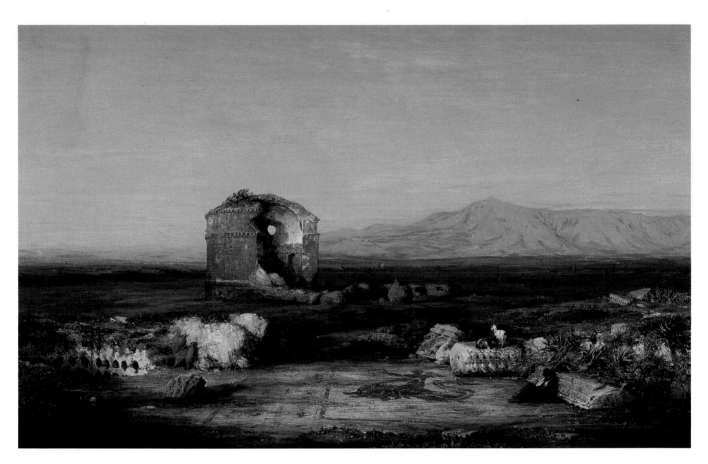

2 Thomas H. Hotchkiss, *Torre di Schiavi*, 1865. Oil on canvas, 22⅜ × 34¾ in. National Museum of American Art, Smithsonian Institution

dows high on the outer walls, of which two are still intact. Beneath the main floor was a crypt supported by a central pillar. Both floors were decorated with semicircular and square niches containing freestanding sculpture. On the exterior, the building originally had a portico and pediment, now in ruins.[2] Although much smaller in scale, the architecture and skillful engineering of the mausoleum has been compared to the Pantheon in Rome.

With the publication of Giovanni Battista Piranesi's engravings of Rome and its surroundings in the mid-eighteenth century, the Torre dei Schiavi became a popular subject for *vedute* painters. Tourists began to clamor for images of the Torre as souvenirs of their trip to Italy. In the early nineteenth century, there was also renewed archaeological interest in the Gordian villa. Excavations of the site were conducted continuously from the 1830s to the 1870s.[3] Hotchkiss was one of several nineteenth-century American artists to frequent the area.[4] On one lucky occasion, he

3 Thomas H. Hotchkiss, *Eight Amphora*. Gray wash and black chalk with traces of white gouache on pale blue laid paper, 3⅜ × 7¼ in. The New-York Historical Society, X.443(H)

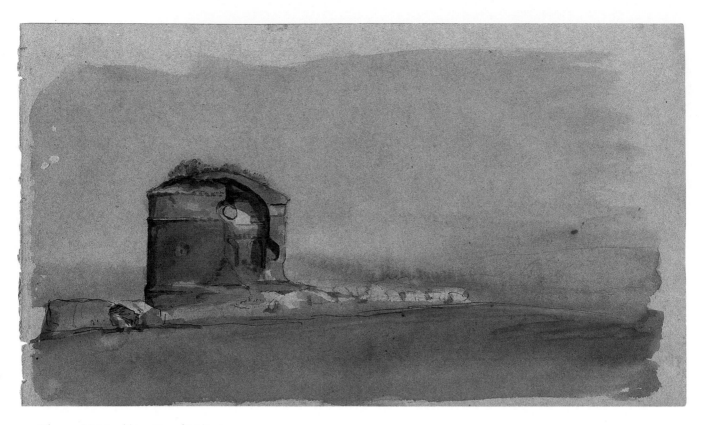

4 Thomas H. Hotchkiss, *Torre dei Schiavi*. Watercolor and pen and black ink on tan wove paper, 5½ × 9½ in. The New-York Historical Society, x.443(M)

discovered an ancient glass vase among the ruins and was able to sell it for a handsome sum.[5]

Two of Hotchkiss's largest canvases, very similar in composition, document his interest in the Torre dei Schiavi (Figs. 1, 2; see also p. 11).[6] Both paintings isolate the mausoleum within a panoramic space extending across the Campagna to the Sabine Hills on the horizon. Architectural debris and wildflowers are scattered around the scene, which appears preternaturally calm, as if the last fifteen hundred years had passed in a single moment. The mausoleum itself is devastated by the fractured dome and portico. Through this gaping hole, a single oculus acts as a conduit to the landscape beyond. In the foreground is an ancient mosaic pavement showing a boy riding a dolphin, while at lower left are recently excavated chambers of a columbarium, with three cinerary urns leaning nearby.[7] In a separate study, Hotchkiss explored the distinctive profiles of these urns in a delicate wash drawing, tracing their graceful curves in a series of overlapping forms (Fig. 3). Hotchkiss's canvases also include at left a human skull and bones, potent reminders of human mortality amid discarded pieces of a glorious past: fragments of columns, entablatures, and ornately carved friezes.

In addition to these paintings, Hotchkiss made several watercolor studies of the site, including one unconventional view of the back of the mausoleum (Figs. 4, 5). He was also intrigued by another ruin, a tall triangular fragment, not far from the Torre (Figs. 6, 7). In all four sheets, Hotchkiss was less interested in recording archaeological detail than in evoking a sense of mood and place.[8] The irregular forms of the ruins provided focal points for his composition, allowing him to experiment with broad washes of rich color, subtle modulations of tone, and two-dimen-

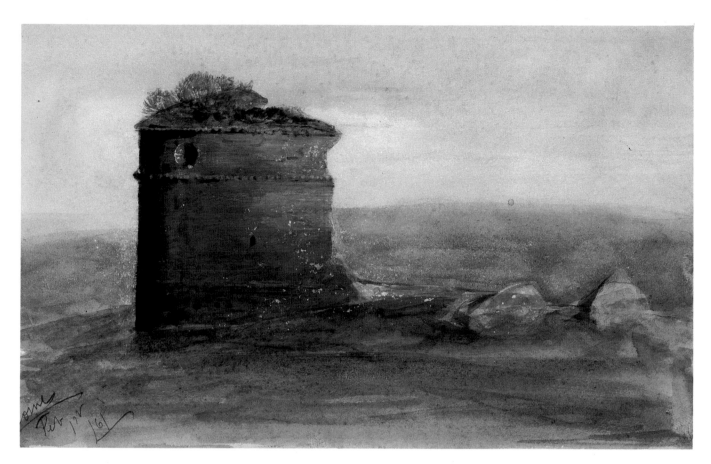

5 Thomas H. Hotchkiss, *Torre dei Schiavi*, 1861. Oil over watercolor and gouache with traces of graphite on off-white wove paper, 5⅛ × 7⅝ in. The New-York Historical Society, x.443(s)

sional design. On adjacent pages of a sketchbook, Hotchkiss combined the two ruins in a panoramic sweep of the Roman countryside (Fig. 8).

By the mid-nineteenth century, the Torre dei Schiavi had become closely associated with the annual *Walpurgisnacht* (May Day) festivities, organized each spring by the German artists in Rome. The celebrations began at the Torre dei Schiavi, where artists of all nationalities gathered for breakfast. Dressed in fantastic costumes, the artists and their followers then proceeded across the Campagna in wildly decorated wagons and carts to the grotto of Cervara or, later, to the groves of Egeria. The gaiety continued into the evening with comic theater, recitals, games, and an elaborate feast.[9] For the artistic community in Rome, the May Day festival was one of the social highlights of the year. It attracted a great amount of public attention and curiosity and fortified the artists' professional and personal camaraderie. As a result, the Torre became a symbol of artistic enterprise, creativity, and self-expression.

The Torre dei Schiavi may have had additional meaning for nineteenth-century American artists, as is suggested by its sudden popularity at mid-century (Fig. 9). One possibility is that the Torre dei Schiavi, whose common English translation is "Slaves' Tower," began to be viewed within the emotionally charged atmosphere of contemporary American politics.[10] While the country struggled with the worsening civil crisis, many American expatriate artists joined their voices with the rising support for abolition. Although there is no historical evidence to support the association of the Gordian ruin with slaves (the designation "Torre dei Schiavi" has unknown origins), popular opinion prevailed. Travel writers

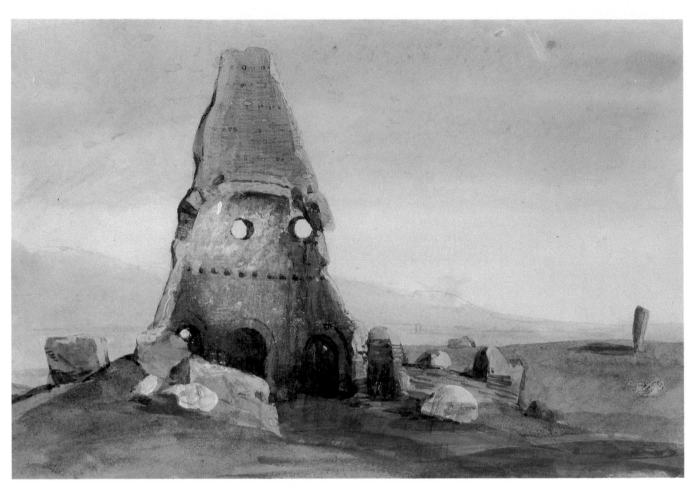

6 Thomas H. Hotchkiss, *Ruin on the Campagna*. Watercolor, gouache, and graphite on off-white wove paper, 5¼ × 7¾ in. The New-York Historical Society, X.443(K)

continued to suggest that the monument was somehow linked with the ancient Roman practice and with the slave insurrections of the late Empire. Augmenting this interpretation was the proximity of the mysterious columbarium to the Torre, purportedly bearing inscriptions left by "liberti." Thus Hotchkiss's lonely goatherd, who sits on the right in Figure 2, acts as a surrogate for the viewer, contemplating the historical ignominy of slavery as well as the past glories of the Roman civilization.

NOTES

1. Charles C. Eldredge, "Torre dei Schiavi: Monument and Metaphor," *Smithsonian Studies in American Art* (Fall 1987): 19.
2. *A Handbook of Rome and Its Environs* (London: John Murray, 1869), 417.
3. Eldredge, 21.
4. Other American landscape artists who painted the Torre dei Schiavi include John G. Chapman, Thomas Cole, Jasper Cropsey, John F. Kensett, Sanford R. Gifford, Christopher Cranch, George Yewell, John Rollin Tilton, William S. Haseltine, and Elihu Vedder.
5. On the verso of Vedder's painting *Ruins, Torre dei Schiavi* (Munson-Williams-Proctor Institute Museum of Art) is his inscription: "A good subject / Hotchkiss used to go out there frequently / 'twas here he found a niche in this Columbarium which had not been / discovered a beautiful glass vase and sold it for a good sum / of money

7 Thomas H. Hotchkiss, *Ruin on the Campagna*. Watercolor on blue wove paper, 4⅜ × 6⅝ in. The New-York Historical Society; Gift of Nora Durand Woodman, 1932.194

which came in well in those days . . . Hotchkiss / made some good things at this Torre dei Schiavi / Vedder." Gwendolyn Owens and John Peters-Campbell, *Golden Day, Silver Night: Perceptions of Nature in American Art, 1850–1910*, exh. cat. (Ithaca, N.Y.: Herbert F. Johnson Museum of Art, 1983), 102. Armstrong recalled a similar incident when Hotchkiss discovered some large Etruscan vases in a tomb on the Campagna. These vases were in Hotchkiss's studio at the time of his death. [David] Maitland Armstrong, *Day Before Yesterday: Reminiscences of a Varied Life* (New York: Charles Scribner's Sons, 1920), 191–2.

6. Hotchkiss exhibited a view of the Torre dei Schiavi at the National Academy of Design in 1865. The owner of the painting was listed as A. A. Low. A reviewer of the exhibition in *The Nation*, July 13, 1865, wrote: "Torre de Schiava [*sic*] seems to be good, but is perched up above a large picture, and half hidden by the frame thereof, and is altogether too high to be judged aright, even with the useful opera-glass." The artist must have been disappointed with such half-hearted notice. Henry T. Tuckerman briefly mentioned Hotchkiss's "fine view of Torre di Schiare [*sic*], with the Sabine hills in the distance," in his *Book of the Artists* (Reprint. New York: James F. Carr, 1967), 569.

7. Several years later, Armstrong reported that while he was sketching at the Torre dei Schiavi, a group of treasure hunters excavated "part of a fine Roman pavement, in perfect condition, decorated with white peacocks on a black ground." Having no use for the mosaic, they refilled the pit and went away. Armstrong, 216.

8. That Hotchkiss was interested in the history of the site is evident in a letter dated June 1864. The letter, attached to the verso of *Torre dei Schiavi*, 1864 (private collection), was probably intended for the original owner of the painting. Hotchkiss identified the Torre as a Roman temple on the ancient Via Sabina. He also identified all the topographic and man-made features in the landscape, closing his description with the note that "the picture is painted from studies made in the winter of 1861 during some excavations but the place in the foreground is now quite changed."

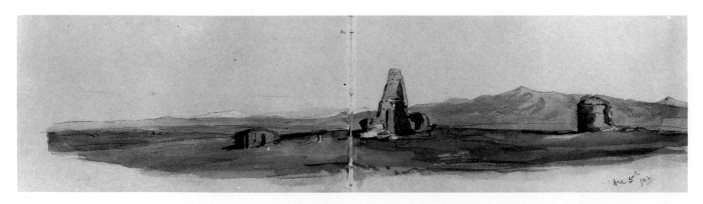

8 Thomas H. Hotchkiss, *Torre dei Schiavi and Ruins*, 1862. Watercolor and pen and brown ink with traces of graphite and black chalk on buff-brown wove paper, 5½ × 19 in. The New-York Historical Society, X.443(BB)

9. For contemporary descriptions of the "Artists' Festival," see Florentia, "The Artists' Festa: Rome," *The Art-Journal* 6 (September 1854): 271–3, William Wetmore Story, *Roba di Roma* (2 vols. London: W. Clowes and Sons, 1863), 1: 190–6, and Francis Wey, *Rome* (New York: D. Appleton & Co., 1875), 269. See also Walter Crane, *An Artist's Reminiscences* (New York: Macmillan, 1907), 137 and [David] Maitland Armstrong, op. cit., 167–8.

10. This interpretation was suggested by Charles C. Eldredge in "Torre dei Schiavi: Monument and Metaphor," 29–32.

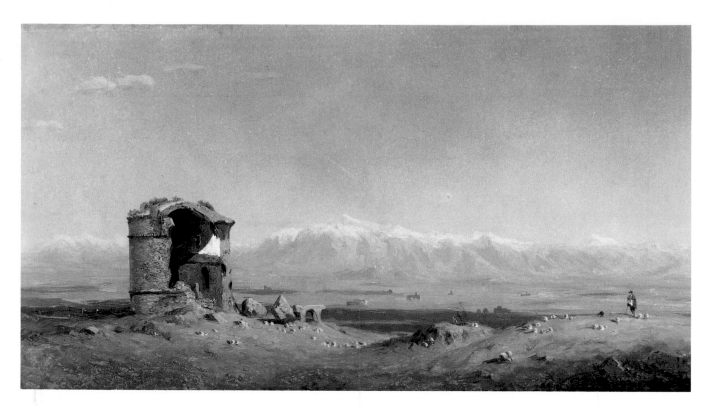

9　Sanford R. Gifford, *Torre di Schiavi, Campagna di Roma*, ca. 1864. Oil on canvas, 8½ × 15¾ in. Henry Melville Fuller

XII

Nature Studies

1 Thomas H. Hotchkiss, *Plant Study*. Oil
on paper, 9⅜ × 12⅞ in. Graham Williford

Throughout his career, Hotchkiss continued to produce carefully observed nature studies, a habit he maintained from his early association with artists of the Hudson River School. These outdoor sketches formed the foundation of his art; by drawing on his knowledge of individual form, Hotchkiss was free to manipulate detail in his larger compositions. In an undated work of exceptional beauty, Hotchkiss studied the effects of brilliant sunlight upon the rapier-sharp blades of a century plant (Fig. 1). He captured the characteristic low-growing habit and sandy locale of this plant, native to hot, dry climates. He focused on the central example while

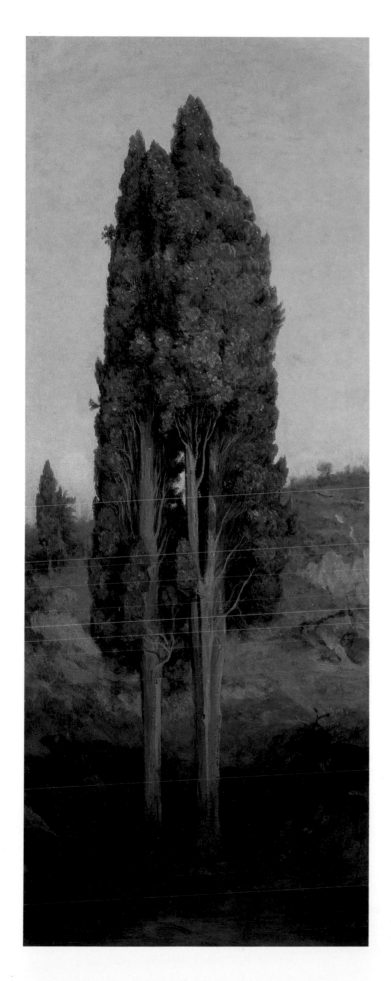

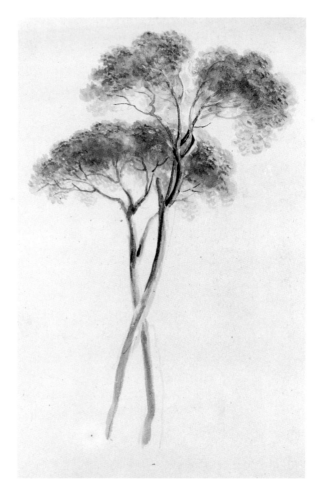

3 Thomas H. Hotchkiss, *Italian Pines*. Gouache and watercolor over traces of graphite and black chalk on green wove paper, 8½ × 6½ in. The New-York Historical Society, x.443(N)

2 Thomas H. Hotchkiss, *Italian Cypresses*. Oil on composition board, 21¹⁵⁄₁₆ × 8½ in. The New-York Historical Society; Gift of Nora Durand Woodman, 1932.42

4 Thomas H. Hotchkiss, *Italian Pines and Cypresses*. Oil on wove paper, 4⁷⁄₁₆ × 8⁵⁄₁₆ in. The New-York Historical Society; Gift of Nora Durand Woodman, 1932.211

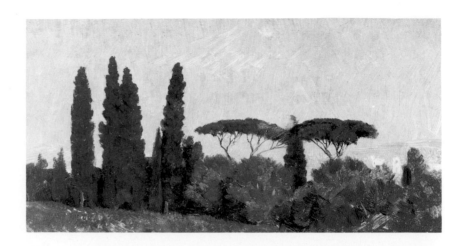

5 Thomas H. Hotchkiss, *Study, Italian Landscape (Cypresses)*, 1862. Oil on wove paper, 3⁵⁄₁₆ × 9¼ in. The New-York Historical Society; Gift of Nora Durand Woodman, 1932.200

smaller plants dot the background. The work is painted with careful attention to variations of texture, color, and light. So convincing is his delineation of the hard, flat leaves that one can practically feel their waxy surface under the glaring light of the noonday sun.

Hotchkiss pursued his Italian tree studies with the same enthusiasm he applied to his youthful effort, *Tree Study, Catskill Clove* (see p. 35). Compared to the Ruskinian realism of his Catskill work, however, *Italian Cypresses* and *Italian Pines* (Figs. 2, 3) are less detailed, with a more summary execution of the branches and foliage. Hotchkiss seems to have been particularly interested in the arresting profile of the cypress tree, whose columnar form he included in several important landscapes. In *Italian Cypresses*, Hotchkiss studied the striated trunk, dense green foliage, and short, thin branches that characterize this towering tree. In each of these examples, Hotchkiss placed the subject in the center of his composition and isolated it from its immediate surroundings. As with his earlier Catskill painting, Hotchkiss used a vertical format that may have been influenced by Asher B. Durand, who preferred this orientation for his own tree studies.

Given their small size and quickly brushed surfaces, two small oil studies of cypresses were probably painted plein-air. Arranged in a straight line along the horizon, Hotchkiss placed their distinctive silhouettes against an unclouded evening sky (Figs. 4, 5). Although modest in scale

and execution, the planar organization of the composition and the interlocking vertical and horizontal forms found in *Italian Pines and Cypresses* gives this image the visual impact of a much larger painting. Hotchkiss continued to use cypress and pine trees as focal points for his landscapes in two black chalk drawings, *Cypress Trees with Figures* and *Figures in a Garden* (Figs. 6, 7). Both sheets have been cut from a larger support and use graphic techniques that are unusual within Hotchkiss's oeuvre. In *Cypress Trees with Figures*, the artist used white chalk not to highlight form, but to relieve the dark, scumbled forms of the landscape against the blue paper. *Figures in a Garden* is rather stiffly worked, as if Hotchkiss were uncomfortable with the inflexible touch of his media. The pastoral setting of both sheets suggests they may have been executed on the grounds of a park or private villa such as the Villa Barberini in Albano, or the Pincio, Villa Borghese, and Palace of the Caesars in Rome.[1]

NOTES

1. Located on a high hill and covered with ruins, cypress trees, flowers, and trailing vines, the Palace of the Caesars was a favorite sketching spot for landscapists working in Rome. Hotchkiss visited the site with Carrie Rosekrans, Elihu Vedder's future wife. In a letter from Carrie to Vedder on August 2, 1867, she mentions this visit with Hotchkiss: "I am shocked at what you say of Hotchkiss. I had no idea his health was shattered and to find him so nearly gone is very sad. He impressed me so pleasantly one day we spent together at the Palace of the Cesars [*sic*] and the feeling has been increased by all I have heard of him since I left. It must be very hard to feel that the [disease?] has your [illegible] when the earth still seems full of delight and there is so much work left that one's soul longs to do. I wish I were with you although I don't know what I could do but it seems so sad to me to think of Hotchkiss in his condition traveling around in the wretched [health?] you speak of, and though your kindness and gentleness are equal to a woman's, and perhaps mean everything to him, still I would share your labor with you." In August 1867, Vedder and Hotchkiss were busy sketching the landscape around Perugia. Elihu Vedder Papers, Archives of American Art, Smithsonian Institution, Roll 516, Frame 144.

6 Thomas H. Hotchkiss, *Cypress Trees with Figures*. Black and white chalk over graphite on blue wove paper, 6⅝ × 4¾ in. The New-York Historical Society, x.443(v)

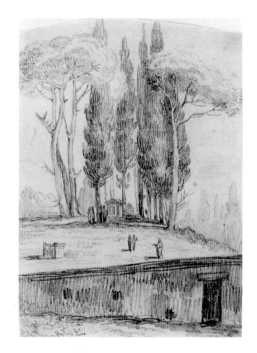

7 Thomas H. Hotchkiss, *Figures in a Garden*. Black chalk on pale gray laid paper, 7½ × 5¼ in. The New-York Historical Society, x.443(p)

XIII

Paestum

In the sixth century B.C., Greek colonists established the city of Poseidonia in southern Italy as an active trading and communication center. Located about fifty miles south of present-day Naples, it had close contacts throughout the Mediterranean. In 273 B.C., the Romans assumed control of the city, changing its name to Paestum. The city declined in population after the first century B.C., and was finally abandoned, its residents moving nearby to Capaccio Vecchio. The Salso River, which ran just outside the city walls, silted up and flooded, turning much of the adjacent area into marshland. The city fell into almost complete obscurity. With the discovery and opening of excavations at Pompeii and Herculaneum in 1738–48, there was a renewal of interest in archaeology and in the magnificent ruins at Paestum, now considered one of the finest complexes of Greek temples to survive from the ancient world. Public appreciation of this site was fueled by several late eighteenth-century publications, including a series of engravings by Thomas Major in 1768 and Giovanni Battista Piranesi in 1778. In the United States, the publication of Henry Pickering's epic poem *The Ruins of Paestum* in 1822 did much to arouse interest in the ancient city.

For the first fifty years after their rediscovery, the ruins of Paestum were shrouded in mystery. The severe Greek Doric style of architecture was unfamiliar to historians, who could not date the ruins, identify the builders, or decipher the function of the temples. The romance of the site was fed by an absence of guidebooks, an exaggeration of its difficulty of access, and fear of malaria. Nevertheless, Paestum soon became the final stop for American and European tourists traveling on the Grand Tour. By 1854, one traveler recalled being disgusted by the popularity and commercial exploitation of the site.[1]

Access to Paestum from Naples became increasingly easy in the mid-nineteenth century, and could be accomplished in an overnight trip by railroad and carriage.[2] Hotchkiss may have stopped by Paestum while on his way to Taormina, as the road to Sicily passed only a few miles north of the city.[3] He was not the first American artist to visit the ancient temples.[4] In 1848, Christopher P. Cranch (1813–1892) traveled there on a sketching trip with Jasper Cropsey (1823–1900) and William Wetmore Story (1819–1895). Cranch's first impressions of the site were wildly enthusiastic: "Never have I seen anything more perfect, such exquisite proportions, such warm, rich coloring, such picturesquely broken columns; flowers and briers growing in and around, and sometimes over fallen capitals. . . And over all brood-

1 Thomas H. Hotchkiss, *Temple of Neptune, Paestum*, 1864–67. Oil on paper mounted on panel, 9 × 16¼ in. The New-York Historical Society; Gift of Nora Durand Woodman, 1932.36

ed such silence and solitude. Nothing stood between us and the Past, to mar the impression. Mysterious, beautiful temples! Far in the desert, by the sea-sands, in a country cursed by malaria, the only unblighted and perfect things, standing there for over two thousand years. It was almost like going to Greece."[5]

Hotchkiss seems to have made his initial sketch of Paestum in May 1864, and reworked the image in Rome three years later (Fig. 1).[6] The large temple in the center of the composition is the best-preserved of the three Doric temples at Paestum. Built around 475 B.C., this building was known as the Temple of Neptune (or Poseidon), although it is now thought to honor the Greek goddess Hera.[7] The pronounced *entasis* (or cigarlike swelling) and fluting of its columns is clearly evident. The smaller temple to the left was built about one hundred years earlier and was also dedicated to Hera. Both temples were built of travertine, a local stone whose pitted surfaces were coated with a smooth layer of stucco to imitate marble. Evidence of gray paint across the image of the older temple suggests the artist planned to eliminate this building from his composition, focusing our attention on the monumental structure of the Temple of Neptune.

Hotchkiss's painting of Paestum is filled with a sense of desolation. Unlike similar compositions of this subject by Thomas Cole, Jasper Cropsey, Albert Bierstadt, and John R. Tilton, Hotchkiss's canvas does not include genre elements in the foreground to mitigate the isolation of the site (Fig. 2). The murky, stagnant pool of water in the foreground hints at the constant threat of malaria (Cranch and his sketching party had been warned it was unsafe to remain in the area after three o'clock),[8] while the low, gray sky casts a melancholy pall over the entire scene. Bits of ruins in the right foreground attest to the demise of this ancient civilization.

1. Giuseppe Massara, "British and American Travellers and the Image of Paestum," in Joselita Raspi Serra, ed., *Paestum and the Doric Revival, 1750–1830: Essential Outlines of an Approach* (Florence: Centro Di, 1986), 156.

2. *A Handbook for Travellers in Southern Italy; being a Guide for the Continental Portion of the Kingdom of the Two Sicilies* (London: John Murray, 1855), 240.

3. Elvira Chiosi, Laura Mascoli, Georges Vallet, "The Discovery of Paestum," in Serra, *Paestum and the Doric Revival, 1750–1830,* 44.

4. John Singleton Copley traveled to Paestum in 1775, Thomas Cole in 1832, Jasper Cropsey, Christopher P. Cranch, and William Wetmore Story in 1848, and Sanford R. Gifford and Albert Bierstadt in 1857.

5. Quoted in Leonora Cranch Scott, *The Life and Letters of Christopher Pearse Cranch* (Boston: Houghton Mifflin Company, 1917), 147.

6. The painting is signed and dated at bottom center: "T. H. Hotchkiss / May 64," while inscriptions in the artist's hand on the verso read: "Temple of Neptune / Pestum / 1864" and "T. H. Hotchkiss— Rome— / 1867." Evidence of paint along the edges of the composition suggest the paper sketch was mounted on canvas before it was reworked in 1867.

7. John Griffiths Pedley, *Paestum: Greeks and Romans in Southern Italy* (London: Thames and Hudson, 1990), 53–4, 88.

8. Scott, 147. Against the advice of his guides, books, and physicians, Thomas Cole traveled to Paestum to sketch in 1832. He spent a difficult night there, battling the mosquitos, in "one of those wretched shelters for the marsh laborers." Louis L. Noble, *The Course of Empire, Voyage of Life, and Other Pictures of Thomas Cole, N.A.* (New York: Cornish, Lamport & Co., 1853), 164.

2 John Rollin Tilton, *The Temple at Paestum*,
 ca. 1872. Oil on canvas, 15⅜ × 23 in. The
 Brooklyn Museum, Bequest of Colonel
 Robert Buddicon Woodward, 15.509

XIV

Façade of a Gothic Palazzo

Hotchkiss's careful representation of the façade of a Gothic palazzo is his only known architectural study (Fig. 1). For years this image was thought to depict an example of Venetian architecture, but a faint inscription in the artist's hand at lower right identifies the site as Taormina, Sicily.[1] The image is painted over an unrelated graphite sketch of a semicircular arch, traces of which are still visible at lower right. Hotchkiss turned the sheet upside down and began anew, laying in a light gray undercoat for the background. Given the genesis of this sheet, the artist's inscription could refer to the original graphite drawing (perhaps of the Greek Theater at Taormina) or the oil study.

Although the artist's other images of Taormina all depict the famous Greek Theater, the town did contain notable examples of Gothic architecture. One nineteenth-century travel guide described several Gothic churches and private palazzos, noting that Taormina "has many quaint old mansions of feudal times, and is full of interesting morsels for the architect, and most tempting scenes for the portfolio."[2] The author mentioned specifically that many houses in Taormina "have simple pointed or elliptical doorways and windows, generally without mouldings, but with lava and marble, black and white alternately, with stringcourses banded and diapered, of the same materials."[3] Although the exact building Hotchkiss represents has not been identified, the architectural features depicted, such as the large double windows, elegant tracery, and black and white chevron diapering, are typical of the indigenous Gothic style in Taormina.[4]

Hotchkiss's meticulous rendering of architectural detail suggests that *Façade of a Gothic Palazzo* may have been painted during his first trip to Taormina in 1864. His choice of subject may have been influenced by his early readings of John Ruskin. The English art critic not only insisted upon an exact transcription of the artist's subject, but was an ardent champion of Gothic architecture, which he believed to be the most perfect expression of morality, art, and nature. Hotchkiss may have read Ruskin's writings about architecture as early as 1855, when *The Crayon* reprinted his essays on "The Poetry of Architecture."[5] Subsequent issues included lengthy excerpts from Ruskin's two books of architectural theory and history, *The Seven Lamps of Architecture* (1849), and *The Stones of Venice* (1851–53), copies of which Hotchkiss may have owned.[6]

1 Thomas H. Hotchkiss, *Façade of a Gothic Palazzo*, ca. 1864. Oil and graphite on wove paper, 8 × 11¹¹/₁₆ in. The New-York Historical Society; Gift of Nora Durand Woodman, 1932.209

NOTES

1. Another inscription, "T. H. Hotchkiss / Venice," appears on the lower right corner of the mat and is not in the artist's hand. Similar inscriptions appear on many of Hotchkiss's paintings and drawings and were probably added after his death.

2. *A Handbook for Travellers in Sicily* (London: John Murray, 1864), 459.

3. Ibid., 460.

4. Compare the 19th-century description of the Palazzo del Duca di Sto. Stefano in Taormina with Hotchkiss's subject: "The lower story has double lights pointed, with lava labels, all undecorated. The upper has large windows sharply pointed, divided into double lights by slender columns; the heads of the lights being trefoiled, and those of the dominant arches filled in with tracery. The parapet is machicolated with triple chevron and trefoil corbellings—all in black lava." Ibid., 460.

5. Roger B. Stein, *John Ruskin and Aesthetic Thought in America, 1840–1900* (Cambridge: Harvard University Press, 1967), 110.

6. In the auction of Hotchkiss's effects in New York in 1871, item 54 was listed as "2 vols Stories [*sic*] of Venice," item 57 was listed as "3 vols Modern Painters," and item 58 was listed as "4 vols Ruskin's Works." Johnston & Van Tassell Auctioneers, *Catalogue of Artist's Effects*, December 9, 1871, New York City. Copies of the auction catalogue are in the Manuscript Collection, New-York Historical Society and the John Durand Papers, Rare Book and Manuscript Division, New York Public Library, Astor, Lenox and Tilden Foundations.

XV

Taormina and Mount Etna

The panoramic view from the ancient Greek Theater at Taormina, Sicily, is one of the most spectacular sights in Italy. Built on the side of a mountain 850 feet above sea level, the theater was cut into a natural hollow of rock, so that the audience looked seaward toward the stage and through the architectural backdrop of the *scena* to the snowcapped peak of Mount Etna in the distance. In the opposite direction, the view stretches all the way up the coast to the straits of Messina. The scene is one of sublime beauty, described by one nineteenth-century visitor as "altogether, one of the most entrancing and romantic views on earth, never the same, always changing, always beautiful."[1] Friends and contemporaries of Hotchkiss generally acknowledged that his best work was done at this enchanted spot.[2]

Not surprisingly, the amphitheater at Taormina became a pilgrimage site for nineteenth-century tourists. Guidebooks lauded the view and encouraged visitors to make the two-day journey from Rome. Artists invariably chose the prospect looking toward Mount Etna from the back of the theater for their compositions, framing the massive shoulders of the mountain through the broken arches of the ancient ruins. The amphitheater itself is an outstanding example of Greek design, marrying nature and art in a

1 Thomas H. Hotchkiss, *Theatre at Taormina*, 1868. Oil on canvas, 15¾ × 30¾ in. Private collection

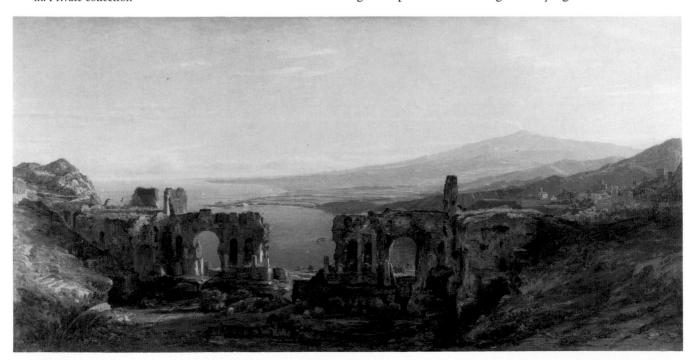

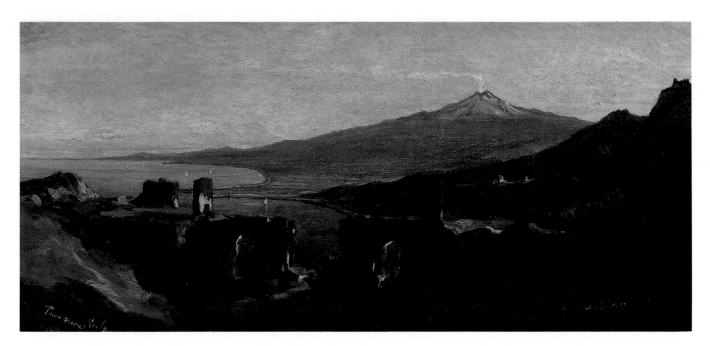

2 Thomas H. Hotchkiss, *Taormina, Island of Sicily*, 1868. Oil on canvas mounted on panel, 4¹¹⁄₁₆ × 10⁵⁄₁₆ in. The New-York Historical Society; Gift of Nora Durand Woodman, 1932.45

perfectly complementary relationship. The original theater was built by Greek colonists in 395 B.C. and refurbished by the Romans in the second century A.D. The statuary and ornamental marble added at that time have long since disappeared, victims of looting and military destruction. Very little has survived of the *cavea*, which had three tiers of seating arranged in a semicircular plan, with room for 40,000 people. Likewise, only the brick foundations remain of the large wooden stage, which had underground passageways and vaulted channels for drainage. Behind the stage, the *scena* consisted of two tiers of Corinthian columns with three arched gates and numerous niches for decorative statuary. Now in ruins, the *scena* was originally faced with marble.

The village of Taormina lies below the theater on a narrow ledge of mountain. In Greek and Roman times, it was a fairly large town, spilling down the cliffs toward the ocean, but by the nineteenth century, Taormina was little more than a single street, not a mile long. Despite its great fame and scenic appeal, Taormina was slow in accommodating tourists. A guidebook from the 1860s gloomily reported that not a single inn could be found.[3] Visitors either made private arrangements or traveled to Taormina for the day, lodging in nearby Catania. Hotchkiss made two, and perhaps three, trips to Taormina to paint the view from the Greek Theater toward Mount Etna.[4]

Henry Tuckerman, one of the few nineteenth-century art critics to give Hotchkiss any attention, visited the artist's studio in Rome. He singled out for particular praise Hotchkiss's view of the Greek Theater that left the ruins of the *scena* in shadow, while the background was bathed in bright afternoon sunlight.[5] Perhaps he saw *Theatre at Taormina*, dated 1868, one of Hotchkiss's largest known works (Fig. 1; see also p. 7). Given its size and high degree of finish, this painting was most likely painted in the artist's studio, based on detailed drawings and studies Hotchkiss made on the spot. The small canvas, *Taormina, Island of Sicily*, may have been one of these plein-air studies, a quickly executed summary of highlights and shadows (Fig. 2).

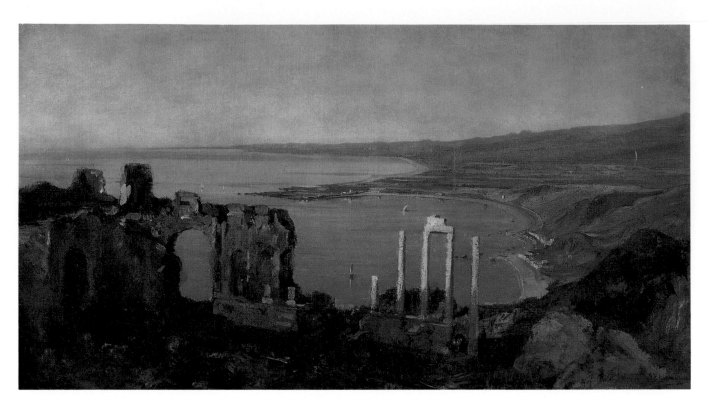

3 Thomas H. Hotchkiss, *Near Mount Etna, Sicily*. Oil on canvas, 11¼ × 20⁹⁄₁₆ in. The New-York Historical Society; Gift of Nora Durand Woodman, 1932.41

Another view, *Near Mount Etna, Sicily* was left unfinished, its underdrawing still visible beneath the thin layers of paint (Fig. 3). Works such as this demonstrate the artist's willingness to modify the composition to suit his pictorial needs: the brick *scena* on the right has been eliminated in order to isolate the white marble columns against the bay of water below. In *Mount Etna, Sicily*, Hotchkiss focused on the architectural details of the right side of the *scena*, perhaps as a reference for future compositions (Fig. 4). Although there are variations in all four paintings, Hotchkiss's views from Taormina are very similar to Thomas Cole's monumental canvas, *Mount Etna from Taormina, Sicily*, 1843 (Fig. 5). It has been suggested that Cole's composition was adapted from an even earlier pictorial precedent, an engraving of the site published by the English watercolorist Peter DeWint in 1823.[6] By the time Hotchkiss painted his views, the composition was fairly standard; a nearly identical arrangement appears in Sanford R. Gifford's sketchbook of 1868 and in William Stanley Haseltine's paintings of 1873 and 1889.[7]

Hotchkiss received at least one commission for a view from Taormina. In an undated letter from Venice, Hotchkiss mentioned that "Just before I left Rome I had an order from a Mr. Gurnee of New York to paint a picture of the Theatre at Taormina in Sicily and I shall go down there in August and stay until October or November. . ."[8] (Hotchkiss's decision to travel to Sicily in August seems to run counter to the advice found in contemporary travel guides, one of which suggested the best season for travel was October to May as "few Englishmen would select the summer months for a tour through the island.")[9] It is not known whether Hotchkiss finished this painting, although his patron, W. S. Gurnee of Irvington, New York, attended the auction of Hotchkiss's effects in Rome in 1871 in order to obtain material related to his commission.[10] Another American patron living in Rome, William H. Herriman, also owned a view of Taormina by

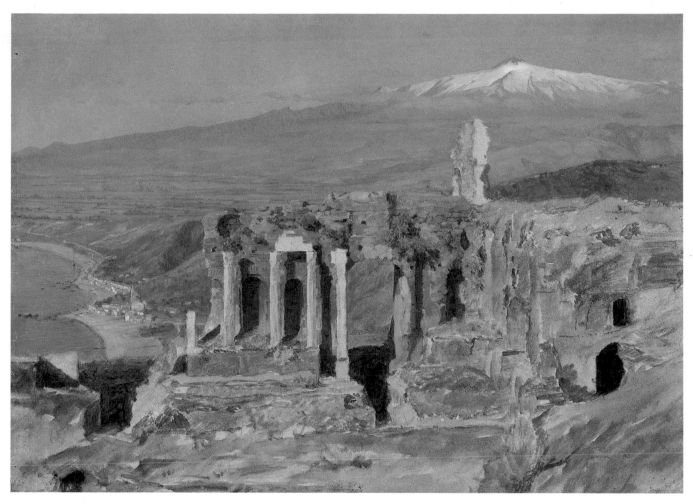

Hotchkiss, although this work may have been acquired at the same auction.[11]

Hotchkiss died near the Greek Theater at Taormina in August, 1869.[12] By coincidence, the American landscape painter John Rollin Tilton was in Taormina and with Hotchkiss at his death. The two artists were friends and maintained studios in the same building in Rome. Tilton was responsible for Hotchkiss's burial and for informing their friends of the sad news. It was not a pleasant task. A series of letters between Hotchkiss's friends attest to the acute grief occasioned by his death. A year later, George Yewell (1830–1923) wrote Elihu Vedder that he had recently seen Hotchkiss's last studies made at Taormina at the American consul's office in Rome. Yewell poignantly described these studies as "the finest of all his things: as large, and fine in drawing, so masterly and full of knowledge in every way: it seemed as though one grasped him once more by the hand."[13]

4 Thomas H. Hotchkiss, *Mount Etna, Sicily*. Oil and traces of charcoal pencil on off-white wove paper mounted on panel, 12⅛ × 16½ in. The New-York Historical Society; Gift of Nora Durand Woodman, 1932.210

NOTES

1. [David] Maitland Armstrong, *Day Before Yesterday: Reminiscences of a Varied Life* (New York: Charles Scribner's Sons, 1920), 190.

2. Elihu Vedder singled out Hotchkiss's views from Taormina for particular praise, "His view of Mount Etna is marvellous [*sic*] in its detailed accuracy; the eye seeking for it, can trace the tracks of every eruption

ancient and modern—and yet with all this detail the vast space is filled in with a clear and delicate atmosphere." Vedder, *The Digressions of V* (Boston and New York: Houghton Mifflin Co., 1910), 429. David Maitland Armstrong, who never met Hotchkiss, acknowledged that Hotchkiss's "chief fame was among artists," and that "Some of his finest work was done at Taormina, where a favorite subject was that most beautiful ruin in the world, the Greek Theatre." Armstrong, 189.

3. *A Handbook for Travellers in Sicily* (London: John Murray, 1864), 459, warned its readers that Taormina, "a poor and dirty town, of between 4000 and 5000 inhab., now represents the ancient grandeur of Tauromenium. Anywhere but in Sicily a spot so full of interest would be a fortune to innkeepers; here there is not a *locanda* where the tourist can stay to enjoy at leisure the wonderful combination presented of the utmost magnificence of natural scenery with most attractive remains of ancient and mediaeval art."

4. A correspondent to the *New York Evening Post* reported in "Affairs in Rome: The Painters," January 5, 1865, that "Hotchkiss has made a visit to Sicily the past summer, and has brought back the most charming studies from the neighborhood of Etna I have ever seen of that country." George Yewell recorded in his diary on December 3, 1867, that Hotchkiss "showed me some fine Sicilian studies & views of Etna from Taormina which were very beautiful and artistic in treatment and excellent in color." George Yewell Papers, Archives of American Art, Smithsonian Institution, Roll 2428, Frames 382–3. Since two of Hotchkiss's known paintings of Taormina are dated 1868, it seems likely that he made a second trip to Sicily in 1867. Hotchkiss died in Taormina in 1869.

5. Henry T. Tuckerman, *Book of the Artists* (Reprint. New York: James F. Carr, 1967), 569. Tuckerman also mentioned two other views of Mount Etna, "One of these especially gives wonderfully, for so small a canvas, the idea of distance. The eye is forbidden to rush over the whole at a glance, but compelled, as it were, to travel from point to point, detained by the delicate finish of every part. This completeness of finish and singularly just distribution of light are among the qualities which have made the works of this artist deservedly admired." The present location of these two paintings is unknown.

6. Ellwood C. Parry III, *The Art of Thomas Cole: Ambition and Imagination* (Newark, Del.: University of Delaware Press, 1988), 292.

7. Sanford R. Gifford visited Mount Etna in 1868 and did not find the volcano very appealing. He found the Greek Theater at Taormina fascinating, however, and made a detailed pencil study of the view toward Mount Etna is his sketchbook. The drawing is reproduced in Ila Weiss, *Poetic Landscape: The Art and Experience of Sanford R. Gifford* (Newark, Del.: University of Delaware Press, 1987), 117.

8. Hotchkiss to Lucy Durand Woodman, Manuscript Collection, New-York Historical Society.

9. *A Handbook for Travellers in Sicily*, 1.

10. In a letter from Carrie Vedder to her sister, March 19, 1871, Carrie relates that Mr. Gurnee and William H. Herriman, American collectors in Rome, were active bidders at Hotchkiss's estate auction the previous

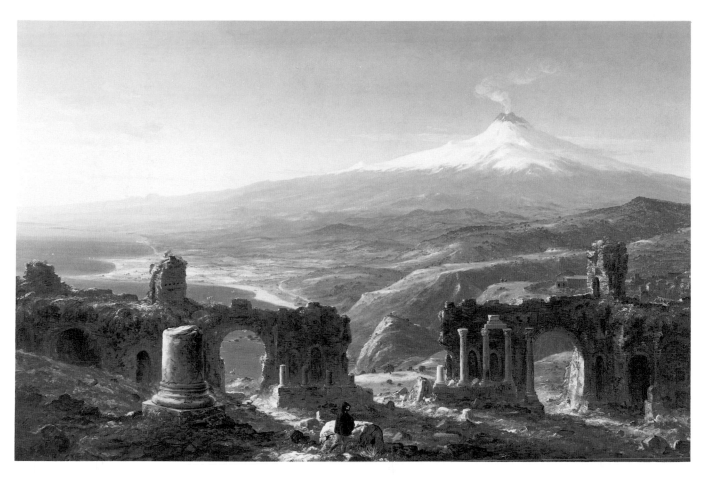

week. See Appendix below. Elihu Vedder Papers, Archives of American Art, Smithsonian Institution, Roll 516, Frames 512–4.

11. See the inventory of Herriman's estate in Rome, dated April 22, 1919. According to this inventory, Herriman owned at least two paintings by Hotchkiss, *View of Taormina* and *Scene of Road from Perugia to Gubbio*. Herriman also owned works by other American artists working in Rome, including Charles C. Coleman, Elihu Vedder, and William Graham. In his will, Herriman left all his paintings by American artists to the American Academy in Rome, excluding works by Elihu Vedder, which he gave to the Brooklyn Museum. Repeated inquiries to the American Academy in Rome have turned up no record of Hotchkiss paintings at that institution. William H. Herriman Papers, The Brooklyn Museum Archives. I am grateful to Jennifer Taylor for bringing the Herriman papers to my attention.

12. For details of Hotchkiss's death, see the essay by Barbara Novak, "Dreams and Shadows: Thomas H. Hotchkiss in Nineteenth-Century Italy."

13. George Yewell to Elihu Vedder, May 23, 1870. Vedder Papers, Archives of American Art, Smithsonian Institution, Roll 516, Frames 356–8. Yewell acquired a painting by Hotchkiss of the Greek Theater at Taormina (University of Iowa Museum of Art). He may have purchased the painting at the New York auction of Hotchkiss's effects. An annotated copy of the sale catalogue lists Yewell as a successful bidder. John Durand Papers, Rare Book and Manuscript Division, New York Public Library, Astor, Lenox and Tilden Foundations.

5 Thomas Cole, *Mount Etna from Taormina, Sicily*, 1843. Oil on canvas, 78⅝ × 120⅝ in. Wadsworth Atheneum, Hartford, Connecticut

Thomas Hiram Hotchkiss Chronology

ca. 1833 Born in Coxsackie, New York.

1853 APRIL Exhibits a genre scene of children at a cottage door (*Game of Marbles?*) at the Rochester, New York, studio of Henry Johnson Brent.

1855 MAY Sketches at Palenville, New York.

1856 SPRING Exhibits three paintings at the National Academy of Design, *Sunrise in Kauterskill Clove*, *Storm in Kauterskill Clove*, and *Study in Kauterskill Clove*. Gives his address as 358 Broadway, New York City.

AUGUST TO OCTOBER Sketches at North Conway, New Hampshire. Among his colleagues are Benjamin Champney, Aaron D. Shattuck, Samuel Colman, Alvan Fisher, James Suydam, and William J. Stillman. Asher B. Durand sketches nearby, in West Campton.

DECEMBER Has a studio at 804 Broadway.

1857 SPRING Exhibits four paintings at the National Academy of Design, *Landscape, On the Catskill Creek*, *Study from Nature, North Conway, N.H.*, and *Meadows of North Conway, N.H.*. Gives his address as 806 Broadway.

AUGUST Sketches at Catskill, New York, with either James McDougal Hart or William Hart and John William Hill.

1858 SPRING Exhibits three paintings at the National Academy of Design, *Autumn–Lake in the Catskills*, *On Catskill Creek*, and *Summer–Conway Valley*. Gives his address as Catskill, New York.

AUGUST Sketches in Catskill with Asher B. Durand and Samuel L. Gerry.

1859 FEBRUARY Exhibits at the Tenth Street Studio Building, New York City.

MARCH Exhibits in Troy, New York.

SPRING Exhibits two paintings at the National Academy of Design, *Landscape* and *Harvest Scene*.

AUGUST Sketches at Geneseo, New York, with Asher B. Durand and James Suydam.

WINTER Elected associate member of the National Academy of Design. Gives his address as 15 Tenth Street.

DECEMBER Sails for Europe.

1860 FEBRUARY In London. Studies the work of J. M. W. Turner.

SPRING Travels to Paris, then to Italy, possibly with George Fuller.

SUMMER Meets Elihu Vedder in Florence. They sketch together and travel to Umbria.

JUNE Sketches at Volterra.

AUGUST Travels to Switzerland.

WINTER Moves to Rome and takes a studio.

1861 APRIL Sketches in Rome.

JUNE Paints a picture for William T. Walters of Baltimore.

WINTER Sketches at the Torre dei Schiavi.

1862 DECEMBER Studies life drawing in Rome. Visits with William James Stillman.

1864 SUMMER Sketches at Taormina, Sicily.

1865 SPRING Exhibits two paintings at the National Academy of Design, *Torre de Schiava* [*sic*] and *Cypresses at the Convent of San Miniato, Florence*.

JULY TO SEPTEMBER Travels to Paris, then to London, possibly with William Linnell.

AUTUMN Visits the John Linnell family at Redhill, Surrey. Stays in London with the Pre-Raphaelite painter Henry Wallis. Travels to North Wales.

1866 DECEMBER Vedder returns to Italy, settling in Rome. Renews friendship with Hotchkiss.

1867 JULY TO AUGUST Sketches with Vedder in Umbria, near Perugia.

DECEMBER Has a studio in Quattro Fontana, Rome. Sketches in the Roman Campagna with George Yewell.

1868 MARCH AND APRIL Lives in Rome. Visits with Yewell, Vedder, and Charles C. Coleman.

SUMMER Sketches with Vedder in Umbria.

SEPTEMBER Travels to the United States, possibly with Vedder. Sketches in Catskill with Benjamin B. G. Stone.

OCTOBER TO DECEMBER Lives in Rome, in poor health. Visits with Sanford R. Gifford.

1869 JANUARY Sketches in Venice, then travels to the Tyrol.

AUGUST 18 OR 19 Hotchkiss dies at Taormina, Sicily, with John Rollin Tilton present.

OCTOBER Vedder arrives in Rome.

1870 Attempts to contact Hotchkiss's family fail.

SUMMER John Durand begins correspondence with David Maitland Armstrong, American consul in Rome, to remove Hotchkiss's effects to New York City.

1871 MARCH Hotchkiss's effects auctioned in Rome by order of the American consul.

DECEMBER 9 Hotchkiss's effects auctioned in New York City by Johnston & Van Tassell, by order of the public administrator.

Appendix

Letter from Samuel P. Avery to Thomas H. Hotchkiss, September 12, 1861. [John Durand Papers, Rare Book and Manuscript Division, New York Public Library, Astor, Lenox and Tilden Foundations.]

48 Beekman St. Sept. 12 1861

My Dear Hotchkiss,

Long and weary has been the time since I last wrote to you—and no doubt the time has also been one of anxiety to you, the affairs of our country have of course given you many anxious hours, away from home—among strangers and with precarious means of support. I have often thought that your position was very harrassing. I have remained silent so long because I had no word of encouragement to send—but hoping constantly to be able to have such good word, and therefore delayed writing until it could serve a double purpose. I must also confess to much selfishness and indifference to everything and every body—each day for months has brought its own exciting event commanding attention before all other affairs. I am glad however at last to be able to enclose you a draft for 100$. The last time I wrote to you was just at the time your package arrived after its long delay by the disabling of the Australian—her putting back and the reshipment of her cargo delayed the things more than a month besides adding to the expense. You must believe that *I* did all I could *immediately* to dispose of your things but could get *no* encouragement—those persons who liked Dunnings picture—did not like the last one so well (and I must agree with the Dr., Mr Durand and others of your friends in preferring the original—there is a metallic quality about the latter—and a waxiness in the sky that is unpleasant) The only thing promptly disposed of was the *Mackerel* to Dunning for 25$ (the *only* offer I had) I was forced to use that amount to reimburse me for the expenses—charges *freight* 17$—customhouse dues duties 4$. putting in Passe Partout the two sketches 4$—Suydam would not even take the Harvesting for his 50$ commission but offered to head a raffle. So I got up a paper 25 shares at 4$ each, by the aid of Mr Durand and Dunning I was enabled to get the list full after very long delays—and still longer in getting *all* of the money paid up—last week however the *last* 4$ was paid and we proceeded to *draw.* Wainwright (you remember him don't you) won the picture and two engravers Hatfield and Danforth won the sketch and copy. Allow me here to say that it is useless to send such things for *sale* no one cares for

such things enough to *pay* what they are worth. Pleasing *subjects* are what takes with collectors, and more they have to be very beautiful—elaborate and *cheap* to stand any chance of sale . . . [Dunning] is one of the government sanitary committee and has called home from Fort Munroe.

Sept. 15. Since I commenced the above I have yours of Aug—I was glad to hear from you (and also to hear from Dr. D that you had had the good luck to sell a picture) I am afraid that the *Troy Bridge* will not find a ready sale but few people regard a *copy* as worth anything . . . Copying of *old* Masters has brought the whole subject in disrepute. About Mr. Walters. I do not think that he will care to add to the original commission given you—he was very particular about *that* at the time and you should have complied with it. He always said that he knew nothing of your work and would prefer to have you do him a companion to the *first* one, if that should prove satisfactory.

He has been active in the Secession movement I believe—but he still is interested in art matters and would I think at any time buy works afar if they were of any higher character to those he already has. You would be surprised to see the *quality* of his collection . . . he has committed himself on what we think the wrong side I can never forget the many noble and generous qualities he possesses and the liberal and delicate way that he has rewarded the labors of many of my artist friends. When we write or talk it is on the neutral ground of art and of personal friendship. Just now he is in *Paris*, having sailed from here three weeks ago with his family . . .

Mr. W. has always when I see him something to say of Rhinehart, he seems very proud of him. My sympathy for his work and for Mr. W. makes me feel like an old friend toward the sculptor. Mr. W. tells me that there probably will come in some way consigned to my care one of his works "The Sleeping Children"—from a photograph, I judge it very lovely—and think it will win the favors of the public—*all* can feel the truth of such a work of art. Will you please tell Mr. Rhinehart for me that if I can in any way facilitate [illegible] in regard to it as expressed through Mr. Walters, I shall be very delight [sic] to do so . . .

By the steamer that takes this letter I send a letter of introduction to you by a friend of mine Mr. Geo Graham. Mr. G. is a person very fond of art and having just come into the possession of considerable means and being threatened with a pulmonary complaint he is advised to travel abroad and intends going to Rome direct where he will winter if the climate agrees with his condition. Mr. G. takes valuable letters to persons in Rome and I trust he may be of some solace to you, and if you can be of any aid to him please do so—and I will try and reciprocate . . .

As Ever Sincerely Your Friend
Samuel P. Avery

P.S. Instead of buying a bill of advance, I send the one hundred dollars by Mr. Graham, as you will get it sooner and without any expenses—also the parcel in which I enclose this.

* * *

Two letters from William Graham to George Yewell, August 26 and August 31, 1869. [Yewell Papers, Archives of American Art, Smithsonian Institution, Roll 2428, Frames 210–13.]

Venice Aug. 26 1869

My dear Yewell,

On coming home from S. Marks today I found a letter from Coleman informing me of the *passing away* of our friend Hotchkiss Aug. 19th. He received the sad intelligence by letter, from Mr. Tilton, who was with him (alone) in his last moments.

Coleman requested me to write to Bartlett, but I have forgotten his address. So as you are corresponding with him that duty will devolve upon you. I cannot write you any more at present—as I get additional facts in regard to his last moments I will communicate them to you. Coleman poor fellow is corresponding with everybody who may be interested in this sad event. In regard to my feelings you can appreciate them better than I can express.

Yours all the more friendly and reliant from having our friend the less,

Wm Graham

Venice Aug 31 1869

My dear Yewell,

Thank you for your kind letter just received. I have just received another letter from Coleman in which he gives me the following from Mrs. Tilton.

"I have just this moment received a hasty note from Mr. Tilton in which he tells me to write to you and tell you of the sudden death of our poor friend Hotchkiss at Taormina Sicily on the 19th. Mr. Tilton had gone there some days ago not expecting to find Mr. Hotchkiss there; but there he was; and ill with bleeding at the lungs. He seemed better after my husband's arrival and they dined together; after dinner each went to their rooms to lie down when Mr. Tilton hear [*sic*] Mr. Hotchkiss knock. He went to him, found him bleeding violently and in a few minutes he died in my husbands arms and on the floor. Poor fellow! What a mercy that he had one friend with him. Mr. Tilton was to leave on Sat. 20 for Messina with the body there to have it buried in the Protestant cemetery of that place. Perhaps you will know how to notify his family of his decease. I know no one that belongs to him. Will you please do what you think best in the matter and any other information will be furnished by Mr. Tilton when he returns."

Besides this letter from Mrs. Tilton Coleman writes me that the U.S. Consul has placed his seal upon the effects of our departed friend, and wrote to know if I know whether he made a will? I *do not.*

If you wish you may transmit this or its substance to Bartlett and tell him the reason I have not written direct to him is that I have stupidly forgotten his address. Tell him he may address me here for about

fifteen days yet. I can't promise to be here later than that. Though I would like to be very much to salute you and Mrs. Yewell.

Pardon me for having off so abruptly,
Yours Truly,
Wm Graham

In regard to your inquiries his parents are not living. He had one or two brothers, about whom he cared little or nothing.

<p style="text-align:center">✳ ✳ ✳</p>

Letter from Carrie Vedder to her sister, Annie Butler, March 19, 1871. [Elihu Vedder Papers, Archives of American Art, Smithsonian Institution, Roll 516, Frames 512–14.]

23 San Niccolo da Tolentino
Rome March 19, 1871

My Dear Darling Annie,

. . . Last Thursday or rather a week ago Thursday the sale of Hotchkiss' effects took place. Now as all the proceeds go to the U.S. Government the object was to have the things go as cheaply as possible that a good many of them might be obtained by his friends here and only $1000 worth could be sold here the rest having to be sent to New York as some friends there got the sale removed & only enough could be sold to cover his debts here. Gurnee & Herriman are the only *rich* men to bid but Tilton had *commissions* from people at home to the amount of some $800 nearly enough to cover the entire sale. Herriman like a gentleman sent his list to us artists the night before with the things marked he would like to get but said anything we wished to bid on he would not make an offer for against us but if any outsiders outbid us he should step in & get what he wanted. I know that Gurnee did the same to Tilton only telling him that "there were certain things he meant to have at *any price*, which he considered he had a first claim to as they were sketches for pictures Hotchkiss was painting for him. He did not want to run the sale up [illegible] and as Tilton might be thinking of bidding on these things could they not make some arrangement beforehand." Like the d-d (which only means double dyed) fool that he is, Tilton told him, "Oh they couldn't do anything of that kind, they must wait until the sale!" and then on the very first picture which came No. 8 on the catalogue he ran it up to $165 of course Gurnee got it for he meant to pay 1000 but what he would have it and when after the sale I said to Tilton what a shame it was the things had been so run up, when it was perfectly well known the things Gurnee meant to have at any price, & there was no use to bidding against his money, Tilton actually dared to express his deep regret and say *I did not* know it, which was a *barefaced lie* for Gurnee told me himself what I have written. There is a great deal of feeling against Tilton for his action in this sale and for my own part if there is any way I should like to see [him] kicked from the

Pincio to the Capitol and back again. It is that same old cat. Not for this alone but for his many sins. If it were not for his wife who is a most charming and estimable woman there are a good many in Rome who would have a bout at Tilton. Of course at this sale Gurnee got much and at every bid Tilton made ran him up to the last point, but when the other artists bid Gurnee held off so that some half a dozen others got things but Tilton only secured after all one portfolio of six sketches and one picture which last he got by mistake of the auctioneer not hearing Mr. Herriman bid higher. My only comfort is that Tilton feels so uncomfortably on the matter that he can't enjoy even those. He did come afterwards to the Herrimans and begged them to take the picture but of course they wouldn't and he said "Well I feel dreadfully about it altogether; I have acted so that now whatever I do is wrong & I am blamed whatever course I may take" and Mrs. Herriman didn't tell him he would not be. However we got nothing except some old studio stuff that Vedder bought to keep away from the jews. Completely used up by the excitement I went to the Herrimans to lunch and on coming home later found a portfolio with three sketches for "Mrs. Vedder with Mr. Gurnee's compliments" and I hear he sent Mrs. Rogers one and Charley Coleman one. Mrs. Herriman also had picked out one from her portfolio for us but hearing of Gurnee's present she sent it to Graham. The sales stopped at No. 26 the amount having been realized and the rest of the things up to No. 115 will go to N.Y. We mean to keep a look out for it and I hope things will go more reasonably there and that we may get some of the sketches. There were [illegible] portfolios with six sketches some with 40 and one with 100. All are wanted so much. You don't take much interest in this I am afraid but it has been the excitement of Rome and has not yet entirely subsided . . .

✻　✻　✻

CATALOGUE of ARTIST'S EFFECTS: Oil Paintings, Engravings, &c. FINE
HOUSEHOLD FURNITURE, MIRRORS, &c., &c., December 9, 1871, John-
ston & Van Tassell, Auctioneers, New York City.
[Manuscript Collection, The New-York Historical Society.]

1 The Conflagration dated 1619
2 Sketch
3 do
4 Our Savior and the Leper
5 Landscape
6 Sketch
7 Virgin and Child
8 2 Sketches—Tower and Landscape
9 2 do Collesium, Ruins and Bay
10 2 do
11 3 Paintings—Views in Rome, &c.
12 3 Scriptural Pieces—Bearing the Cross, &c.
13 Painting—Birds, &c.
14 5 Sketches, &c.
15 3 Paintings—Study from Nature, Temple of Nature, &c.
16 2 Scriptural Pieces
17 5 Sketches
18 2 Paintings
18a Diana the Huntress
19 2 Sketches
20 2 do
21 3 do
22 3 do
23 allegorical Painting
24 Sketch
25 oil Painting and 2 Studies—View of the Collesium
26 oil Painting and Study
27 2 Sketches
28 Painting—Near Rome
29 Satyrs Sacrifice &c.
30 do Companion
31 Madonna and Child
32 Nymphs Bathing
33 Sketch
34 Landscape
35 2 old Heads
36 2 Sketches
37 3 Sketches
38 3 do
39 View in Venice
40 3 Sketches
41 3 do
42 The Holy Family
43 Sketches
44 Angels
45 Scriptural Piece
46 Flowers

47	Scene from Hamlet, water color by Stansfield
47a	Portrait
48	Still Life
49	5 small Paintings
50	ancient Engravings
51	8 vols Murrays Hand Books
52	2 vols Wordworth & Landor
53	Millais Illustrations
54	2 vols Stories of Venice and Eastlakes History of Oil Paintings
55	2 vols Bewick's Birds
56	vol Balzac's Works, illus
57	3 vols Modern Painters
58	4 vols Ruskin's Works
59	2 vols Holbein's Dance of Death and Barnard's Foliage
60	vol Passion Week, illus
61	5 Vols assd
62	elgt wal and gilt Mirror, console Table and 2 Cornices
63	2 blue Lambrequins
64	lace Curtains, 2 win
65	2 elgt inlaid Pedestals
66	2 Statuettes—the Refugees and Postmaster
67	elgt wal and gilt parlor Suit, silk reps and slip covers, 7 pcs
67a	yds Fr moquet Carpet
68	3 elgt wal and gilt Cornices
69	blue Lambrequins, 3 win
70	lace Curtains, 3 win
71	50 Engravings, Lithographs, &c.
72	1 Portfolio containing about 50 studies
73	4 vols, Art in Italy
74	1 Portfolio containing a number of studies
75	Russian leather glove Box
76	inlaid segar box
77	odor box, 3 bottles
78	wal work box
79	jewel box
80	paper mache hdf Box
81	do writing Desk
82	1 bundle artists Brushes
83	1 do do
84	1 case oil Sketches
85	1 tapestry Carpet
86	1 do
87	3 antique Vases, 1692
88	large model Figure with Picture
89	small do do
90	wooden Frame
91	oil Painting and Frame—Cupids
92	oil Painting—Figure piece
93	wal library Table
94	ptd Table
95	oil Portrait
96	lot Pallettes, Paintings, Engravings, &c.

97	lot artist's Canvass sizes for painting
98	2 crayon Drawings—Artistic Bears, &c.
99	ptd Table
100	oil Portrait and Stand
101	oil Pianting and Frame—In a Storm
102	Bureau and contents
103	evd wal Suit in maroon plush, 7 pcs
104	wal Easel
105	2 crayon Drawings—The Artists
106	lot stretchers
107	oil painting—Siege of Troy
108	gilt Frame
109	do
110	pt Bedstead and Mattress
111	lot canvas, Stretchers &c.
112	Portfolio and contents
113	portfolio stand
114	oil Sketches
115	lot Canvas and Stretchers
116	wal Easel
117	pat Easel
118	wal and gilt fr Painting
119	crayon Drawing
120	parlor Suit in stpd reps 7 pcs
121	crayon Drawing
122	gilt fr oil painting
123	box ancient Engravings
124	lot artists Materials, hat Box &c.
125	lot Engravings
126	lot Engravings and water Colors
127	do do
128	2 volumes Illuminated Books, &c.
129	vol Illuminated Missile
130	vol Plutarch
131	vol Homer
132	2 vols Clauduptole, &c.
133	2 vols Scripture and Reference
134	vol Illuminated Missile
135	2 vols Andreae Alciati and Gregory
136	2 vols Giacomo Giustiniani, &c.
137	2 vols Ariosto, &c.
138	lot Books
139	do
140	2 lots Books
141	lot Books in vellum
142	lot Books
143	do
144	3 vols Books
145	lot Pamphlets, &c.
146	lot Books
147	do
148	portfolio of Engravings, &c.

Exhibition Checklist

WORKS IN THE NEW-YORK HISTORICAL SOCIETY
BY THOMAS H. HOTCHKISS
(LISTED BY ACCESSION NUMBER)

1. *Monte Mario, Rome,* 1868 *(p. 70)*
 Oil on paper mounted on canvas
 17 × 11⁹⁄₁₆ in.
 The New-York Historical Society
 Gift of Nora Durand Woodman, 1932.7

2. *Temple of Neptune, Paestum,* 1864–67 *(p. 99)*
 Oil on paper mounted on panel
 9 × 16¼ in.
 The New-York Historical Society
 Gift of Nora Durand Woodman, 1932.36

3. *Tree Study, Catskill Clove,* 1858 *(pp. 18, 35)*
 Oil on canvas
 13⁷⁄₁₆ × 8½ in.
 The New-York Historical Society
 Gift of Nora Durand Woodman, 1932.37

4. *Roman Aqueduct* *(p. 78)*
 Oil on canvas
 16 × 31¾ in.
 The New-York Historical Society
 Gift of Nora Durand Woodman, 1932.38

5. *Roman Colosseum,* 1868 *(p. 69)*
 Oil on paper mounted on panel
 5¹³⁄₁₆ × 16½ in.
 The New-York Historical Society
 Gift of Nora Durand Woodman, 1932.39

Note: Dimensions indicate height by width.
Page numbers in parentheses are provided
for works illustrated in this volume.

6. *Scene in Italy (Roman Campagna)*, 1865 *(p. 73)*
 Oil on paper mounted on canvas
 6⁹⁄₁₆ × 16⁹⁄₁₆ in.
 The New-York Historical Society
 Gift of Nora Durand Woodman, 1932.40

7. *Near Mount Etna, Sicily* *(p. 106)*
 Oil on canvas
 11¼ × 20⁹⁄₁₆ in.
 The New-York Historical Society
 Gift of Nora Durand Woodman, 1932.41

8. *Italian Cypresses* *(p. 95)*
 Oil on composition board
 21¹⁵⁄₁₆ × 8½ in.
 The New-York Historical Society
 Gift of Nora Durand Woodman, 1932.42

9. *Moonlight, Arch of Titus, Rome*, 1867 *(p. 66)*
 Oil on canvas
 14⅜ × 21 in.
 The New-York Historical Society
 Gift of Nora Durand Woodman, 1932.43

10. *Catskill Mountains, Shandaken, N.Y.*, 1856 *(p. 33)*
 Oil on canvas
 10¹⁵⁄₁₆ × 15¹³⁄₁₆ in.
 The New-York Historical Society
 Gift of Nora Durand Woodman, 1932.44

11. *Taormina, Island of Sicily*, 1868 *(p. 105)*
 Oil on canvas mounted on panel
 4¹¹⁄₁₆ × 10⁵⁄₁₆ in.
 The New-York Historical Society
 Gift of Nora Durand Woodman, 1932.45

12. *Sketch from Nature (Cypress Trees at San Miniato al Monte,
 Florence)*, ca. 1864 *(p. 63)*
 Oil on paper mounted on canvas
 13¼ × 10¾ in.
 The New-York Historical Society
 Gift of Nora Durand Woodman, 1932.50

13. *Roman Colosseum* *(p. 67)*
 Oil on canvas
 14⅜ × 21 in.
 The New-York Historical Society
 Gift of Nora Durand Woodman, 1932.51

14. *Study for Catskill Mountains (Haying)*, ca. 1856–59 *(p. 38)*
Oil on wove paper
4¾ × 7 in.
The New-York Historical Society
Gift of Nora Durand Woodman, 1932.187

15. *Catskill Mountains (Haying)*, ca. 1856–59 *(p. 38)*
Oil on canvas
11 × 15⅞ in.
The New-York Historical Society
Gift of Nora Durand Woodman, 1932.188

16. *Cloud Study, Catskill Mountains*, ca. 1856–59 *(p. 34)*
Oil on laid paper
6⁷⁄₁₆ × 13⅛ in.
The New-York Historical Society
Gift of Nora Durand Woodman, 1932.189

17. *Landscape*
Watercolor on blue wove paper
3⅞ × 5½ in.
The New-York Historical Society
Gift of Nora Durand Woodman, 1932.190

18. *Mountain Stream, White Mountains, N.H.*, 1856 *(p. 44)*
Oil on canvas mounted on panel
9⅞ × 7⅛ in.
The New-York Historical Society
Gift of Nora Durand Woodman, 1932.191

19. *San Gimignano, Tuscany*, 1860 *(p. 52)*
Watercolor and gouache and graphite on blue wove paper
11⁹⁄₁₆ × 8⅛ in.
The New-York Historical Society
Gift of Nora Durand Woodman, 1932.192

20. *View on the Roman Campagna*
Watercolor and gouache on blue wove paper
4⁵⁄₁₆ × 7¹⁵⁄₁₆ in.
The New-York Historical Society
Gift of Nora Durand Woodman, 1932.193

21. *Ruin on the Campagna* *(p. 91)*
Watercolor on blue wove paper
4⅜ × 6⅝ in.
The New-York Historical Society
Gift of Nora Durand Woodman, 1932.194

22. *Gateway, Volterra, Tuscany*, 1860 *(p. 55)*
 Watercolor and gouache on light blue laid paper
 12¼ × 8¾ in.
 The New-York Historical Society
 Gift of Nora Durand Woodman, 1932.195

23. *Houses on a Cliff, Italy*, ca. 1860
 Watercolor and gouache and pen and brown ink on
 blue wove paper
 6½ × 9⅝ in.
 The New-York Historical Society
 Gift of Nora Durand Woodman, 1932.196

24. *Study of a Monk*, ca. 1860–63 *(p. 57)*
 Oil and graphite on off–white wove paper
 11¼ × 7⅞ in.
 The New-York Historical Society
 Gift of Nora Durand Woodman, 1932.197

25. *Roman Aqueduct* *(p. 83)*
 Oil on wove paper
 6⁹⁄₁₆ × 8⁹⁄₁₆ in.
 The New-York Historical Society
 Gift of Nora Durand Woodman, 1932.198

26. *Study, Italian Landscape (Cypresses)*, 1862 *(p. 96)*
 Oil on wove paper
 3⁵⁄₁₆ × 9¼ in.
 The New York Historical Society
 Gift of Nora Durand Woodman, 1932.200

27. *Roman Colosseum*, ca. 1860–61 *(p. 64)*
 Pen and brown ink and graphite on light brown laid paper
 18¹⁄₁₆ × 12⅝ in.
 The New-York Historical Society
 Gift of Nora Durand Woodman, 1932.204

28. *Arch of Titus and Roman Colosseum* *(p. 65)*
 Oil on wove paper mounted on panel
 15⅞ × 13⅛ in.
 The New-York Historical Society
 Gift of Nora Durand Woodman, 1932.205

29. *Sunset on the Colosseum* *(p. 67)*
 Oil on paper mounted on panel
 5¹⁵⁄₁₆ × 13³⁄₁₆ in.
 The New-York Historical Society
 Gift of Nora Durand Woodman, 1932.206

30. *Façade of a Gothic Palazzo*, ca. 1864 *(p. 103)*
 Oil and graphite on wove paper
 8 × 11⅛ in.
 The New-York Historical Society
 Gift of Nora Durand Woodman, 1932.209

31. *Mount Etna, Sicily* *(p. 107)*
 Oil and traces of charcoal pencil on off–white wove
 paper mounted on panel
 12⅛ × 16½ in.
 The New-York Historical Society
 Gift of Nora Durand Woodman, 1932.210

32. *Italian Pines and Cypresses* *(p. 96)*
 Oil on wove paper
 4⁷⁄₁₆ × 8⁵⁄₁₆ in.
 The New-York Historical Society
 Gift of Nora Durand Woodman, 1932.211

33. *Study, Italian Landscape* *(p. 74)*
 Oil on wove paper
 3¼ × 9 in.
 The New-York Historical Society
 Gift of Nora Durand Woodman, 1932.212

34. *Italian Hill Town (Le Casacce?)*, ca. 1867 *(p. 125)*
 Watercolor, pen and brown ink, with touches of white gouache
 on blue wove paper
 5⅞ × 8⅞ in.
 The New-York Historical Society
 Gift of Nora Durand Woodman, 1932.216

35. *Italian Hill Town*, ca. 1860 *(p. 50)*
 Watercolor and gouache and pen and red–brown ink on blue
 wove paper
 8 × 12 in.
 The New-York Historical Society
 Gift of Nora Durand Woodman, 1932.217

36. *Italian Hill Town*, ca. 1860 *(p. 51)*
 Watercolor and gouache, pen and brown ink and traces of
 charcoal on blue wove paper
 5¾ × 7⅝ in.
 The New-York Historical Society
 Gift of Nora Durand Woodman, 1932.218

1 Thomas H. Hotchkiss, *Italian Hill Town* (*Le Casacce?*), ca. 1867. Watercolor, pen and brown ink, with touches of white gouache on blue wove paper, 5⅞ × 8⅞ in. The New-York Historical Society. Gift of Nora Durand Woodman, 1932.216

37. *Hill and Lake*
Oil on canvas
3½ × 8½ in.
The New-York Historical Society
Gift of Nora Durand Woodman, 1932.219

38. *Study of Trees*, ca. 1859 *(p. 45)*
Brown ink wash with touches of white gouache and traces of
 graphite and charcoal on cream wove paper
14⅞ × 21¼ in.
The New-York Historical Society
Gift of Nora Durand Woodman, 1932.221

39. *Catskill Mountains, New York*, 1857 *(p. 41)*
Oil and graphite on paper
6¾ × 14⅝ in.
The New-York Historical Society
Gift of Nora Durand Woodman, 1932.222

40. *Landscape Sketch (Roman Campagna)*, 1866 *(pp. 21, 74)*
Oil on wove paper
5¹⁵⁄₁₆ × 15¹¹⁄₁₆ in.
The New-York Historical Society
Gift of the Estate of Nora Durand Woodman
 through Hannah Woodman, 1942.479

41. *Catskill Winter Landscape*, 1858 *(p. 36)*
Oil on canvas
11 × 7¾ in.
The New-York Historical Society
Gift of the Estate of Nora Durand Woodman
 through Hannah Woodman, 1942.480

42. *Landscape Sketch (New England Scene)*, ca. 1856–59 *(p. 41)*
Oil on canvas
10⅞ × 15⅞ in.
The New-York Historical Society
Gift of the Estate of Nora Durand Woodman
 through Hannah Woodman, 1942.481

43. *Mount Washington, New Hampshire*, 1857 *(p. 43)*
Oil on canvas
20 × 29⅞ in.
The New-York Historical Society
The Robert L. Stuart Collection, on permanent loan from the
 New York Public Library, Stuart 5

44. *Tree Study*
Pen and black ink, brown wash, and graphite on cream wove paper
$9\frac{7}{8} \times 7$ in.
The New-York Historical Society, 14907

45. *View of Florence*, ca. 1860 *(p. 49)*
Watercolor, white gouache and pen and black ink with traces of charcoal on ivory wove paper
$8\frac{5}{8} \times 16$ in.
The New-York Historical Society, 14908

46. *Roman Aqueduct* *(p. 79)*
Pen and black ink and graphite on off–white wove paper
$17\frac{3}{4} \times 8$ in.
The New-York Historical Society, 14909

47. *Italian Villa on Hill*
Watercolor and gouache with traces of blue pastel and black ink on ivory laid paper
$3\frac{7}{8} \times 5\frac{1}{2}$ in.
The New-York Historical Society, x.443(A)

48. *Roman Aqueduct* *(p. 82)*
Watercolor and gouache with traces of graphite on off–white wove paper
$5 \times 7\frac{7}{8}$ in.
The New-York Historical Society, x.443(B)

49. *Roman Aqueduct with Shadows* *(pp. 13, 80)*
Watercolor and gouache with traces of graphite on off–white wove paper
$4\frac{15}{16} \times 7\frac{3}{4}$ in.
The New-York Historical Society, x.443(C)

50. *Roman Aqueduct* *(pp. 16, 81)*
Watercolor and gouache with some graphite on off–white wove paper
$5\frac{1}{4} \times 7\frac{7}{8}$ in.
The New-York Historical Society, x.443(D)

51. *Roman Aqueduct in Distance*, 1861 *(p. 83)*
Watercolor, gouache and graphite on off–white wove paper
$5 \times 7\frac{7}{8}$ in.
The New-York Historical Society, x.443(E)

52. *Floor Tiles from the Baths of Caracalla*, ca. 1861 *(p. 85)*
Watercolor and gray wash over traces of graphite on off–white
 wove paper
5⅜ × 7¾ in.
The New-York Historical Society, x.443(F)

53. *Three Figures by a Door*
Gouache and watercolor with traces of graphite on ivory laid
paper
3¹⁵⁄₁₆ × 5¼ in.
The New-York Historical Society, x.443(G)

54. *Eight Amphora* *(p. 87)*
Gray wash and black chalk with traces of white gouache on pale
blue laid paper
3⅜ × 7¼ in.
The New-York Historical Society, x.443(H)

55. *Dark Landscape*
Gray and brown wash with blue pastel and black chalk on ivory
wove paper
4½ × 6¼ in.
The New-York Historical Society, x.443(I)

56. *Ruins on the Roman Campagna*, ca. 1861 *(p. 75)*
Watercolor and gouache over traces of graphite on off–white
wove paper
5⁵⁄₁₆ × 7⅞ in.
The New-York Historical Society, x.443(J)

57. *Ruin on the Campagna* *(p. 90)*
Watercolor, gouache and graphite on off–white wove paper
5¼ × 7¾ in.
The New-York Historical Society, x.443(K)

58. *Village with River and Bridge*
Watercolor and gouache on blue wove paper
5⅝ × 7¾ in.
The New-York Historical Society, x.443(L)

59. *Torre dei Schiavi* *(p. 88)*
Watercolor and pen and black ink on tan wove paper
5 ½ × 9 ½ in.
The New-York Historical Society, x.443(M)

60. *Italian Pines* *(p. 95)*
Gouache and watercolor over traces of graphite and black
chalk on green wove paper
8½ × 6½ in.
The New-York Historical Society, x.443(N)

61. *Figures in a Garden* *(p. 97)*
Black chalk on pale gray laid paper
7½ × 5¼ in.
The New-York Historical Society, x.443(P)

62. *Ruins on a Hill, Boat on a River*
Watercolor and gouache with traces of black chalk on blue
wove paper
4¹⁵⁄₁₆ × 7⅜ in.
The New-York Historical Society, x.443(Q)

63. *Roman Aqueduct* *(p. 81)*
Watercolor, gouache and black chalk on blue laid paper
5⅝ × 7¾ in.
The New-York Historical Society, x.443(R)

64. *Torre dei Schiavi*, 1861 *(p. 89)*
Oil over watercolor and gouache with traces of
graphite on off–white wove paper
5⅛ × 7⅝ in.
The New-York Historical Society, x.443(S)

65. *Ruins on the Roman Campagna*, 1861 *(p. 76)*
Watercolor and gouache with traces of graphite on off–white
wove paper
5⅜ × 7⅞ in.
The New-York Historical Society, x.443(T)

66. *Cypress Trees with Figures* *(p. 97)*
Black and white chalk over graphite on blue wove paper
6⅝ × 4¾ in.
The New-York Historical Society, x.443(V)

67. *Ruins on the Roman Campagna*, ca. 1861 *(p. 75)*
Watercolor, gouache and graphite on off–white wove paper
4⅞ × 7¼ in.
The New-York Historical Society, x.443(W)

68. *Straw Hut Among the Ruins*, ca. 1861
Watercolor, gouache and graphite on off–white wove paper
5³⁄₁₆ × 7⅝ in.
The New-York Historical Society, x.443(X)

69. *Arched Ruin*, ca. 1861
 Watercolor with traces of graphite on off–white wove paper
 $5\frac{1}{8} \times 7\frac{7}{8}$ in.
 The New-York Historical Society, x.443(Z)

70. *Hut and Haystack*, 1861
 Watercolor and gouache with traces of graphite on off–white wove paper
 $5\frac{3}{8} \times 7\frac{15}{16}$ in.
 The New-York Historical Society, x.443(AA)

71. *Torre dei Schiavi and Ruins*, 1862 *(p. 92)*
 Watercolor and pen and brown ink with traces of graphite and black chalk on buff–brown wove paper
 $5\frac{1}{2} \times 19$ in.
 The New-York Historical Society, x.443(BB)

72. *Ruins*, ca. 1861 *(p. 77)*
 Watercolor and gouache with traces of graphite on off–white wove paper
 $5 \times 7\frac{3}{4}$ in.
 The New-York Historical Society, x.443(DD)

73. *Ruins*, ca. 1861
 Watercolor and gouache with traces of graphite on off–white wove paper
 $5\frac{3}{8} \times 7\frac{3}{4}$ in.
 The New-York Historical Society, x.443(EE)

74. *Entry to Italian Hill Town*, ca. 1860 *(p. 50)*
 Watercolor and gouache with pen and brown ink on blue wove paper
 $7\frac{1}{8} \times 7\frac{3}{4}$ in.
 The New-York Historical Society, x.443(FF)

75. *Italian Villa on Hill*, ca. 1860 *(p. 51)*
 Watercolor and gouache with pen and brown ink on blue wove paper
 5×7 in.
 The New-York Historical Society, x.443(GG)

2 Thomas H. Hotchkiss, *Landscape with Hill Town (Olevano)*. Oil on canvas, 11¾ × 16¾ in. Private collection

76. *Cypresses and Convent of San Miniato, Florence, Italy*, 1864 (*p. 62*)
 Oil on canvas
 14¾ × 9⅛ in.
 Collection of the William A. Farnsworth Library and Art Museum,
 Rockland, Maine

77. *Torre di Schiavi*, 1865 (*p. 87*)
 Oil on canvas
 22⅜ × 34¾ in.
 National Museum of American Art, Smithsonian Institution

78. *Harvest Scene*, 1858 (*p. 40*)
 Oil on canvas
 5½ × 11¾ in.
 Jane and Simon Parkes

79. *Torre dei Schiavi*, 1864 (*pp. 11, 86*)
 Oil on canvas
 17 × 27 in.
 Private Collection

80 *Theatre at Taormina*, 1868 (*pp. 7, 104*)
 Oil on canvas
 15¾ × 30¾ in.
 Private Collection

81. *Landscape with Hill Town (Olevano)* (*p. 131*)
 Oil on canvas
 11¾ × 16¾ in.
 Private Collection

82. *Cypresses*, ca. 1864 (*p. 61*)
 Oil on canvas
 13½ × 8½ in.
 Whitney Sudler Smith

83. *Italian Landscape (Monte Mario, Rome)*, ca. 1868 (*p. 71*)
 Oil on canvas
 13¾ × 9 in.
 Whitney Sudler Smith

84. *Haying in the Catskills, New York*, ca. 1858 (*p. 39*)
 Oil on canvas
 5¾ × 11⅛ in.
 Graham Williford

3 Thomas H. Hotchkiss, *Wilderness Hills,*
ca. 1867. Oil on canvas, 7¾ × 16¾ in.
Graham Williford

85. *Winter Landscape, Catskill, 1858* (p. 37)
 Oil on canvas
 6¾ × 15½ in.
 Graham Williford

86. *Wilderness Hills, ca. 1867* (p. 133)
 Oil on canvas
 7¾ × 16¾ in.
 Graham Williford

87. *Study of a Hilly Landscape*
 Oil on canvas
 5½ × 16 in.
 Graham Williford

88. *Plant Study* (p. 94)
 Oil on paper
 9⅜ × 12⅞ in.
 Graham Williford

WORKS BY OTHER ARTISTS
(LISTED ALPHABETICALLY BY ARTIST)

1. Thomas Cole (1801–1848)
 Study: Dream of Arcadia, 1838
 Oil on panel
 8¾ × 14½ in.
 The New-York Historical Society
 Gift of the children of Asher B. Durand, through John Durand, 1903.9

2. Charles Caryl Coleman (1840–1928)
 Italian Mill
 Oil on canvas
 12¹³⁄₁₆ × 9⅞ in.
 The Brooklyn Museum
 Bequest of William H. Herriman

3. Charles Caryl Coleman
 Monk Reading, 1869
 Oil on panel
 13⅝ × 6⅝ in.
 The Haggin Collection
 The Haggin Museum, Stockton, California

4. Charles Caryl Coleman
 View of Sorrento, 1880
 Oil on composition board
 6¼ × 9⅝ in.
 Graham Williford

5. Charles Caryl Coleman
 The Villa Castello, Capri, 1885
 Oil on panel
 11¼ × 7½ in.
 Graham Williford

6. Asher B. Durand (1796–1886)
 Landscape, ca. 1855 *(p. 18)*
 Oil on canvas
 23⅞ × 16⅞ in.
 The New-York Historical Society
 Gift of Nora Durand Woodman, 1932.26

7. Asher B. Durand
 Man in an Oriental Costume, 1840
 Oil on board
 18 × 15 in.
 Jane and Simon Parkes

8. Sanford R. Gifford (1823–1880)
 The Falls of Tivoli, A Study, 1869
 Oil on canvas
 7 × 13 in.
 Alexander Gallery

9. Sanford R. Gifford
 Torre di Schiavi, Campagna di Roma, ca. 1864 *(p. 93)*
 Oil on canvas
 8½ × 15¾ in.
 Henry Melville Fuller

10. Sanford R. Gifford
 Lake Maggiore, 1858
 Oil on canvas
 17¾ × 30 in.
 The New-York Historical Society
 The Robert L. Stuart Collection, on permanent loan from the
 New York Public Library, Stuart 193

11. Sanford R. Gifford
 Study for Lake Nemi, ca. 1856
 Oil on canvas
 6¾ × 10⅛ in.
 Graham Williford

12. William Graham
 Snowing in Campo SS. Giovanni E Paolo, Venice, 1879
 Oil on canvas
 13¼ × 23⅝ in.
 Museum of Fine Arts, Boston
 Gift of Mary Bartol, John Bartol, and Abigail Clark

13. Casimir C. Griswold (1834–1918)
 Hadrian's Wall, Rome, 1879
 Oil on composition board
 5 × 6¾ in.
 Graham Williford

14. Casimir C. Griswold
 Villa Strohl–Fern
 Oil on canvas
 16¼ × 10½ in.
 Graham Williford

15. John Rollin Tilton (1828–1888)
 The Temple at Paestum, ca. 1872 *(p. 101)*
 Oil on canvas
 15⅜ × 23 in.
 The Brooklyn Museum
 Bequest of Colonel Robert Buddicon Woodward

16. John Rollin Tilton
 Taormina, Sicily, Greek Theatre in Foreground Looking Towards Etna. A Sirocco Day
 Oil on canvas
 11⅞ × 23½ in.
 Graham Williford

17. Elihu Vedder (1836–1923)
 The Cliffs of Volterra—Le Balze, 1860
 Oil on canvas mounted on paperboard
 12 × 25 in.
 The Butler Institute of American Art, Youngstown, Ohio

18. Elihu Vedder
 San Gimignano, Tuscany, 1858 *(p. 53)*
 Oil on canvas
 17 × 13¾ in.
 Joseph Jeffers Dodge, Jacksonville, Florida

19. Elihu Vedder
 Ruins: Torre dei Schiavi, ca. 1868
 Oil on panel
 15½ × 5¼ in.
 Munson-Williams-Proctor Institute Museum of Art,
 Utica, New York

20. Elihu Vedder
 Cypress Trees on San Miniato, Florence, ca. 1865 *(p. 63)*
 Oil on paper
 9¾ × 6½ in.
 Jane and Simon Parkes

21. Elihu Vedder
 Italian Landscape, 1869
 Oil on paperboard
 5½ × 10¾ in.
 Jane and Simon Parkes

22. Elihu Vedder
 Italian Landscape, ca. 1870
 Oil on paperboard
 5½ × 10¾ in.
 Jane and Simon Parkes

23. Elihu Vedder
Dominicans: A Convent Garden, near Florence
(Three Monks at Fiesole), 1859
Oil on canvas
11⅝ × 9½ in.
The Fine Arts Museums of San Francisco

24. Elihu Vedder
Le Casacce, 1867
Oil on cardboard
12⅝ × 11⅝ in.
Smith College Museum of Art, Northampton, Massachusetts
Gift of the American Academy of Arts and Letters, 1955

25. George Henry Yewell (1830–1923)
Torre dei Schiavi
Oil on board
5½ × 8¾ in.
University of Iowa Museum of Art
Gift of Oscar Coast

26. George Henry Yewell
Convent Near Rome, 1871
Oil on canvas
5½ × 9 in.
The Metropolitan Museum of Art
Bequest of Susan Dwight Bliss, 1967

27. George Yewell
View of Venice
Oil on panel
2¼ × 3¼ in.
Graham Williford

Lenders to the Exhibition

Alexander Gallery

The Brooklyn Museum

The Butler Institute of American Art

Joseph Jeffers Dodge

The William A. Farnsworth Library and Art Museum

Henry Melville Fuller

The Haggin Museum

The University of Iowa Museum of Art

The Metropolitan Museum of Art

Munson-Williams-Proctor Institute Museum of Art

Museum of Fine Arts, Boston

National Museum of American Art

Jane and Simon Parkes

The Fine Arts Museums of San Francisco

Smith College Museum of Art

Whitney Sudler Smith

Graham Williford